VENOMOUS
ANIMALS
OF THE
WORLD

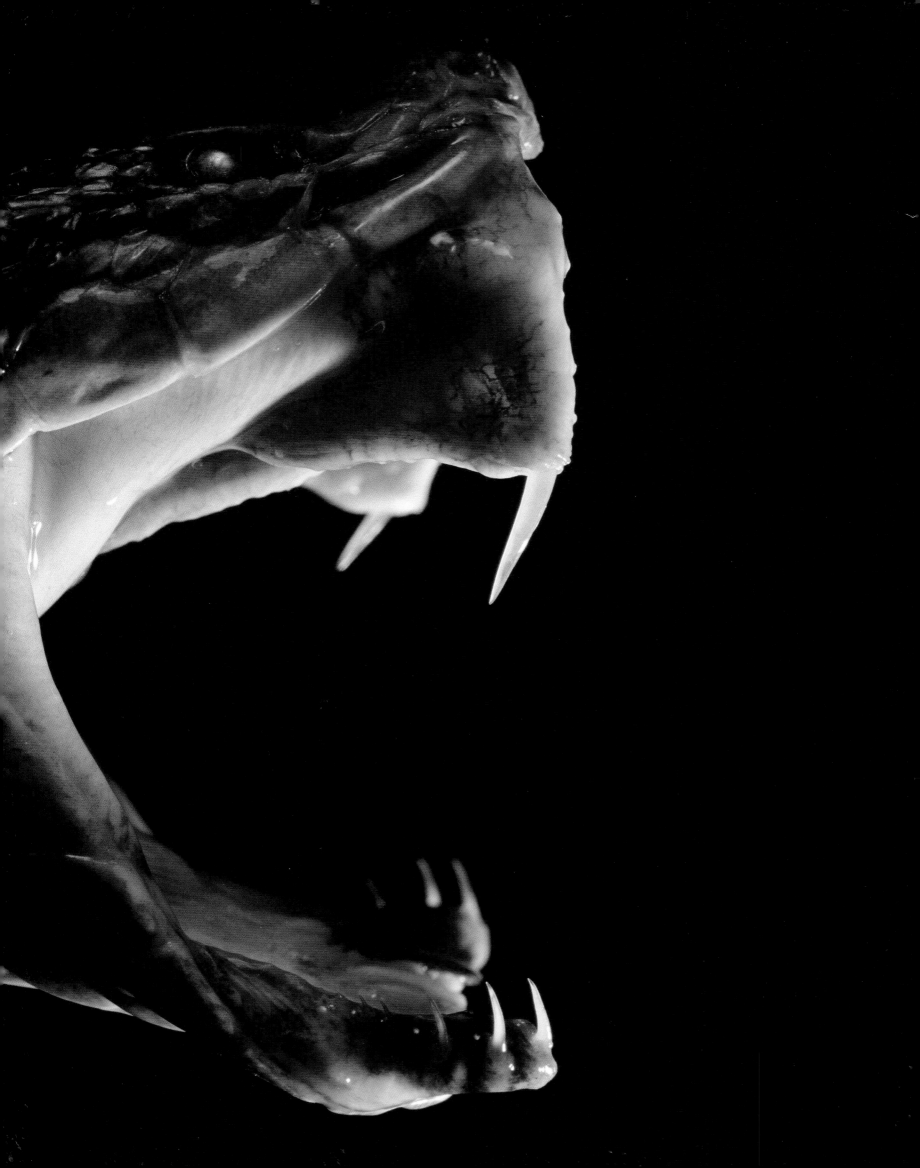

VENOMOUS ANIMALS
OF THE
WORLD

Steve Backshall

THE JOHNS HOPKINS UNIVERSITY PRESS | BALTIMORE

Printed and bound in Singapore by Tien Wah Press

Published in the United Kingdom by New Holland Publishers (UK) Ltd

First published in the United States in 2008 by the
Johns Hopkins University Press.

9 8 7 6 5 4 3 2 1

The Johns Hopkins University Press
2715 N. Charles Street
Baltimore, MD 21218-4363
www.press.jhu.edu

Library of Congress Control Number: 2007931643

ISBN 13: 978-0-8018-8833-5
ISBN 10: 0-8018-8833-6

Editorial Director: Jo Hemmings
Senior Editor: James Parry
Assistant Editor: Giselle Osborne
Copy Editors: Bob Watts and Liz Dittner
Design: Luke Herriot and Alan Marshall
Production: Joan Woodroffe

Photographs: page 1: Cobra hood; page 2: Fer-de-lance; pages 4/5:
Fat-tailed Scorpion; page 7 (clockwise, from top left): Red Spitting Cobra;
Mexican Red-kneed Tarantula; Killer Bee; Thick-tailed Scorpion; Komodo
Dragon; Red Fire Sponge.

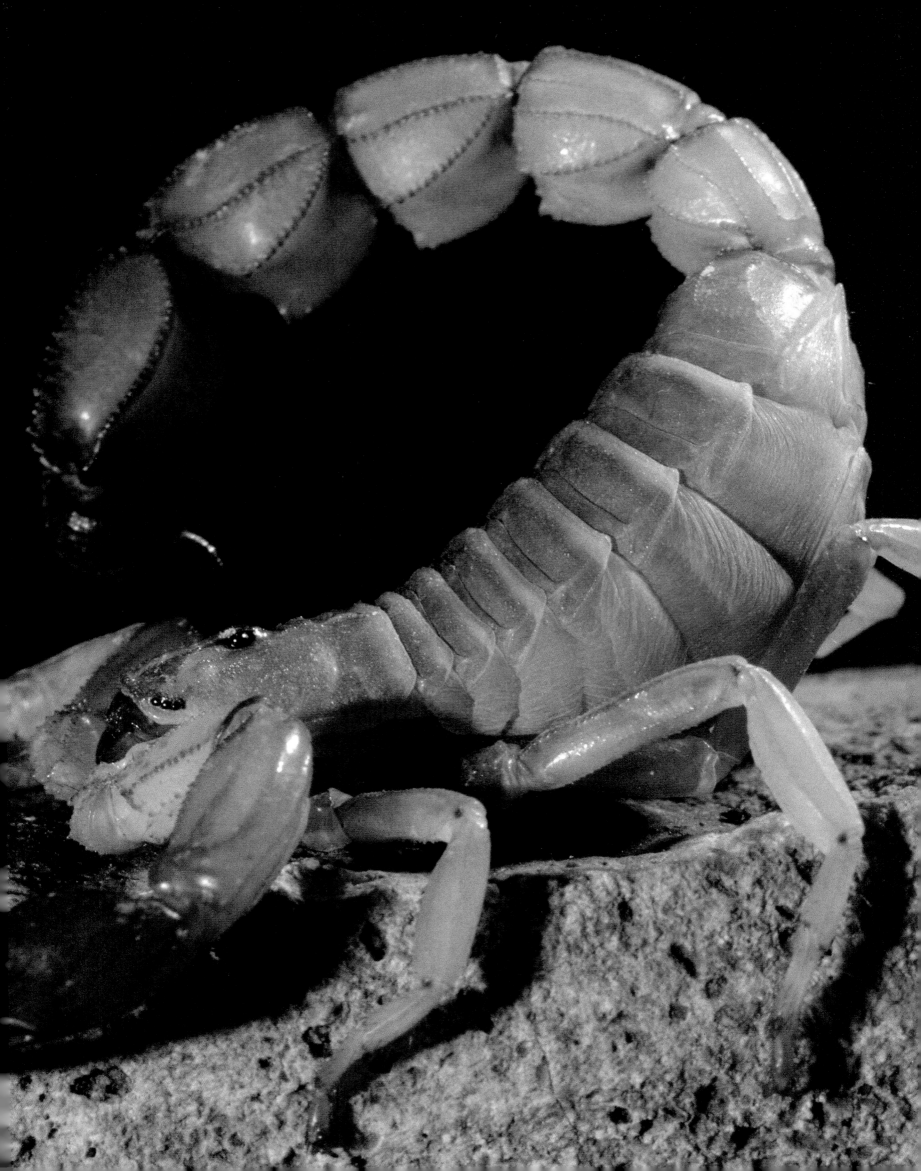

CONTENTS

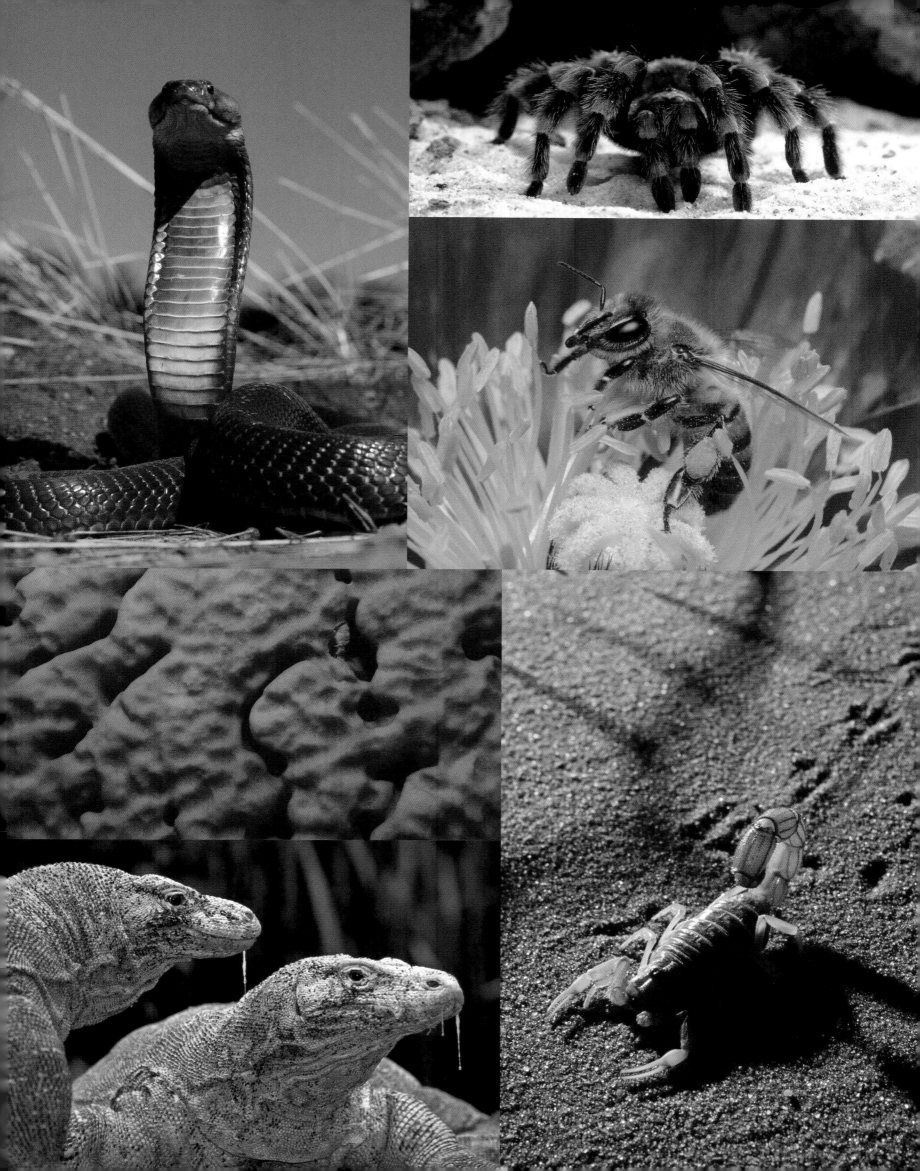

CHAPTER ONE

BRUTAL TOXIN

The fang barely pierced the skin, no more than a faint scratch, yet a teaspoon of virulent, yellowy fluid already surges through the veins, blossoming through the body like ink billowing in a glass of water. Teasing its way into the arteries, the venom begins to wreak havoc, a toxic lava flow let loose in the bloodstream. Complex molecules in the venom assault the body's communication centres, pulsating down the nerves. Under such bombardment, the neurons collapse in confusion, causing breathing and heartbeat to stutter. The serpent recoils, and awaits the inevitable.

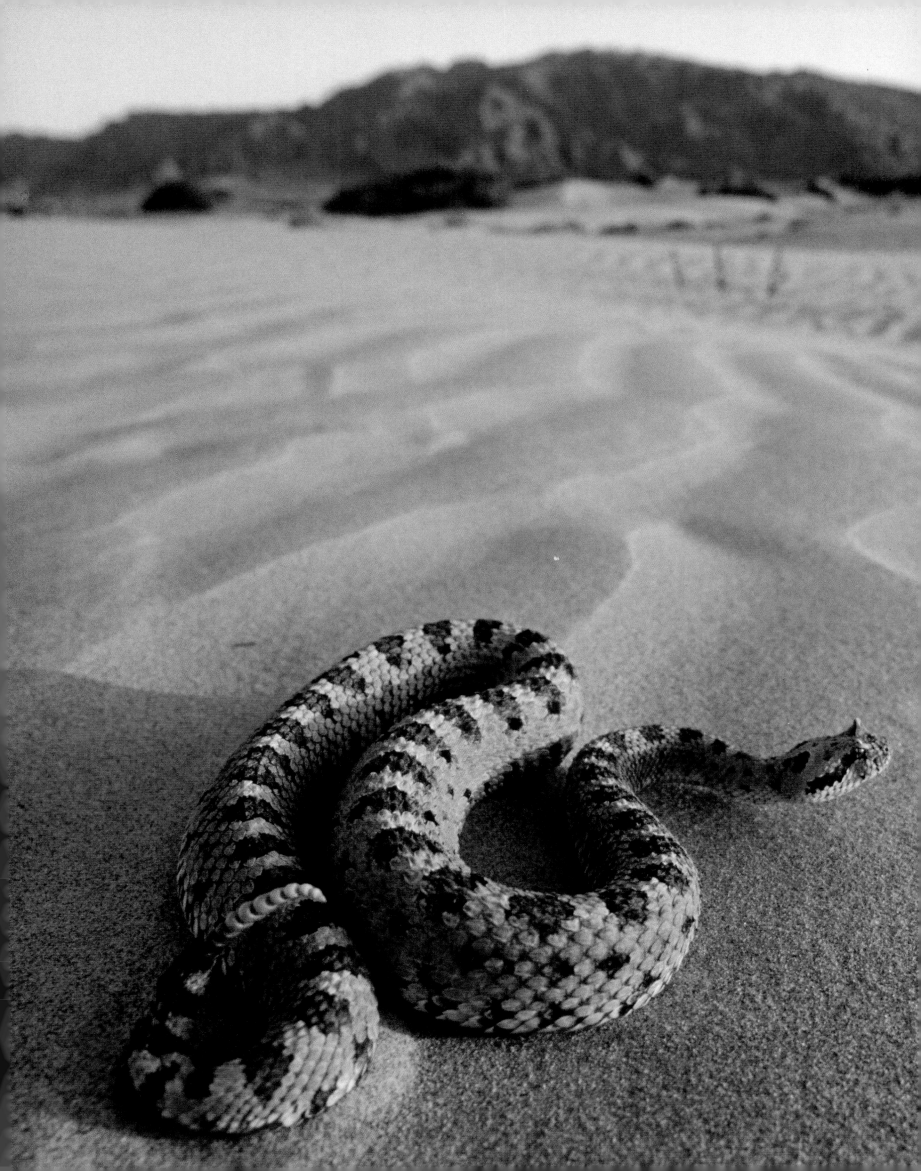

INTRODUCTION

Deep in the jungle on a recent expedition in Borneo, a fellow naturalist caught a tiny reptile that he mistook for a species of harmless kukri snake. He realized too late that it was actually a Coral Snake, *Maticora intestinalis*, a relative of the cobras; too late, because it had just bitten him on the finger. An internationally renowned herpetologist who was with us started running around, screaming out in loud panic that the naturalist's days were numbered, and that he only had a few horribly painful minutes left to live. Quite apart from the fact that this is without doubt the worst possible way to treat a person who has just been bitten by anything venomous, it also couldn't be further from the truth. On average you have a 90 per cent chance of surviving bites from cobras and seasnakes, with death in those few cases not happening until 5–15 hours after the victim has been bitten. (Vipers have a more variable mortality rate of 1–15 per cent, and as much as 48 hours after the bite.)

As it happened, my naturalist pal had received a 'dry bite', ie. no venom had been injected, and he suffered no ill effects at all (it was a close call though – he nearly asked his girlfriend to marry him in the time he thought he was doomed!). Even if venom IS injected, it still doesn't mean the end of one's days. Whilst on a recent filming trip in Thailand, I stayed with a snake dancer who had been bitten no fewer than NINETEEN times by the dreaded King Cobra (*Ophiophagus hannah*), and was still alive to tell the tale. And in Australia, where any bushman will tell you the snakes are deadly enough to kill a herd of buffalo, fewer than two people a year are lost to snakebite.

The point I'm trying to make with these facts and figures is that the actual dangers from venomous creatures are massively overstated – even by those who should know better. I feel almost guilty writing this book; the vast majority of animals in here are of absolutely zero potential danger to human beings, now or ever, and even the most dangerous of species… well, you're less likely to get killed by one than you are to be run over by a milk float!

Yet despite the realities, venom – and the animals that use it – have been an endless fascination to me ever since I was a youngster. It's probably the potential visceral power, the possibility of terrible harm, that is so morbidly absorbing. I guess it's the small boy in me that's writing this now and hoping that someone else feels the same wonder at the extraordinary lethal harpoon of the cone shell, the dart frog that looks like a Fabergé jewel, and the fabled menace of the mamba.

PREVIOUS PAGE: *Poised to strike, a Sidewinder* (Crotalus cerastes) *moves across the desert in search of prey.*

OPPOSITE *One of the* Dendrobates – *a so-called poison dart frog – photographed in silhouette through a banana leaf.*

BELOW *In a typical tropical downpour, I'm frantically assessing the colour bands on this snake to figure out whether it is a deadly Coral Snake or a harmless False Coral. Luckily, it turns out to be the latter!*

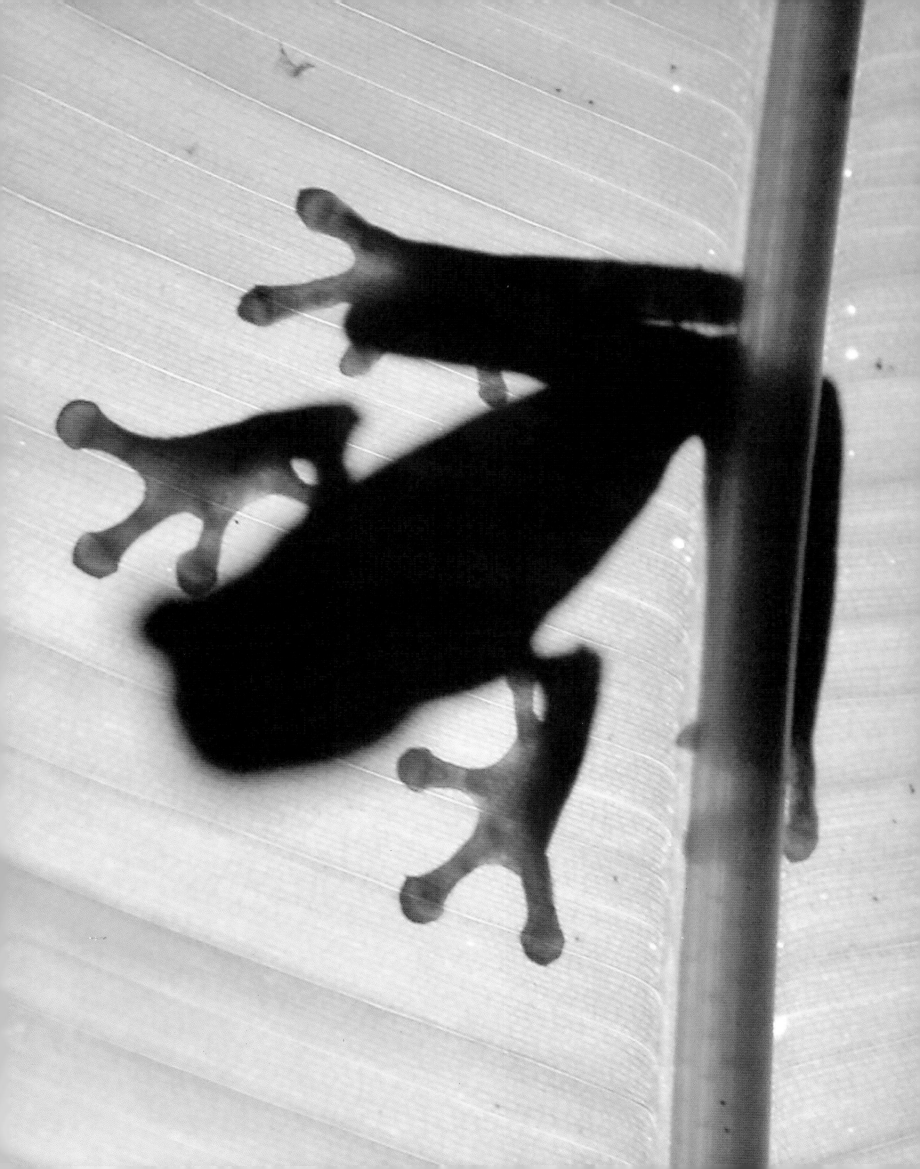

DEFINITIONS

Outside of the lab and the classroom, the terms 'toxin', 'venom' and 'poison' are used carelessly and interchangeably to mean any kind of unpleasant natural chemical. However, they actually mean rather different things. Potentially dangerous toxins exist in both venomous and poisonous animals, but it's the way in which the toxin is delivered that differs. Put simply, venom is injected whilst poison is ingested. Venomous animals have active systems for delivering their vicious payload, injecting toxins into a threatening predator or their prey through the use of fangs, claws, spines, spurs or any other sharp body part that is hollow, grooved or able to break the skin.

Poison is delivered by more passive means, however. It's either eaten or absorbed, and used by the originator for protection only. Poisonous animals store their toxin in their flesh or skin, as opposed to specialized venom glands.

A good example is tetrodotoxin, which can be categorized as either a poison or a venom, depending on how it's used. The pufferfish of the Tetraodontidae family collect (or bioaccumulate) tetrodotoxin from their diet in their tissues – mostly the liver, but also the gonads and skin – as a poison, which has its effect when parts of the fish are eaten (often by unfortunate or unwise Japanese restaurant-goers). The Blue-ringed Octopus (*Hapalochlaena maculosa*), however, stores tetrodotoxin in its salivary glands and uses its beak to bite the venom into a wound. Tetrodotoxin affects voluntary muscles and is so specific that it results in the shutdown of the lungs and eyelids (but not the involuntary muscles, such as the cardiac system). However, with the lungs paralyzed, the victim is unable to draw in air and suffocates.

For the purposes of this book, I'm dealing with those animals that possess natural toxins that they use to their own advantage. I've tried to focus on the more obscure and most interesting examples. So, rather than just listing the 500-odd species of snake that are venomous, I've included toxic amphibians, marine creatures, even mammals and birds, that hopefully will surprise at least some readers. As I type these words, my fingers are stained dark purple from the chemical secretions of one of my giant tropical millipedes (see p.88), and I've just read a scientific journal suggesting that the saliva of my own Taiwanese Beauty Snake (*Elaphe taeniura*) may possess a toxin every bit as complex as that of the cobras (although I've been bitten plenty of times without any ill effects). Venom is a fascinating subject with continued opportunity for new discoveries, and I hope to give a taste of its complexity in the pages that follow.

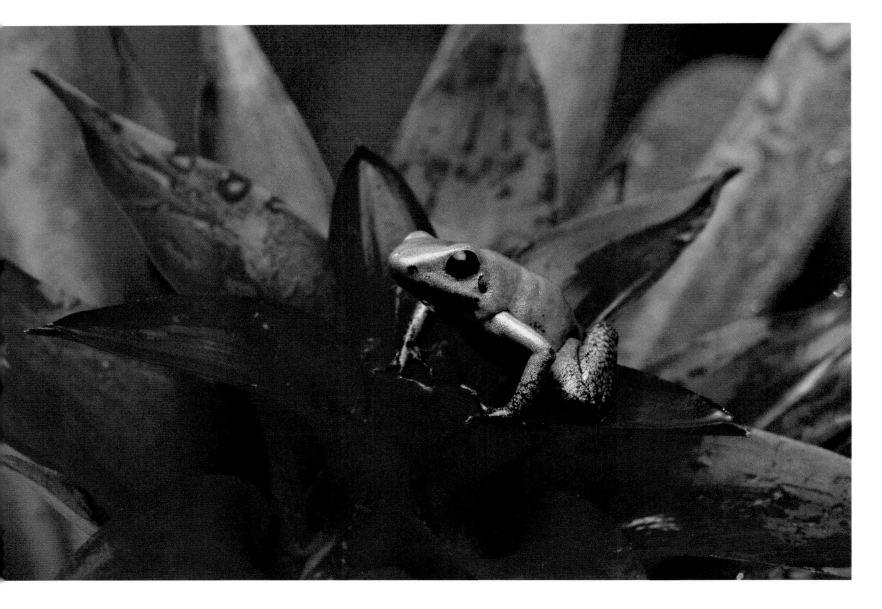

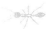

WHAT IS VENOM?

So what is venom? What is it constructed of? In snakes at least, venom is saliva, albeit a highly developed saliva, produced by modified salivary glands and rich in enzymes, a complex mix of polypeptides, nucleases, and peptidases, which help digest prey. Protein comprises more than 90 per cent of venom's dry weight (as established by Napoleon Bonaparte's scientific brother, Lucien, in 1843), with a cocktail of hundreds, sometimes thousands, of different proteins and enzymes. In the case of spiders and other invertebrates such as assassin bugs, the venom also serves a purpose in digesting or pre-digesting prey, but in these cases it may have very different constituents.

Many of these proteins aren't particularly harmful, but some of them are super-toxic. The reason different bites and stings have varying effects is that the percentage of toxic proteins, and the composition of the toxins themselves, vary widely from species to species. As the chart in Appendix One shows, there is a large range of venom types. The two most commonly discussed are haemotoxic and neurotoxic; snakes generally produce both kinds, but one kind is usually dominant in an individual.

The haemotoxins that comprise haemotoxic venom affect blood coagulation and the red blood cells, and attack the cardiovascular system. The destruction of red blood cells creates a chain reaction, which leads either to wholesale blood coagulation or uncontrolled internal bleeding.

Neurotoxins, on the other hand, act on the nervous system, getting in the way of nerve transmission, thereby causing intense pain and paralysis. They also affect the respiratory system, prompting respiratory failure. Powerful venoms in sufficient quantities can cause whole body paralysis, cardiac arrest, asphyxia and death.

OPPOSITE *The ultimate champion of champions,* Phyllobates terribilis *is so toxic that it's believed to have enough poison to kill ten men. This potent load is all synthesized from insects (probably Choresine Beetles), which in turn have sequestered alkaloids from the plants they eat.*

BELOW *A beautiful golden morph of the Eyelash Pitviper* (Bothriechis schlegelii), *coiled and ready to strike a hummingbird in flight (or even a nosy naturalist!).*

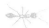

THE EVOLUTION OF VENOM

The British Grass Snake (*Natrix natrix helvetica*) is thought of as a classic non-venomous snake, a shy, retiring, back-fanged colubrid, totally harmless – well, unless you're a frog, that is. So why was the fiery little specimen in front of me hissing and fizzing like a wound-up Black Mamba, and why, after it had sunk its many teeth rather unpleasantly into my hand, did my digits go all red and itchy? Perhaps the Grass Snake's bold behaviour was a result of a new facet to his weaponry: the evolution of a proto-venom…

Some non-venomous snakes have been previously thought to have only mild 'toxic saliva', but recent studies show that they actually do possess true venoms. This answers the question as to why advanced fangs should develop in such snakes if there was no venom for them to deliver; evolutionary selection would have bypassed such sophisticated equipment in this case. It follows therefore that a proto-venom would have evolved before the fang; fangs most likely evolved to hold struggling prey. Venom was a major adaptation for prey capture in snake evolution; the fangs came later.

So how did venom develop in the animals that already possess it? Well, evolution has come up with a phantasmagoria of adaptations to two of life's most essential facets: getting enough to eat, and watching your back. Snake venom probably first appeared over 60 million years ago, during the Tertiary period, and just as the first of the Colubroidea or Advanced Snakes were starting to slither the earth. At the time, all snakes were like the boids of today – huge, heavy-bodied anaconda-like monsters that overcame or constricted their prey. The most likely item on their menu at the time were small, quick rodents, and the hefty snakes were getting left for dead; venom was the tool that allowed them to become smaller in body and hence swifter.

Generally speaking, venoms are the evolutionary result of super-potent salivas. They do the same job of starting the digestive process before the stomach acids take their turn. Their role in actually

overcoming the prey is likely to be a later adaptation, or perhaps evolved alongside these powerful digestive salivas. For example, the bite of the Komodo Dragon (*Varanus komodoensis*), the world's largest monitor lizard, seems to be developing in toxicity and has recently been classified as a true venom (see pp.144–5). This monster has long been thought of by local people as having poisonous breath, whilst scientists believed the dragon's saliva to contain so many strains of toxic bacteria (some of which may come from the decaying remnants of prey putrifying between its teeth) that a bite will inevitably result in hefty infections.

The Komodo Dragon will often take on prey as large as a Water Buffalo by attacking swiftly, then sitting back at a safe distance and waiting for the 'infection' to completely overcome the animal. The same behaviour can be seen in many venomous snakes – strike, inject venom and withdraw to safety to wait for the animal to succumb. The only difference really is that venoms in highly developed snakes, such as taipans, can kill their prey in a matter of minutes, whilst the Komodo may wait days for its prey to fall. However, with its low energy requirement and ability to go without food for long periods of time, this is not necessarily a problem.

As evolution favours the traits that confer an advantage on their owner, the most foul-mouthed of dragons will cripple their prey more quickly and outlive, outbreed and outcompete their fellows more successfully, until one day perhaps thousands of years hence (should dragons be allowed to survive that far) the bite of a Komodo Dragon may be as rapidly fatal as that of a mamba.

ABOVE *The Grass Snake* (Natrix natrix) *is widely considered to be a harmless non-venomous species, but some scientific evidence suggests it may be developing a proto-venom.*

OPPOSITE *The Komodo Dragon* (Varanus komodoensis) *was long thought to have such a nasty bite because of the huge amounts of bacteria in its mouth. Now it seems that Australian scientists have proved otherwise (see p.145).*

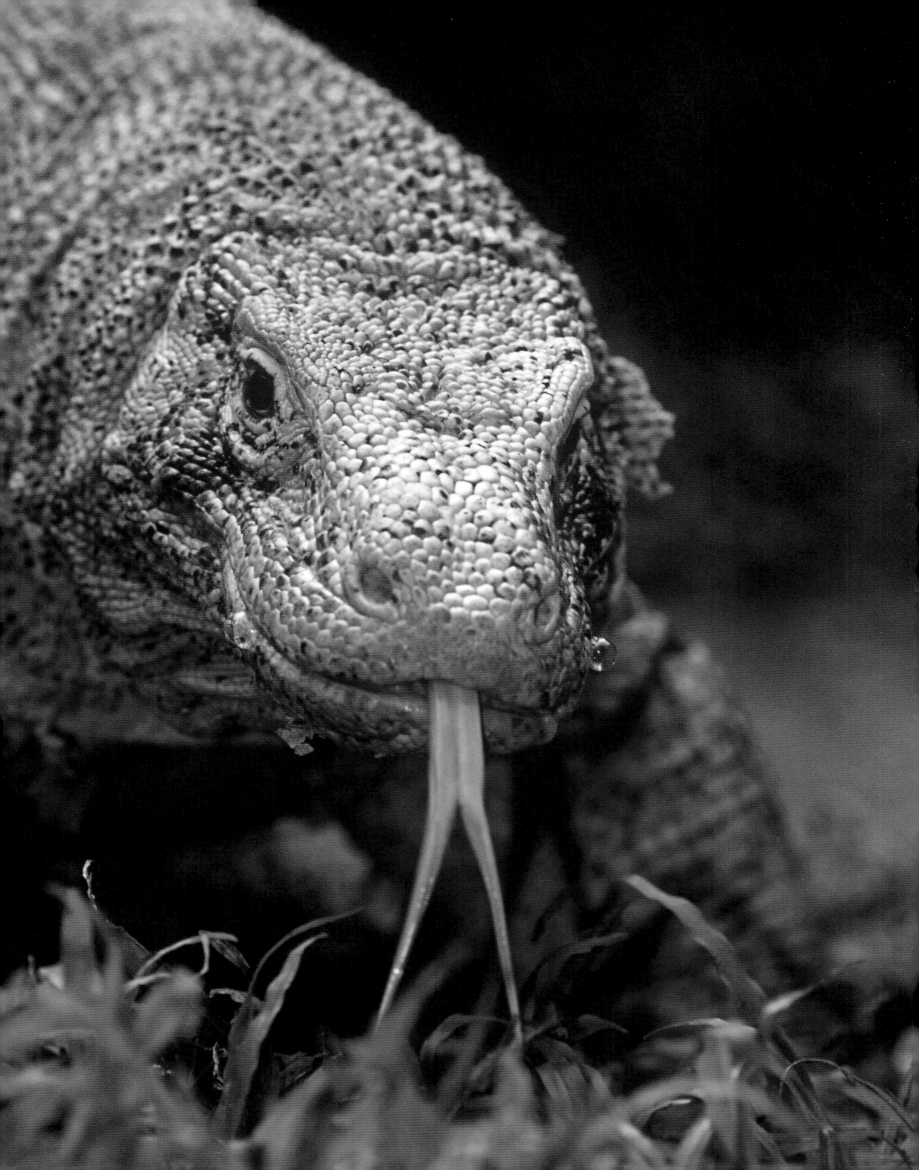

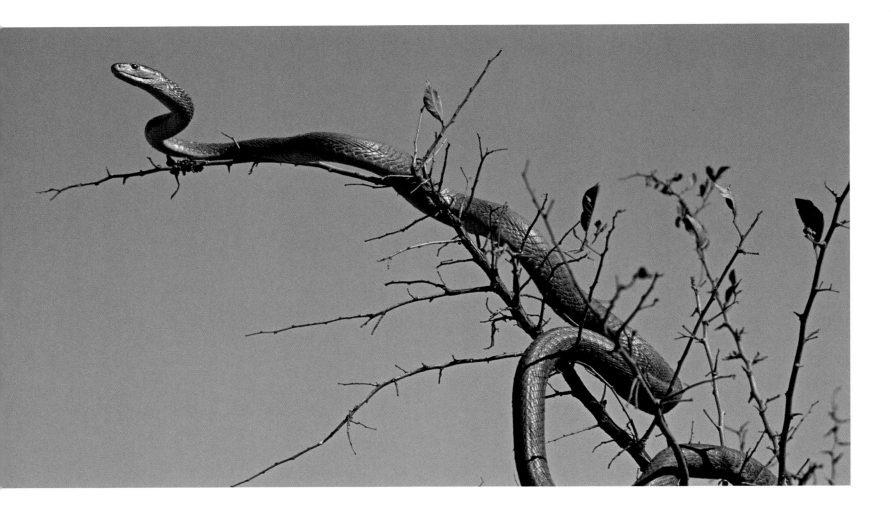

HOW VENOM WORKS

Venoms themselves are more complex than the finest blended whisky, and infinitely more potent. The polypeptide alkaloids are among the chief substances in animal venoms; nitrogen-rich compounds which have powerful physiological effects and are acridly bitter-tasting. They probably account for the fact that cobra venom tastes a bit like rusty nail-varnish remover (as I learned when an 'Mfezi' spitting cobra spat right into my mouth!)

Neurotransmitters

As one of the primary functions of venom is to immobilize a potential meal or an over-inquisitive predator, toxins head for the molecules that are central to the victim's movement. The receptors on the surface of the muscle or nerve cells, such as acetylcholine receptors, potassium channels and calcium channels, are the keys and locks that keep the nerves functioning and the muscles contracting, and it's these that venoms target.

The nervous system functions by conducting electrical impulses along the long nerve cells. The impulse transmits across junctions called synaptic clefts to other nerves or muscle fibres. At the end of the nerve, neurotransmitters such as acetylcholine allow the impulse to effectively continue into target nerves or tissues.

In simple terms, the acetylcholine receptor is the essential bridge for messages to travel through the nervous system and on to the muscular system. When acetylcholine receptors are on the blink,

signals between the muscles and brain go haywire or are blocked completely, causing paralysis. These receptors are a great target for venoms as they exist in so many different species throughout the animal kingdom; a wide range of predatory species has therefore developed toxins that home in on them. Toxins that act on these specific receptors have been found in seasnakes, cone shells, corals and cobras. The bite of a Black Mamba (*Dendroaspis polylepis*) will prompt the release of so much acetylcholine that the victim ends up with a neuromuscular blockage and eventually suffers complete respiratory shutdown. The bungarotoxins, on the other hand – such as those found in krait venom – also attack the neuromuscular junction, but have the opposite effect of inhibiting acetylcholine release, which results in no signals and no muscle twitch. However, the end effect of respiratory shut down is pretty much the same. I guess the message is that if nature finds a good system for killing, it tends to stick with it.

Channels for the ions sodium and potassium also play crucial roles in the transmission of a nerve impulse. Scorpion and anemone stings, *Scolopendra* centipede bites and the skin secretions of amphibians all head straight for the sodium channel, a large protein in the membrane of the nerve and muscle cells, which makes an excellent target for different toxins. Blocking the sodium channel is effectively what a hardcore local anaesthetic will do – doing this on a larger physiological scale is going to result in acute paralysis. The legendary poison dart frogs of South America, poisonous birds from Papua New Guinea and poisonous newts from California all have

tetrodotoxin and homobatrachotoxin in their bodies, which bind to parts of the same sodium channel. On the other hand, some scorpions (such as the Buthidae fat-tails), mambas and the humble honeybee have toxins that interfere with the function of nerve cells by acting on potassium channels. When potassium ions pass through a potassium channel they create a current, which venoms effectively block; blocking these ion channels again leads to respiratory paralysis.

Enzymes

Toxins attack the nerve and muscle cells, but enzymes are another important component in animal venoms. Enzymes are catalysts; proteins that bring about, speed up or catalyze chemical reactions, and are often used to break down complex molecules into their constituents. For example, our own saliva contains an enzyme called amylase, which helps turn starch into sugars, and assists in breaking down our own food. Enzymes are only present in the toxins of venomous species, not poisonous ones, due to the digestive function of enzymes. The venom gland of snakes, being a modified salivary gland, retains that digestive function, which helps explain the predominance of enzymes in their venoms.

Enzymes are found in all snake venom, and in many other animal venoms. Some enzymes are found only in the venoms of vipers and pitvipers, while others are found only in the venom of elapids, (ie. cobras, seasnakes and their relatives). These enzymes are responsible for breaking down tissues; they munch or digest the proteins of the prey animal. Others, such as hyaluronidase, act as a spreading factor, increasing the absorption of venoms through connective tissues.

The LD50 test for venoms

You have only to tune in to one of the ubiquitous satellite natural history channels to realise that human beings have an unhealthy obsession with any animal that can maim or mutilate, and those that deliver venom are obviously high on our fascination list. Our other fixation is to quantify everything, put things in a 'Top Ten', 'Best of', 'Most Lethal' index. The questions I get asked most are either in the "Who do you think would win in a fight between a Great White and a Sabre-toothed Tiger?" format, or the "What's the most venomous creature in the world?" category. Well, science can't really give you any hard answers to either question (though the way cable television is going, it may not be long before live 'shark versus bear wrestling'

hits our screens!), but there is one test that goes some of the way towards answering the 'most venomous' question. The only problem is that it involves sacrificing an awful lot of innocent mice.

Back in 1927, a chemist by the name of J.W. Trevan was looking to create a scale for the relative potency of drugs and medicines in public usage. His answer was the morbidly titled Lethal Dose 50 per cent test, or LD50. This represents the amount of a substance that will kill half of test animals after a single dose, which allows for comparisons between chemicals that may affect the body in very different ways – after all, death is about as quantifiable a result as anyone could ask for.

Where rats and mice are the unlucky subjects of LD50 testing, the rating is given as the amount of chemical administered per 100 grams of animal mass. LD50 tests are usually done with purified toxic chemicals, administered either into the skin (dermal test) or by mouth (oral test). So, the lower the value of the LD50, the less of a chemical is needed to kill off 50 per cent of the test animals, and the more toxic the substance is. See the table below for the scale:

ABOVE *Although the Strawberry Poison Dart Frog* (Dendrobates pumilio) *is not one of the most toxic species, after only a few minutes of holding this specimen the toxins seeped in through my pores and I began to feel dizzy.*

OPPOSITE *Allegedly the fastest snake in the world and with one of the worst reputations, the Black Mamba* (Dendroaspis polylepis).

TOXICITY RATING	COMMONLY USED TERM	ORAL LD50 (single dose to rats) mg/kg	DERMAL LD50 (single application to skin of rabbits) mg/kg	PROBABLE LETHAL DOSE FOR MAN
1	Extremely Toxic	1 or less	5 or less	1 grain (a drop)
2	Highly Toxic	1–50	5–43	4 ml (1 tsp)
3	Moderately Toxic	50–500	44–340	30 ml (1 fl. oz.)
4	Slightly Toxic	500–5000	350–2810	600 ml (1 pint)
5	Practically Non-toxic	5000–15,000	2820–22,590	1 litre (or 1 quart)
6	Relatively Harmless	15,000 or more	22,600 or more	1 litre (or 1 quart)

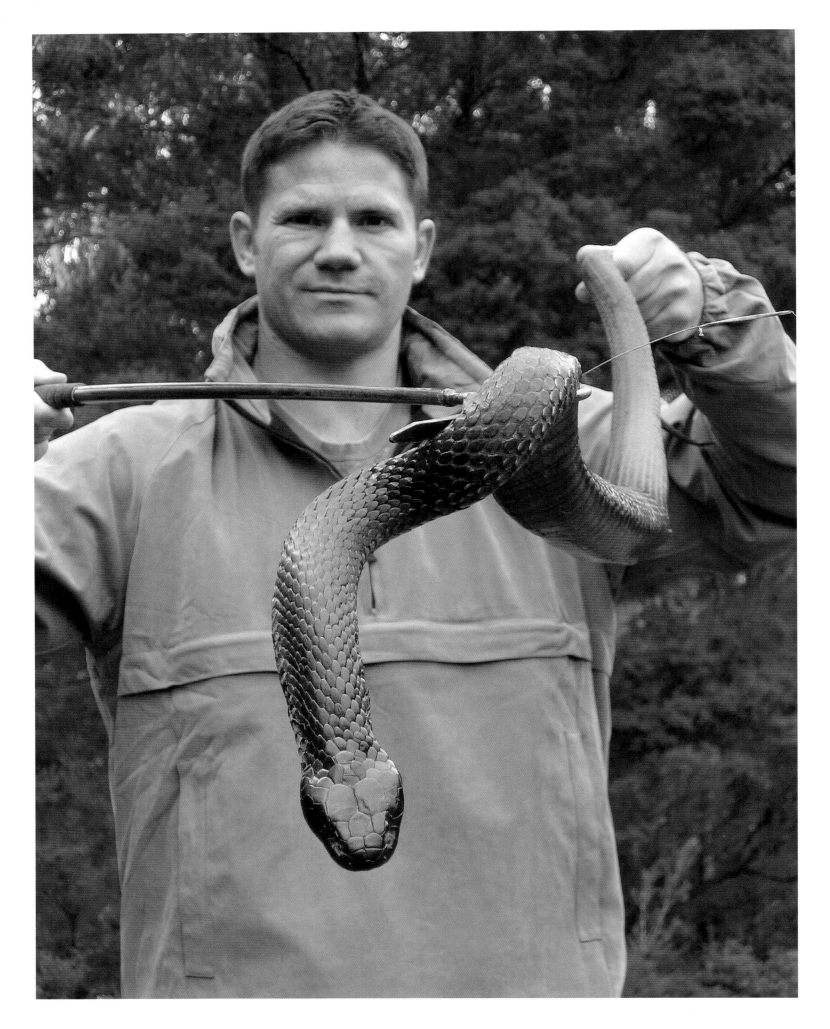

One of the obvious downfalls of these tests is that they are done on rats and mice which – let's face it – are not actually all that similar to humans. The simple fact is that snake venom that has evolved solely to target mice may be wildly more toxic to 90 kilos of mice than to 90 kilos of human being. Also, the LD50 tells only a tiny proportion of the tale when it comes to what really are the most dangerous creatures.

- **Venom yield.** Some snakes may offload tiny amounts of venom per bite, while others (the King Cobra, King Brown and Gaboon Viper, for example) may gush buckets of the stuff. The Eastern Brown Snake has an average venom yield of 2–6mg, whereas an Eastern Diamondback Rattlesnake has a maximum venom yield of 848mg. So although the venom may be less toxic, the bite is certainly incomparably worse.

- **Dry bites.** Venom production has a high-energy cost, and many creatures will bite without envenomation. Studies suggest that in some species as many as 25 per cent of bites are 'dry', ie. without venom, and in seasnakes the figure can be as high as 80 per cent.

- **Bite penetration.** The vast majority of the 50,000-odd species of spiders are venomous but lack big or powerful enough fangs to penetrate human skin. Most venomous snakebites are little more than scratches in the outer dermis, but snakes with huge fangs, like the Gaboon Viper, can actually impose intramuscular bites. These really can get to work deep in the muscle.

- **Aggression.** The world's most venomous land-based snake is the Inland Taipan, but no human fatality has ever been recorded – they're shy, rare and occur far from human habitation. On the other hand, the Russell's Viper lives in close proximity to people, strikes willingly and aggressively, and despite the species having comparatively tame venom, it may kill as many as 20,000 people per annum.

- **Relevance.** Tests have shown the venom of the Sydney Funnel-web Spider (*Atrax robustus*) to be fifty times more effective on human tissue than mouse tissue. Comparing venom toxicity on mice will always bias the results towards creatures that feed on (small) mammals. To be more relevant they should be tested using a variety of animals, such as fish, frogs and birds, and even then it still wouldn't reflect the absolute effects on humans.

- **Children** suffer more than adults as there is more venom administered relative to their body mass. At the same age, healthy individuals do better than their more debilitated counterparts. Victims bitten on the trunk, face and directly into the bloodstream have a worse time than those bitten on the extremities.

- **Running away** after a bite results in blood flow and increased absorption of venom, so those who panic and run around usually suffer more. The protection afforded by clothes and shoes can make a massive difference – some bites won't even penetrate beyond clothes, and venom can easily be injected into the fabrics rather than the victim.

OVERKILL? VENOM STRENGTH AND POWER

So why are certain snake venoms so powerful? The Western Diamondback Rattlesnake (*Crotalus atrox*) injects roughly three hundred times the amount of venom required to kill its mouse prey – isn't this a little excessive? Venom production costs a great deal in terms of energy for the organism, and in order for it to continue to evolve into more and more powerful toxins, there must be considerable evolutionary advantages.

As an idea as to why small creatures might have developed a bite that could kill a horse they obviously couldn't eat, let's consider the most venomous of land snakes, the Inland Taipan (*Oxyuranus microlepidotus*). Some sources suggest that a taipan contains enough venom to kill up to a hundred people; but why?

Taipans are mammal specialists, and mostly feed on rats. However, these insidious ferals are not natural to Australia, and it seems likely that before they were around taipans used to eat a lot more native marsupials, such as bandicoots. Bandicoots are fierce little beasties with sharp claws and teeth, and would make quite a challenging adversary for even a fully-grown taipan. If the snake were to strike with its long fangs, and wait for the bandicoot to succumb to the venom, it would have to cling for several minutes to a rampaging nightmare of teeth and claws fighting for its life. Taipans are tough, but no doubt many snakes would be mortally wounded by their lunch; behaviour that evolution would certainly weed out through natural selection. Instead, the taipan strikes like lightning, injects a hefty dose of hugely powerful venom, then withdraws to safety. In a millisecond the deed is done and the prey's fate is sealed.

However, even as the venom works towards its inevitable conclusion, the swift bandicoot can flee for safety. In a few minutes it could be half a mile away, perhaps down a maze of burrows. The point of having venom of astounding toxicity is that the prey becomes incapacitated much more quickly and collapses within a manageable distance of the strike. Even more ingenious, the taipan's venom contains compounds that relax the bladder control of its prey. As the bandicoot staggers away, it leaves a trail of urine, which the snake – with its superlative olfactory senses – can follow at its own leisure.

OPPOSITE *Tiger snakes (genus* Notechis) *are highly venomous and must always be handled with caution, which is apparent in my face! Sadly, most species of tiger snake are declining and they are now protected by law in most Australian states.*

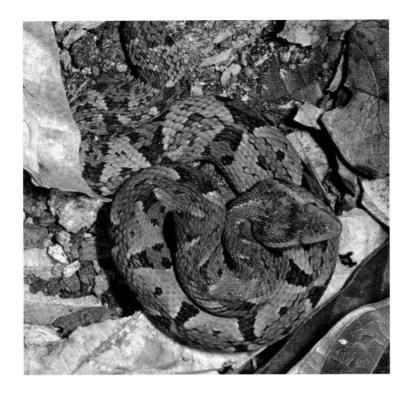

VALUABLE VENOM

Think toxin and you'll probably envisage rusting barrels of sludge polluting the environment. Think poison and you probably imagine mass-murderers and victims clawing their way out of acid baths. Or maybe that's just me! The truth is, however, that there's currently tremendous excitement in the scientific community concerning the pharmacological potential of natural toxins.

In Australia's Institute of Marine Science, there's a simple chest freezer whose contents are said to be worth many millions – potentially billions – of dollars. It contains the purified contents of many insidious toxins isolated from marine organisms, such as sponges, bryozoans and jellyfish, the results of hundreds of man-hours of work. One of the compounds, Bryostatin-1, has shown incredible improvements in human spatial memory, has worked in fighting depression, and is being touted as one of the most exciting new-wave drugs in the fight against cancer. It was isolated from the toxic defence system of a rather wispy seaweedy-looking bryozoan found on the hulls of ocean-going liners.

Nature has spent millions of years perfecting deadly toxins, and they form some peculiarly complex and efficient chemicals. It makes perfect sense to investigate their potential as life-saving medicines. Homeopaths have used venoms for centuries, but in the late 19th century scientists began seriously to investigate what therapeutic uses they might serve. They found many varied functions in aiding blood disorders and pain relief, and it was soon noticed that the bite of the Russell's Viper (*Daboia russelii*) had powerful coagulant properties. It was subsequently applied as a treatment for haemophilia, and is still used as a diagnostic agent to determine deficiencies in clotting factor for haemophiliacs. More recently, the complex molecules found in venoms have been intensively investigated as possible scaffolds for drug design.

- Captopril, a billion-dollar drug for high blood pressure, with few side effects, was sequestered from the venom of a Neotropical Lancehead (*Bothrops jararaca*) snake. It is presently the most effective hypertension reliever, and amongst the twenty best-selling drugs in the world.

- A toad poison called Senso is being tested for its effects in vasodilation (the dilating or expanding of blood vessels) and produces effects similar to those of adrenalin.

- Some of the poison dart frogs produce toxins that have proved over 200 times more effective than morphine in pain relief.

- Bee venom has been touted for years as a cure for rheumatoid arthritis. Melittin, the principal peptide in bee venom, blocks the expression of inflammatory genes that can cause painful tissue swelling in rheumatoid arthritis patients – effectively it works as an anti-inflammatory.

- Research into *Elaphe* rat snakes (very commonly kept as pets) show that they actually possess a typical cobra-style neurotoxin, one that is as potent as comparative toxins found in elapids. The rat snake toxin has good potential to be used as a scaffold for use in drug design and development.

- In June 2005, the US Food and Drug Administration approved a new diabetes drug called Byetta™ (exenatide); derived from a compound in the venomous saliva of the Gila Monster. Byetta is effective against type 2 diabetes.

- A Californian company is assaying the venom of cone shells in an attempt to make a painkiller that is 50 times more potent than morphine, but non-addictive.

- Deathstalker Scorpion (*Leiurus quinquestriatus*) venom contains a peptide called chlorotoxin, which has been shown to have potential for treating brain tumours in people. Other factors in the venom may also help to regulate insulin, and therefore treat diabetes.

ABOVE *The Neotropical lanceheads are the worst offenders for serious snakebite in South and Central America, but their venom has provided a best-selling drug used to relieve hypertension.*

OPPOSITE *Milking snakes can be a risky business, but some snake farms may milk hundreds in a day to provide the raw materials for research and antivenins.*

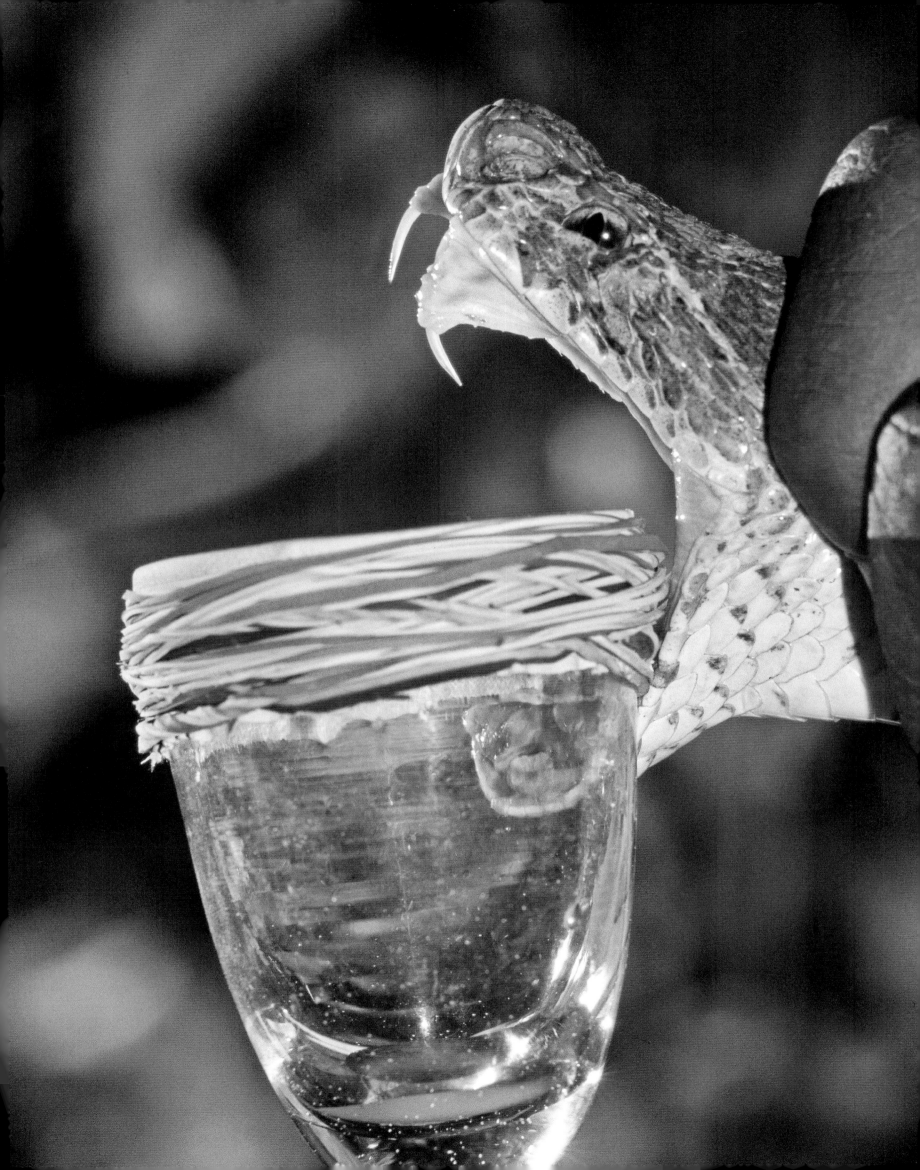

ANTIVENIN – MIRACLE ANTIDOTE?

We've all seen it a hundred times on the silver screen: our hero has been struck by an evil toxin, whether the germ warfare agent of Dr Disaster, the jaws of a glow-in-the-dark giant spider or a viper bite in the depths of the desert, and there's only twenty minutes left to find the serum. At the last minute, the antidote is found, pumped into his veins, and our hero wakes from his coma, leaps to his feet and dashes the evil Doctor's attempts to take over the world.

Well, aside from my love of cliché, there's quite a lot wrong with this scenario. For a start, antivenoms are rather toxic substances, and were you to be injected with one right now, the chances are it would make you very sick and possibly even kill you. A lot of the effects of venom are irreversible, whatever you inject yourself with afterwards, and other effects may take a long time to overwhelm. A study on cobra bites in India looked at victims with neuromuscular paralysis, some of who were given antivenin (sometimes known as antivenom). Four of the patients did not receive any antivenin, and all survived. Of five who had more than 50 units of the antivenin, two died. It doesn't exactly make good reading. However, it's worth looking at how these things actually work.

Antivenin is an artificial biological product used to treat venomous bites; classified as monovalent, (ie. effective against the venom of one particular species) or polyvalent (effective for several species). The first modern antivenins were developed by Albert Calmette, a French scientist working for the Pasteur Institute in Indochina. His method of producing those original antivenins (then called anti-ophidic serums) was very similar to those used by Louis Pasteur to create vaccines. In 1887, Henry Sewall at the University of Michigan used this development to immunize pigeons against pitviper bite.

Countless unlucky domestic mammals are put to service to provide the substance, although unlike in LD50, they don't have to die for antivenin to be produced. A small amount of a certain venom is injected into animals such as beagles, horses, goats, sheep or rabbits. Those animals' immune systems go into overdrive, producing antibodies, which are then harvested.

Many individuals react to having a foreign substance such as antivenin injected into their veins with anaphlaxis – immediate hypersensitivity, or delayed hypersensitivity called serum sickness. Obviously just injecting beagle blood into a sick patient isn't going to do a great deal to prevent this, so the antivenin is purified by a range of different processes. Once they've been purified, antivenins are kept as freeze-dried ampoules and must be injected intramuscularly as soon as possible after the venom has been injected; up to 4–5 hours after the envenomation is the normal requirement. Though they are not miracle cures that have heroes leaping instantly from their comas, the perfection of antivenins has meant that some bites, which would once have meant a certain call to the undertaker, are now rarely fatal if the antivenin can be delivered on time.

The administration of antivenin needs to be done very carefully; if insufficient amounts are given to neutralize a neurotoxic venom, receptor sites will remain blocked and the person will still not be able to breathe without assistance. However as the antivenin molecule is pretty big, if too much antivenin is administered it may shield the receptor site from interaction with acetylcholine; pretty much the same effect as the bite itself, and with the same resultant symptoms. To the present date, antivenins have been developed for (amongst others) the Sydney Funnel-web, Redback and black widow spiders of the *Latrodectus* genus, and wolf spiders of the Lycosidae family. Amongst the snakes, specific serums for the mamba, taipan, death adder, coral snake and rattlesnake are effective, as well as several polyvalent serums.

New antivenins

Simon Wagstaff and colleagues at the Liverpool School of Tropical Medicine have recently created antivenin without using any actual venom as the starting point. Instead, they began with the DNA of a species of carpet viper (responsible for many deaths in West Africa) and looked for genes that were active as the snake was refilling its venom sacs. From these genes, which appear to render the venom deadly, they isolated DNA that seems to elicit antibody responses. So far, it seems to have been a success in test animals.

Another even more appealing possibility was revealed to me when filming with King Cobras in Thailand. Local 'snake boxers', who dance with or tease King Cobras on stage and are often bitten, take a local root *Curcurma longa* mixed with alcohol and seem to have remarkable resilience to the venoms (and other neurotoxins too). Dr Eric Lattman of Aston University ran tests on the plant, and discovered – unbelievably – that it was nearly 100 per cent effective against neurotoxins (and certainly more effective than the conventional antivenins)! Now all we need to do is convince people in developing countries to grow this root in their back gardens…

OPPOSITE *A superb example of a threat display designed to help a snake avoid potential injury (eg. the breaking of a fragile tooth) in a defensive strike. The rattlesnake's famous rattle is actually formed from buttons of dry skin.*

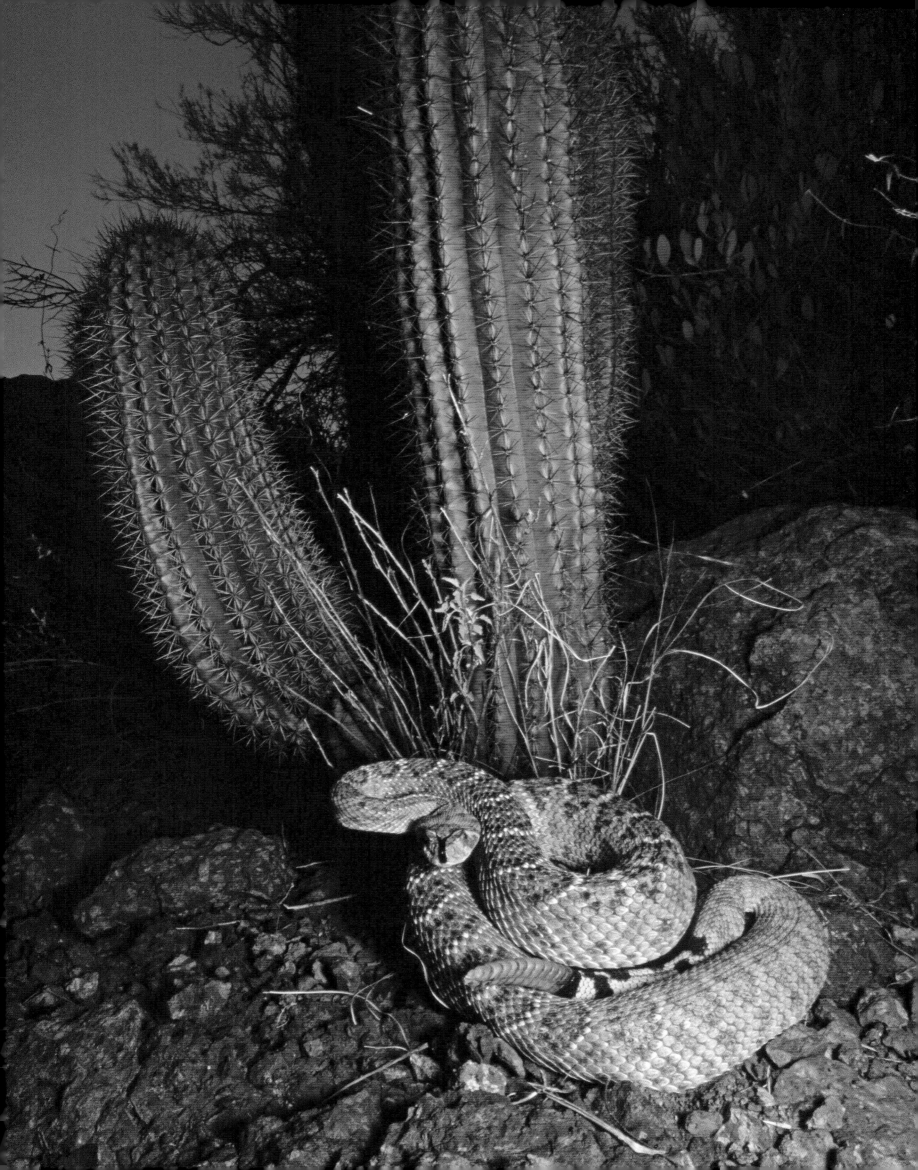

WHAT TO DO IF YOU ARE BITTEN

I've sat through an awful lot of medical lectures on what to do in the event of getting bitten, and often come out none the wiser. It seems that most of the advice is based on the assumption that you are just a telephone call away from a vehicle to get you to a hospital system with the exact antivenin you require. Unfortunately, for someone like me, it's far more likely to happen on an expedition in the middle of nowhere, and a good deal of the treatment is likely to have to happen in that environment, whilst trying to get out to 'civilization'.

The once ubiquitous advice for dealing with snakebite was to cut out the flesh surrounding the bite – even amputate the limb – and suck out as much venom as possible. However, as systemic venom absorption starts almost instantly, (particularly in the case of neurotoxins) this is now very much questioned. It's argued that trying to suck cobra venom out of someone's veins is a bit like trying to extract a drop of ink out of a glass of water. Plus, of course, if the venom gets into tiny cuts, fillings, ulcers etc. in the mouth of the person doing the sucking, the venom is going to go straight to their brain. Present wisdom tells us not to suck snakebites. However, call me old-fashioned, but if I get bitten by a King Brown in the middle of the outback, I'm going to be sucking the wound like a mad thing – I

figure getting even a pinprick of venom out of the wound could be the difference between life and death! For the super-prepared boy scouts among us, however, there is a patented machine – the Sawyer extractor – devised to remove venom quickly from a wound, although trials have shown conflicting results regarding its effectiveness.

Cutting a wound is certainly not a good idea, and can result in trauma, infection etc. When filming in Costa Rica recently I was told of a local boy who had been bitten on the hand by a coral snake. His father took an axe and chopped his arm off at the elbow. That the shock didn't kill him is a miracle; what good this somewhat extreme treatment did is likely to be negligible!

Accepted wisdom suggests that the wound should be cleaned with a sterile solution, dressed with a pressure bandage, enough to prevent the venom travelling through the lymph system, but not a tourniquet that prevents blood flow. You should be able to just get a single finger underneath the bandage. Others say you should not clean the wound, as remnants of venom on the skin may be used to identify the venom type later on and advise antivenin use. Certainly the victim must be kept calm, and not exert himself, as increasing the heart rate will increase blood flow, and speed the venom's passage around the body, and he must of course be evacuated to a hospital as soon as possible.

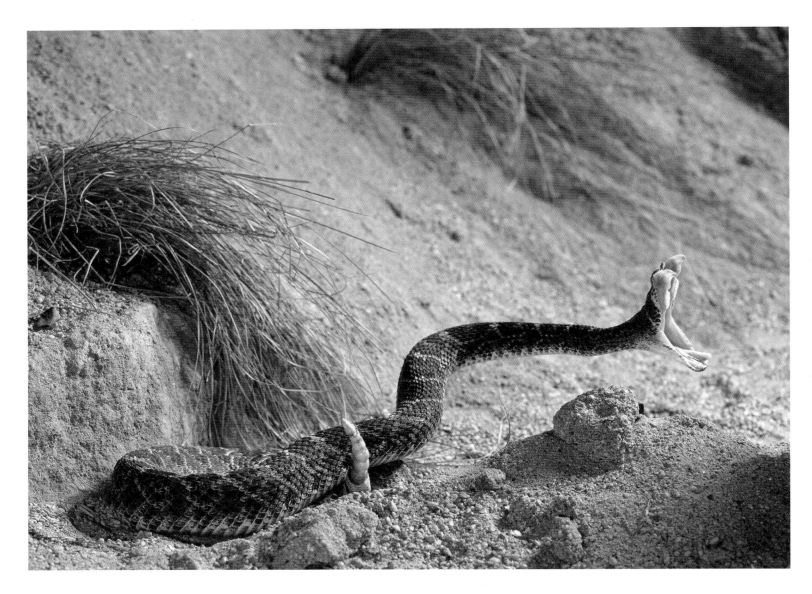

Some say analgesics such as aspirin are acceptable for pain relief, others that this may precipitate bleeding internally. I've applied wetted aspirin directly to the site of a scorpion sting, and it definitely eased the localized pain. Meanwhile, most gung-ho military experts will advise killing the offending creature in order that it can be identified (indeed, military survival courses advise sweeping campsites and killing all venomous creatures within the perimeter). This is complete madness. Further provoking a furious animal is not going to solve anything, but may well get someone else bitten, and just because it has bitten once, absolutely doesn't mean the next bite is going to be any less potent. By far the most likely time to get bitten by a venomous creature is when you are deliberately interacting with it. Leave them well alone!

The wound site itself – particularly in tropical environments – is an obvious site for infection to enter the body and efforts should be taken to keep the site sterile. Generally speaking, puncture marks are likely to be fairly small, unless substantial necrosis (cell death) takes place. In this case surgical debridement may be suggested, as well as hyperbaric oxygen therapy and drugs such as dapsone. In the case of neurotoxins that cause paralysis, such as fugu poisoning or Blue-ringed Octopus bite, artificial ventilation may be vital to keep the patient's respiration active. Getting plenty of fluids into a patient

may be a good way of flushing out the system, and preventing kidney damage.

Though inducing vomiting is often suggested as a good way of ridding the body of poisons, it should be noted that this can cause subsequent loss of airway reflexes, thereby stopping the breathing. Flushing the system with copious amounts of water or milk is more often suggested.

OPPOSITE *A Western Diamondback Rattlesnake* (Crotalus atrox) *making a strike. The speed with which these snakes move is astonishing, but they only attack humans if provoked.*

BELOW *The world's longest venomous snake, and I would say the most intelligent of all serpents, the King Cobra or Hamadryas* (Ophiophagus hannah) *is a real handful. This male was over three metres in length, and they can reach double this size!*

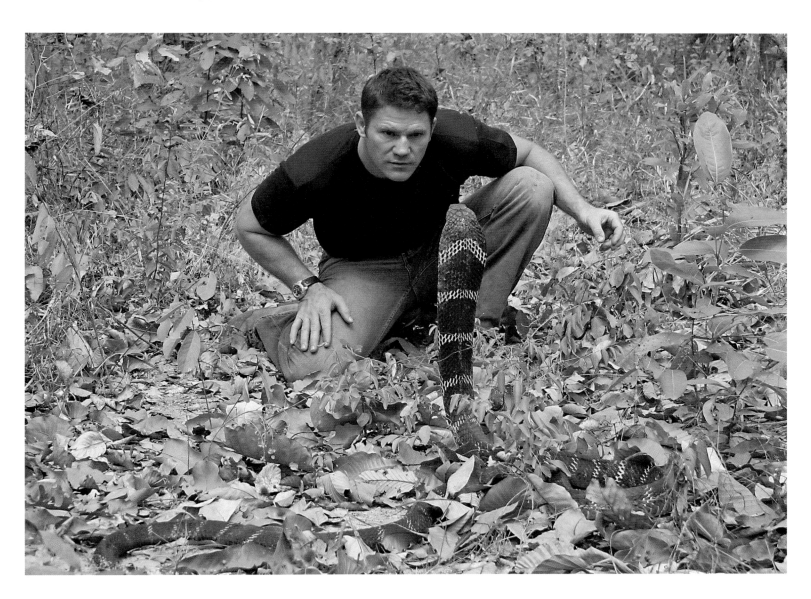

MYTHS ABOUT VENOM

The myths about venoms are so vast that you could fill a whole library with them, but here's a quick hitlist, with an 'Old Wives' Tale' rating ranged from 0 (100 per cent true) to 10 (total fiction).

• "The Daddy-long-legs is the most venomous spider in the world." Leaving aside the fact that harvestmen (arachnids with no venom glands) and crane flies (harmless flying insects that can't bite and don't even eat as adults) are more usually called daddy-long-legs in Britain, the Daddy-long-legs Spider of the Pholcidae is what we're probably talking about here. The pholcids certainly have short fangs (known as uncate fangs), as do Brown Recluse Spiders, which can

inflict dreadful bites, but pholcids do not give painful bites to people. This is due either to the increased jaw musculature of the recluse spider, or the fact that pholcid venom just has no effect at all on humans. No LD50 test has ever been done on pholcid venom, and as comparable spiders have venom much less potent than that of a nasty such as the Sydney Funnel-web, this seems spectacularly unlikely. **OLD WIVES' TALE RATING: 9**

• "Seasnakes cannot bite you." When diving and swimming in the tropics, I've very often got tangled up with seasnakes. They seem to like physical contact, and are rarely if ever aggressive. However, they possess some of the most potent venoms in the world, designed to paralyze the fleetest fish in seconds before they can swim out of range. But with small heads and rear fangs, they would certainly find it difficult to achieve a high level of envenomation into a human without chewing on an earlobe or finger. Even so, bites on arms and legs have been recorded and are not unusual among fishermen in rural communities (usually occurring when they try to extract the snakes from their nets). **OLD WIVES' TALE RATING: 4**

ABOVE *A Daddy-long-legs Spider, reputedly the most venomous of all arachnids, but is this reputation justified?*

LEFT *Virtually all of the* Hymenoptera *(wasps, ants, bees and their relatives) need to be treated with respect. The high amounts of allergens they contain means that even a single sting can kill the sensitive.*

OPPOSITE *It may look like a monster from a horror film, but the Camel Spider does not even have venom glands.*

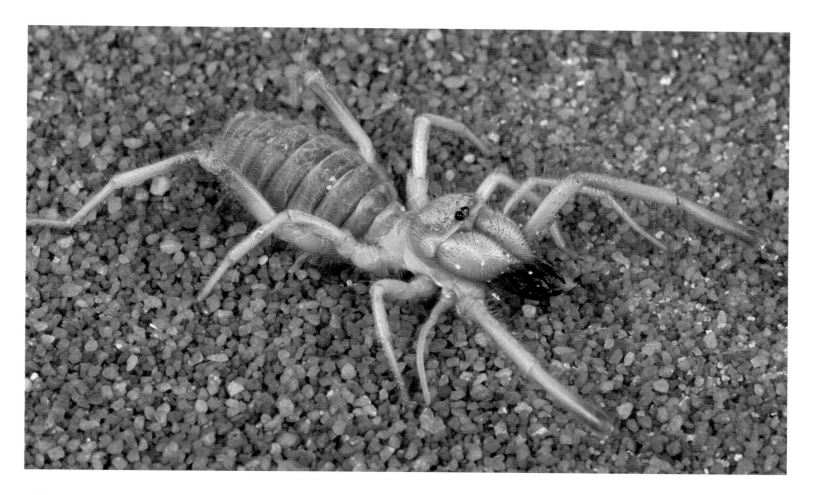

- "You can become immune to poisons and venoms". Generally speaking, some of the people most vulnerable to venoms in general are herpetologists or reptile-farm workers, who are exposed to venoms and venomous bites repeatedly and have developed hypersensitivity. Many ophiophagic animals, i.e. those that feed on snakes, are genetically immune to the bites of some species, via the presence of antihaemorrhagic and antineurotoxic factors in their blood. For a human to develop immunity, they would have to steadily and carefully introduce themselves to tiny graded amounts of a specific poison over some years to stand any chance of benefits. According to Greek mythology this was practised by King Mithras to make sure he didn't get poisoned, so the process is now known as mithridization. **OLD WIVES' TALE RATING: 2**

- "Camel Spiders inject novocaine into a wound so they can eat the flesh." Camel Spiders, Wind Scorpions, Sun Spiders – more correctly solifugids – don't have venom glands at all, much less venom glands capable of delivering a prescription artificial drug. They're not spiders, either. But they do have incredibly powerful mandibles that can cut clean through a pencil, and the several hundred species comprise one of the most fascinating arachnid orders in the world. **OLD WIVES' TALE RATING: 10**

- "Red on black venom lack, black on yellow kill a fellow." A little rhyme to remember, whether you're looking at a deadly coral snake or at one of its harmless mimics. This is generally pretty sound advice, but unfortunately there are several species of coral snake that totally flaunt the rules. Better to remember the Central American word for frog (the coral snake's favourite food) – rana – as a mnemonic for the colours red, yellow, black, yellow. Even this doesn't work with some species though, so remember the even better rule: look, but don't touch. **OLD WIVES' TALE RATING: 5**

- "African 'Killer Bees' can kill with a single sting." Their venom is actually no more toxic than the venom from any other bee species, and the European Honeybee injects slightly more venom per sting. The crucial factor is that European Honeybees have been bred for centuries to be people-friendly, whereas the African Honeybees are much closer to being 'wild'. They act defensively with intense aggressiveness and are prone to making group attacks, in which a victim could get spiked with hundreds of stings. These could kill a healthy adult, whilst young, elderly, allergic or immune-suppressed individuals could be at risk from just one sting of any kind of bee. **OLD WIVES' TALE RATING: 1**

- "Venomous creatures are immune to their own venom." This may well be true. Vipers and rattlesnakes have been shown to have elements in their blood that inactivate their own venoms, whilst in cobras the receptor to which the venom would normally bind has been shown to be completely different to mammalian receptors, and possibly blocked by the presence of a sugar molecule. In other words, the venom is like a key that doesn't fit the lock in the cobra's receptors. Even more interestingly, it's been shown that mongooses that feed on cobras also obscure the binding site on their receptors with a sugar molecule – which could suggest this confers a degree of immunity on the mongoose. Scorpions, pufferfish, newts and frogs all seem to be similarly resistant to their own toxins. **OLD WIVES' TALE RATING: 2**

FACTS AND STATISTICS

A lot of people would be genuinely shocked to find out that it is unusual for more than three or four people to be killed by sharks globally every year. After all, if a surfer gets attacked in Queensland, Australia, it makes headline news all round the world. The thousands who die on Britain's roads rarely get a mention – unless they die in a single spectacular accident. The horrible truth is that people love sensationalized, brutal and unusual deaths, and are also totally fascinated by any animal that might be able to do them damage. Discovery Channel has made its millions off shark weeks and snake stories, but the simple fact is, you're more likely to die by being brained by a falling coconut than you are to be killed by a wild animal.

Of the 35–50,000 species of spiders, maybe only 60 are potentially dangerous to humans. In Australia, where the spiders are notoriously nasty, only one person died from spider bite in the entire decade of the 1980s. Estimates for global fatalities from spider bite are around 200 annually. Around 3,000 venomous snakebites are reported annually in Australia, and an average of one (well, 1.6) fatality.

Of 7,000 venomous snakebites reported annually in the United States, around 3,000 are classed as 'illegitimate', meaning they happened while the victim was handling or molesting the snake. Of these, 15 fatalities resulted, placing the chance of survival at roughly 499 out of 500. 85 per cent of the natural bites are below the knee, and according to one source 50 per cent are dry bites. This holds true with the pitvipers.

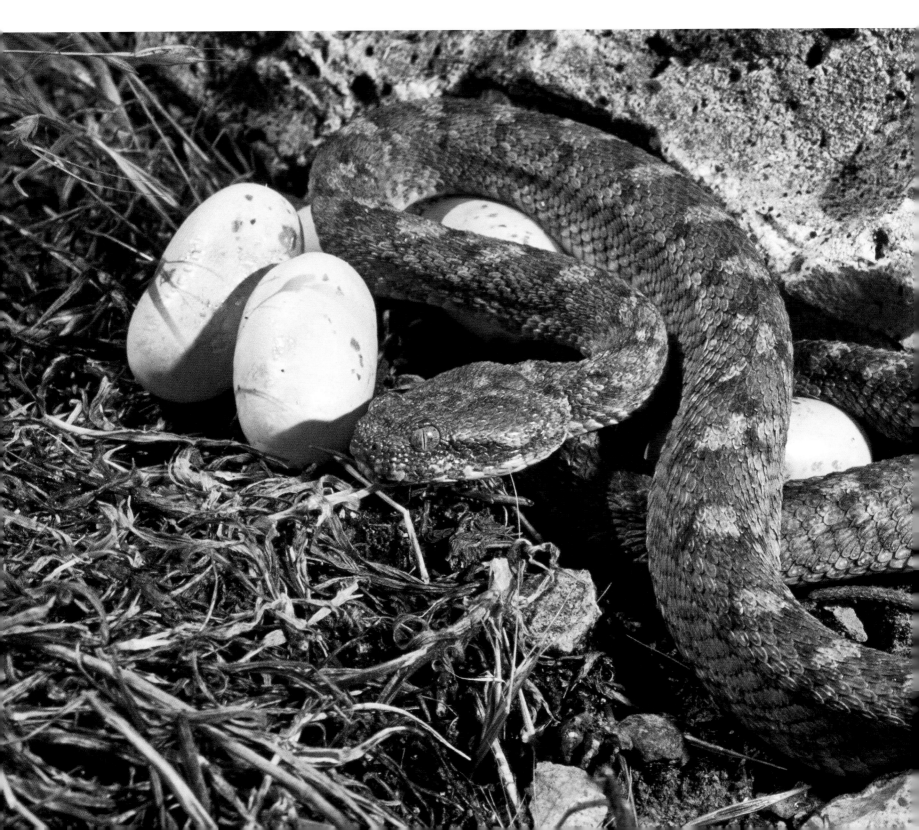

There's lot of space allocated in this book to the creatures with the most toxic venom, but there is no doubt that these are nothing like the most deadly creatures. After all, the Inland Taipan has never recorded a human fatality. However, the Russell's Viper, found from Pakistan to China and Indonesia, the lanceheads (*Bothrops* spp.) of South America, and the *Echis* vipers of northern Africa, the Middle East, India and Sri Lanka are believed responsible for up to 50,000 deaths each year. Compare this with the number of people who die from malaria spread by the humble mosquito (1.5–3 million annually) and this seems pretty tame.

Based on the number of its human victims, the world's deadliest snake is probably the Saw-scaled Viper (*Echis carinatus*), especially in Sri Lanka. About fifty people in every million die from snakebite there

every year, mostly due to a paucity of antivenins, the aggressive response of this small, common but deadly species and the fact that many Sri Lankans live in rural areas and hence in close promixity to snakes.

BELOW LEFT *The Saw-scaled Viper* (Echis carinatus) *may be small, but the species could be responsible for more human deaths than rattlesnakes, cobras and mambas combined. This female is guarding her eggs.*

BELOW *The formidable fangs of a striking Sydney Funnel-web Spider* (Atrax robustus)*, a grasshopper's worst nightmare and probably the very last thing it'll ever see.*

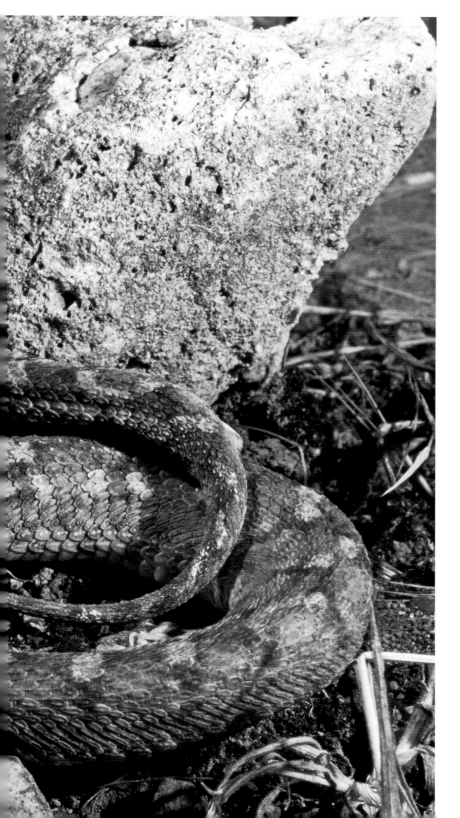

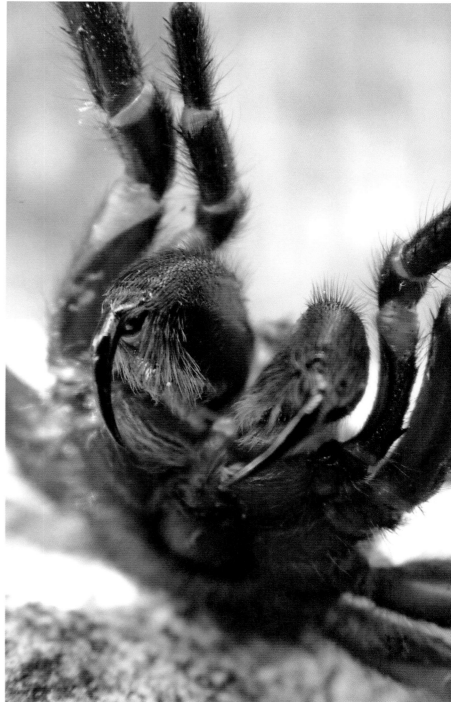

CHAPTER TWO

EUROPE

As an inhabitant of northern Europe, I grew up in one of the most benign parts of the world as far as wildlife goes. Our ancestors did a pretty good job of eliminating most of our charismatic megafauna centuries ago. In the few places where such superb beasts as bears and wolves have managed to hang on, they are generally rare and hard to see. That doesn't mean, however, that Europe lacks dramatic wildlife. There are plenty of exciting and surprisingly toxic invertebrates and herptiles here, and around the Mediterranean – and further over towards the Middle East – you can find some of the most toxic creatures on the planet.

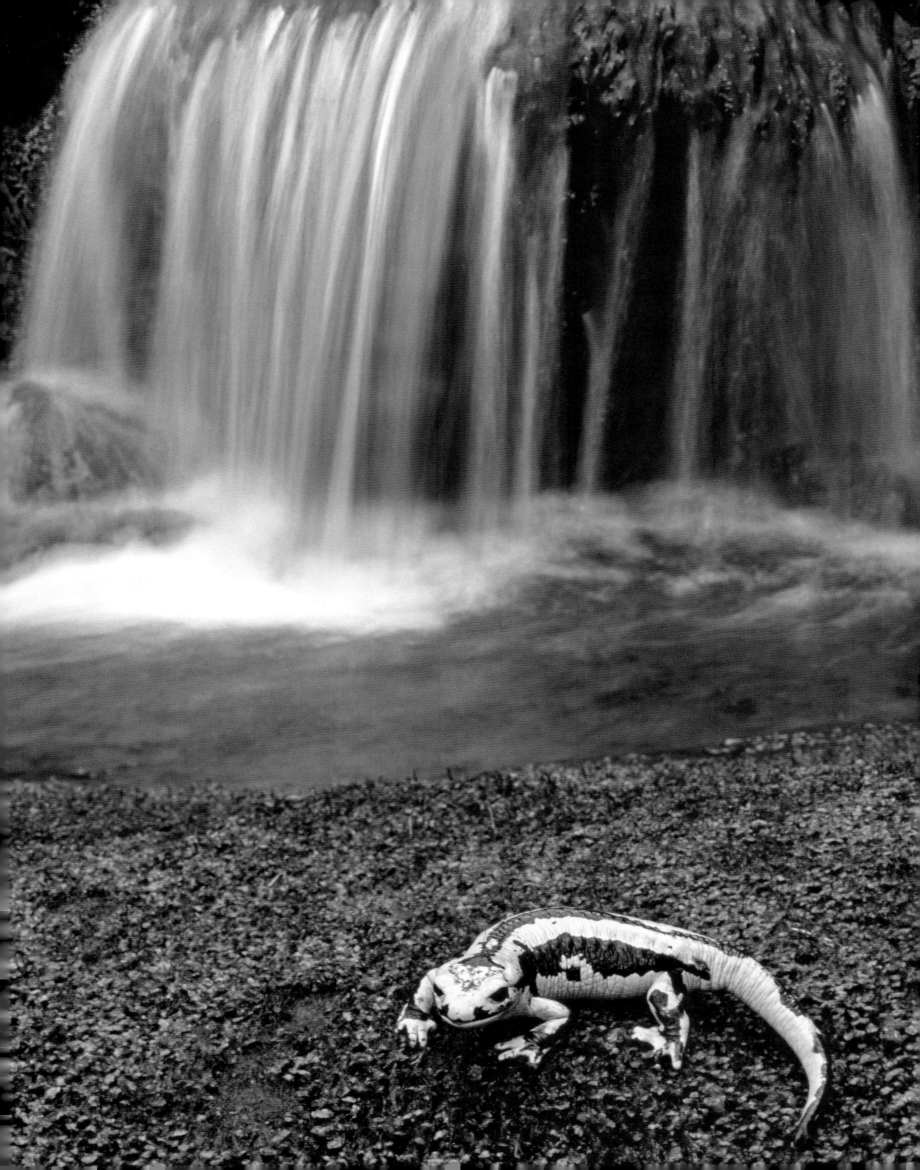

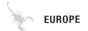

VIOLIN, FIDDLEBACK AND RECLUSE SPIDERS

(*Loxosceles* spp.)

WHERE FOUND: Europe, as well as temperate parts of the Americas, Africa and Australia.

Various nightmare pictures of recluse bites circulating on the internet are not going to do a great deal for the disposition of arachnophobes. Showing great chunks of flesh rotting off a victim's arm, they are the most extreme of reactions to a recluse spider bite. Though North America's Brown Recluse is the best known of these arachnid horrors, we do have a European species: *Loxosceles rufescens*, the Mediterranean Recluse. The name is due to their reclusive or shy nature – they're not aggressive, and will bite only when inadvertently stepped on, crushed or handled. The recluse is nocturnal and makes messy white webs in a kind of bedspread effect over stones, logs and under tree bark; it spends its day squeezed into cracks and crevices, a true recluse if ever there was one! Whereas most spiders have eight eyes, recluse spiders have six eyes, arranged in pairs in a semicircle on the forepart of the cephalothorax. Recluse spiders generally occupy dark, undisturbed sites, and can occur indoors or outdoors in quite dense populations.

A person's reaction to a recluse spider bite depends very much on how much venom is injected and on the person's sensitivity. Some people will be totally unaffected, whereas others experience the most notorious aspect of recluse spider bites, necrosis or tissue death. A small white blister is the first initial sign of a necrotic reaction, followed by swelling and the formation of a blue-grey or blue-white, sinking patch with ragged edges. In horror story reactions, the flesh boils into a 'volcano lesion', a gangrenous rotting mess in the flesh. The dead tissue gradually sloughs away, exposing underlying tissues, but may leave a gaping hole the size of a fist, which heals very slowly, and inevitably leaves hideous scarring. Not to be trifled with! Victims of these more serious reactions may well have clinical flesh removal and hyperbaric treatments to try and stop the spread of the necrosis.

PREVIOUS PAGE *The Fire Salamander* (Salamandra salamandra) *is among the most colourful of amphibians and can squirt its toxins towards the eyes of an attacker.*

OPPOSITE *Unobtrusive and nondescript, the Mediterranean Recluse* (Loxosceles rufescens) *is certainly dangerous and can give a nasty bite.*

BELOW *The Brown Recluse* (Loxosceles reclusa), *found in the south-central United States, is more venomous than its European relative.*

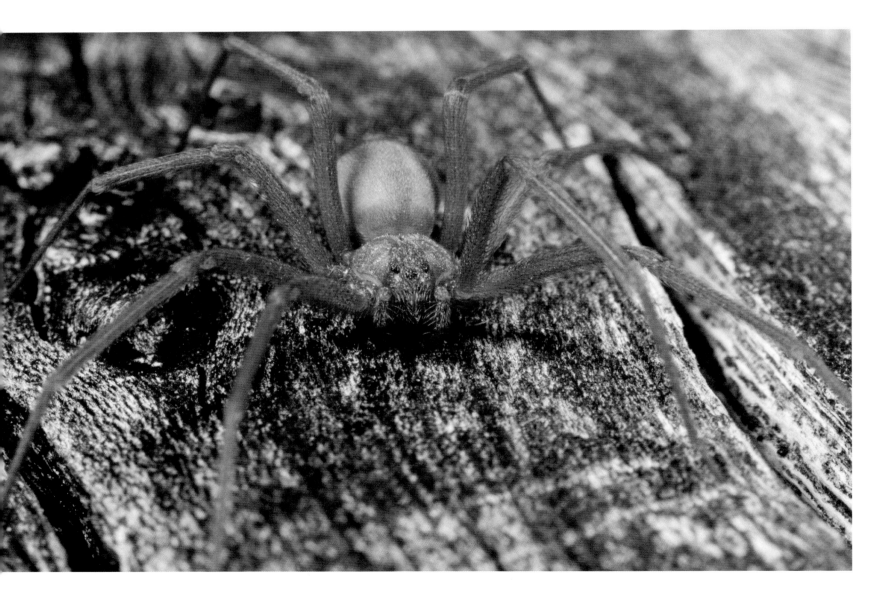

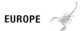

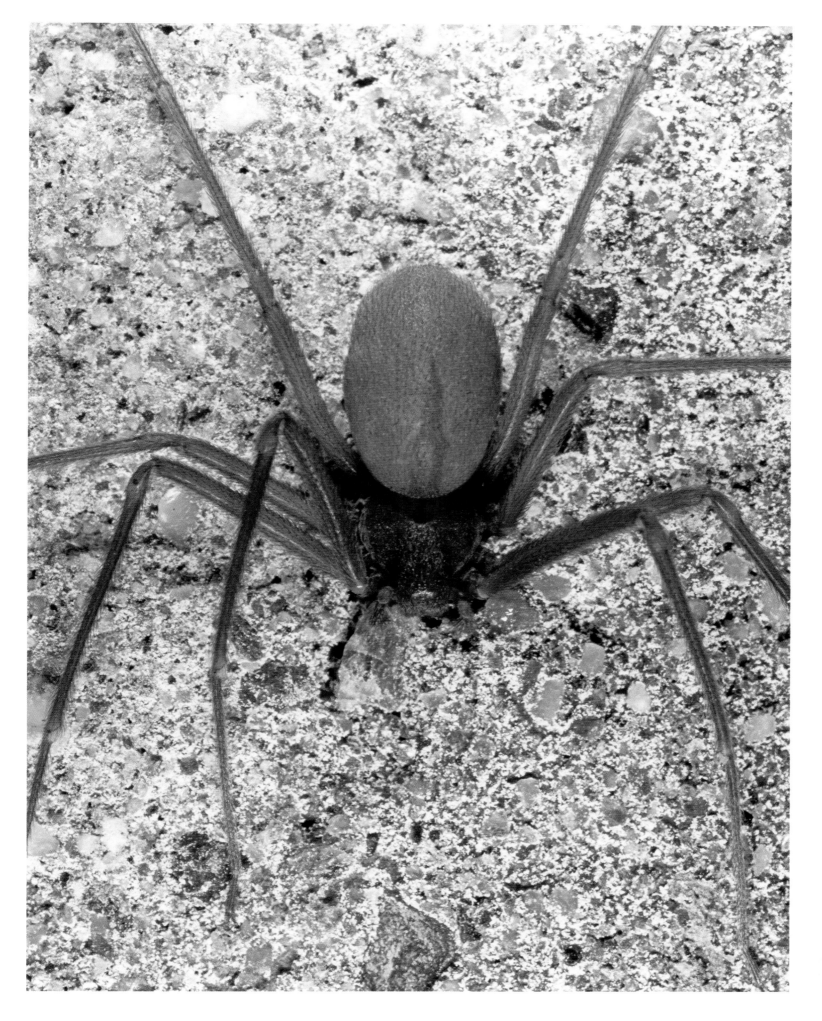

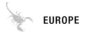
FAT-TAILED SCORPION (*Buthus occitanus*)

WHERE FOUND: AROUND THE MEDITERRANEAN ON COASTS AND ISLANDS, BUT QUITE POSSIBLY MAKING A MOVE FURTHER NORTH AS GLOBAL TEMPERATURES RISE.

Some of the other buthid scorpions, notably *B. parabuthus*, are known to actually 'flick' venom from the tip of the tail towards the eyes of predators; I've sat with one for hours hoping it would try out its party trick on me, but with no success. With *B. occitanus*, however, it's the sting you have to be worried about – far more reliable. And it is quite a sting, containing neurotoxic elements that mean it could potentially be fatal in extreme cases. However, the last thing I want to do is instil an idea of scorpions as horrifying killing machines – the female scorpion is a fine mother, carrying her hatched offspring around with her on her back, and the courtship dance of scorpions is one of the most beautiful displays of intimacy seen amongst the invertebrates. After a little showing off to establish his intentions, the male grasps the pincers of his would-be mate and the two begin a dazzling waltz, which results in the male leading the female over the packet of sperm he has laid on the ground for her. All scorpions are nocturnal, and tend to wait in ambush for their prey, detecting it with sensory hairs located mainly on the pincers. Amazingly, they can live for months without food and even water.

It may also surprise English residents to know that they have their own thriving scorpion species. *Euscorpius flavicaudis* is one of several European species common in the Mediterranean region, but the only one that seems to have set up shop in Britain. There are now several colonies that seem to have developed around old ports, the original colonists presumably having arrived as stowaways on shipments from continental Europe. These small yellow scorpions are not considered especially dangerous, but it's certainly best not to poke them to find out!

Along with the scorpions, there are also Mediterranean species of *Scolopendra* centipede and *Scutigera* centipede. Similar species from the same genus are described elsewhere (see pp. 68-9).

OPPOSITE *This buthid exemplifies the rule of thumb when dealing with scorpions – if it's got a fat tail and thin claws, it's going to hurt! Reverse the equation, and the scorpion probably uses strength and its claws as its primary weapon and so may be very loath to sting at all.*

BELOW *Whilst many of the jungle scorpion species are extremely dark, those that live their lives in arid environments tend to be much lighter in coloration, reflecting the different conditions in their habitats. However, both groups will fluoresce wildly under ultraviolet light.*

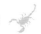

WEEVERFISH (*Echiichtys vipera*)

WHERE FOUND: English Channel, the Eastern Atlantic, coastal waters of the Black, Mediterranean and North Seas.

The tiny, sandy-coloured, 15cm-long Weeverfish is Europe's most unpleasant fish. It's usually found buried under the sand and sediment on the seabed with just its venomous dorsal fin showing. The spines on this fin are used solely for defence – it is an ambush predator which moves with lightning speed to grab small fish prey.

Probably the only time I ever saw my father (who is a rugby player the size of a fridge-freezer) cry when I was a child was when he was stung on his big toe by a Weeverfish. His toe swelled to the size of a plum tomato, and he had to bite down on a rolled-up tea towel to stop from squealing! His agony was perhaps not helped by a local fisherman's attempt to excise the wound using a rusty penknife! My father was quite lucky, however. Hospitalization in such cases is common, and some victims have reported total and permanent loss of sensation in affected extremities.

When Weeverfish gather in large groups, you'll actually see rows of their black spines sticking out of the sand, waiting for the unwary. The dorsal fin contains four to eight spines, with grooves down their length to allow the venom (secreted by the glandular tissue) to flow into the victim. These spines are needle-sharp, and will quite happily penetrate through a flip-flop and even a thick wetsuit boot. Due to the nature of the venom's proteinaceous content, it mostly produces localized pain and oedema, and as the toxin is made unstable by heat, treatment with hot water may be effective; temperatures above 40°C denature the protein in the venom, but just make sure you don't scald yourself! The only fatality put down to the Weeverfish was in 1927 at Dungeness, Kent.

Stargazers of the family Uranoscopidae are relatives of the weevers – a dozen species are found through the Atlantic, Pacific and Indian Oceans. This quite extraordinarily ugly fish possesses a tough, curved shoulder-spine with attached glandular tissues, and delivers a sting similar to that of its relative.

Europe's Stingray (*Dasyatis pastinaca*) is not really considered a danger, although it does possess a venomous sting and could potentially ruin an unlucky fisherman's day. Electric rays of the genus *Torpedo* have no toxins whatsoever, but have evolved the ability to generate strong electrical charges, and can emit repeated electric shocks of up to several hundred volts. Organs on their undersides build up an electrical charge, just like capacitors, which is then used as shock pulses to stun its prey. There are species throughout the world's seas, several of which occur through the European section of the Atlantic.

BELOW *As diminutive and unassuming as it may appear, the Weeverfish can pack a powerful punch and should always be given a wide berth. Note the venomous spines on the dorsal fin.*

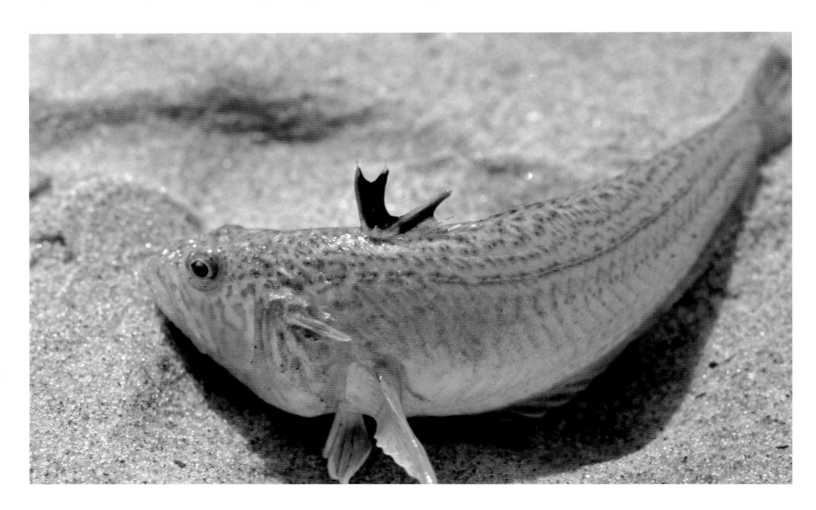

DOG WHELK (*Nucella lapillus*)

WHERE FOUND: Often abundant along rocky coasts in temperate regions, particularly in Europe.

One of the most unlikely of venomous hunters is to be found lurking in rock pools round the coasts of Europe and particularly Britain: the Dog Whelk. Most often found clustered on rocks in large numbers, sometimes many thousands, these very ordinary-looking saltwater snails are actually ferocious predators, preying on shellfish such as cockles, limpets and barnacles. If you find an empty cockle on the beach with a perfectly bored hole in its shell, this is almost certainly the work of a hungry Dog Whelk.

The Dog Whelk's secret weapon is a modified radula (usually a rasping tongue in their snail relatives), which in the whelk has been transformed into a lethal drill. It uses this to penetrate the shell of its prey and, whilst reports are divided, some sources report that after the whelk's radula has pierced the shell, it injects liquidizing digestive enzymes into the hole. These break down the innards of the prey, so the whelk can suck up the contents more easily. To help this process along, an organ in the whelk's foot secretes a chemical that actually softens up the shell of the victim before drilling begins!

Despite this seemingly ferocious nature, there is evidence that Dog Whelks may be rather good at caring for their young. The whelks gather in the spring to mate, then after they have fastened their eggs in masses of protective yellow cases to rocks, it is not uncommon for the parents to lurk protectively right next to their eggs, as if standing guard.

The related Edible Whelk (*Buccinum undatum*) is of course regularly consumed by humans. Before putting this book together, I had understood that this was the only whelk that was so eaten, but I then found a recipe online for 'dog whelk à la chilli beans'. Knowing how the Dog Whelk feeds, I suggest giving this a wide berth!

BELOW *The yellow egg cases of the Dog Whelk are highly visible.*

BOTTOM *Clusters of whelks are a common seaside sight in Britain, often alongside barnacles, upon which they prey.*

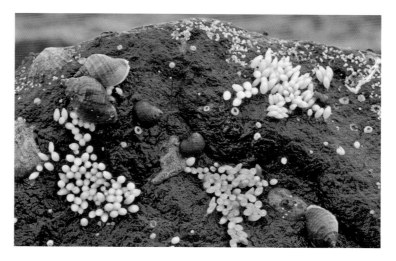

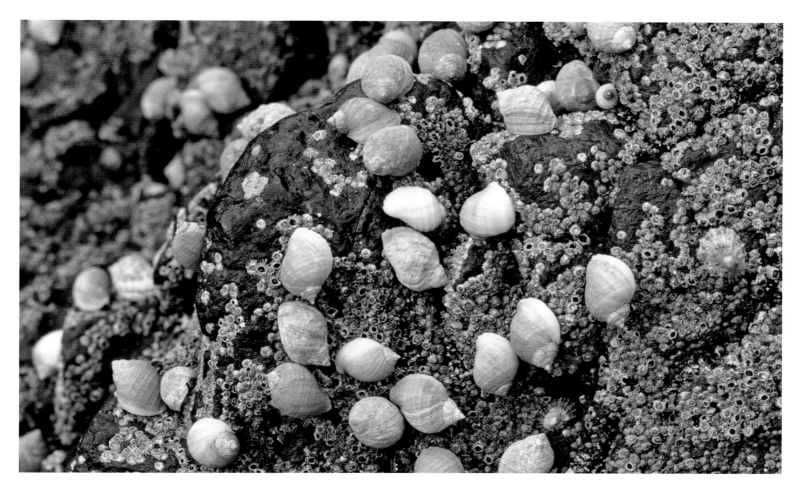

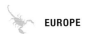

MAUVE STINGER (*Pelagia noctiluca*)

WHERE FOUND: The Mediterranean, and temperate seas globally.

The Mauve Stinger is a beautiful gelatinous mass, phosphorescing purple and yellow at night, and dramatic in coloration. However, don't let its Christmas-bauble appearance fool you – it's a particularly nasty stinging jellyfish, and at least one very near-death experience (in Greece) has been recorded from hyper-reactivity to its sting. With the impact of global warming, they are now a common sight as far north as Northern Ireland, and large swarms wash up on Cornish beaches about once every five years. The sting of this jellyfish triggers the release of multiple antibodies in its victims, which could well lead to anaphylactic shock reactions. This quality – known as being antigenic – makes its toxins attractive targets for drugs of the future, but since it has occurred in plague proportions in the Med, and certainly will again, it's not yet to be considered a great boon for mankind. Treatment with vinegar to the immediate wound site will prevent the firing of dormant stingers. The Portuguese Man-of-War (*Physalia physalis*) occurs in many European waters and has even been spotted off the coast of Britain. It has caused three deaths in European waters in recent years (see separate species account on p.54).

BELOW *Most of the jellyfish that wash up on British shores have little or no sting, but if you see one of these stranded – don't pick it up!*

OPPOSITE *It surprises many people to learn that black widow spiders occur in Europe, but* Latrodectus lilianae*, shown here, occurs in Iberia and may be spreading north, helped by global warming.*

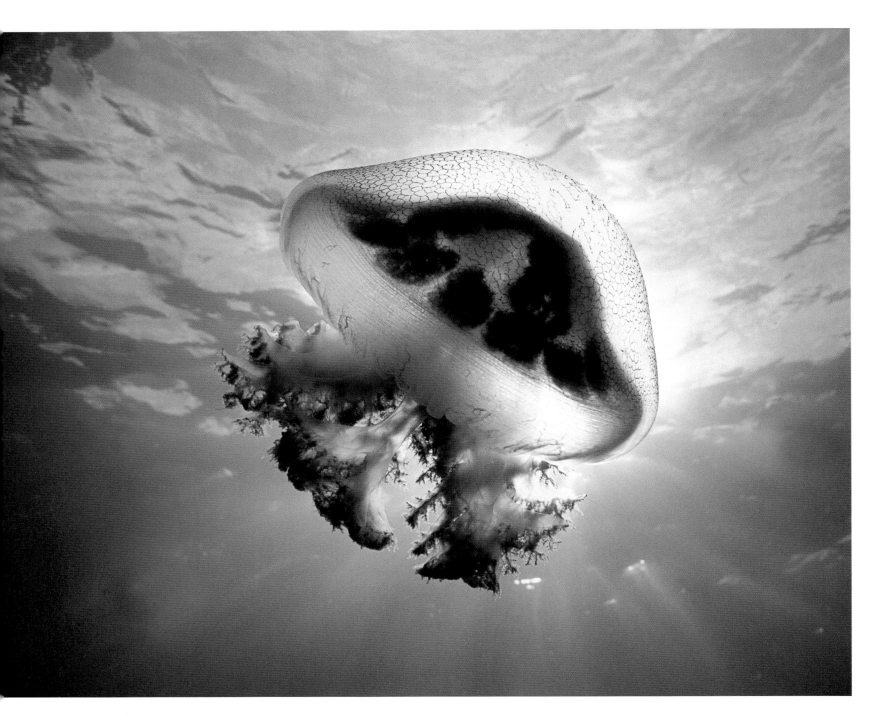

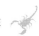

BLACK WIDOW SPIDERS (*LATRODECTUS* SPP.)

WHERE FOUND: POTENTIALLY GLOBAL, EXCEPT FOR THE ARCTIC REGION. SEVERAL SPECIES FOUND IN EUROPE.

With their grisly reputation for consuming their male partner during or after courtship, the skull-like markings on some species, and the fact that so many people just don't like spiders, black widows have a rotten reputation. It's one they don't really deserve – you have to pretty well put a shoe on with a widow inside to get bitten, but as the bite is so painful and has caused fatalities in the past, it's not really surprising that they're so feared.

Latrodectus spiders build a messy three-dimensional kind of web rather than the conventional orb web of the garden spider. This kind of web is especially suited to building inside tin cans and cardboard boxes, in fact in any discarded human detritus that can provide a structure with many attachment points. Some of these silken threads are strung downwards under pressure and attached to the ground; when potential prey such as an ant nudges one of these elastic threads and gets stuck on it, the thread is shaken free from its attachment, and fires upwards, taking the ant with it. This allows the spider to incapacitate the ant while it dangles helplessly in midair.

There are widow spiders on every continent of the world, bar Antarctica. Europe's genuine endemics are probably *Latrodectus tredecimguttatus*, otherwise known as the Mediterranean Widow, and Spain's *Latrodectus lilianae*. There are definitely members of the *Latrodectus* genus doing very well in small pockets around Britain. The question is whether they are relict populations of an indigenous arachnid, or more recent imports. If the latter, have they arrived here under their own steam or by hitchhiking with humans? Certainly, the proliferation of black widows around the caravan site of an arachnid breeder in Kent is due entirely to tiny spiderlings ballooning once they have left the egg case. This is the process many spiderlings use to travel away from their siblings – they will climb up to a suitably high vantage point and eject a stream of silk, which then gets caught in the wind, carrying the enterprising Phileas Fogg-esque juvenile off into the air. Spiderlings can travel immense distances this way – potentially across the Atlantic, and certainly across the English Channel.

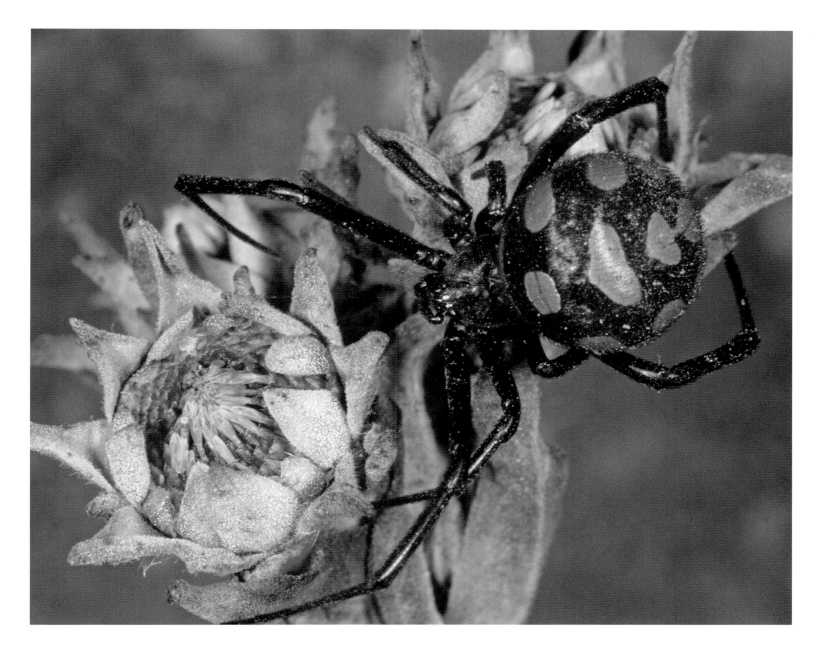

EUROPEAN VIPERS (*VIPERA* SPP.)

WHERE FOUND: FROM BEYOND THE ARCTIC CIRCLE SOUTH TO SOUTHERN FRANCE, IBERIA, ITALY, NORTHERN GREECE AND WEST EUROPEAN TURKEY, AND RIGHT ACROSS RUSSIA AS FAR AS AN ISLAND NORTH OF JAPAN.

The most familiar of the European vipers is the ubiquitous and remarkably hardy Adder or Common Viper, *Vipera berus*, probably the world's most successful serpent, in the sense that it has the largest geographical range of any terrestrial snake (only the seasnake *Pelamis platurus* has a wider distribution). It also occurs further north than any other snake species. This beautiful little snake is not to be underestimated – I once spent three days in hospital after being bitten on the ankle by one whilst out walking the dog.

The best way of identifying an Adder (certainly if you are a British resident and wish to differentiate it from our other two native snakes, which are non-venomous) is the continuous black zig-zag that usually travels down its back, though individuals without the pattern are quite common. Should you get close enough, you'll see the Adder has elliptical pupils as opposed to the round pupils of the Smooth and Grass Snakes.

At the beginning of spring, the Adder starts getting frisky and puts on one of the finest displays of any snake. The males emerge from hibernation in about March, the females following a few weeks later. Rival males will indulge in ritualistic dancing to impress a nearby female. The bite of the Adder is very rarely fatal, and as it is a shy snake, bites are most likely to happen when they are handled – so don't! They are also protected by law in Britain.

RIGHT *The difference in male and female Adder coloration is very evident. The background colour is far lighter on the male than the female (on the left), and the male's heightened black zig-zag intensifies the difference.*

BELOW *Although most references say the Adder's venom is only mildly toxic, the worst bite I've ever suffered was indeed from an Adder and kept me in hospital for three days!*

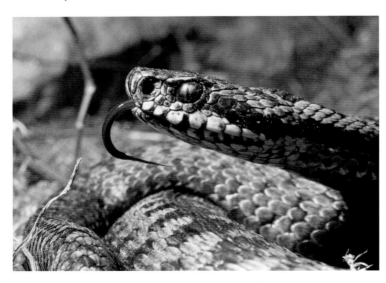

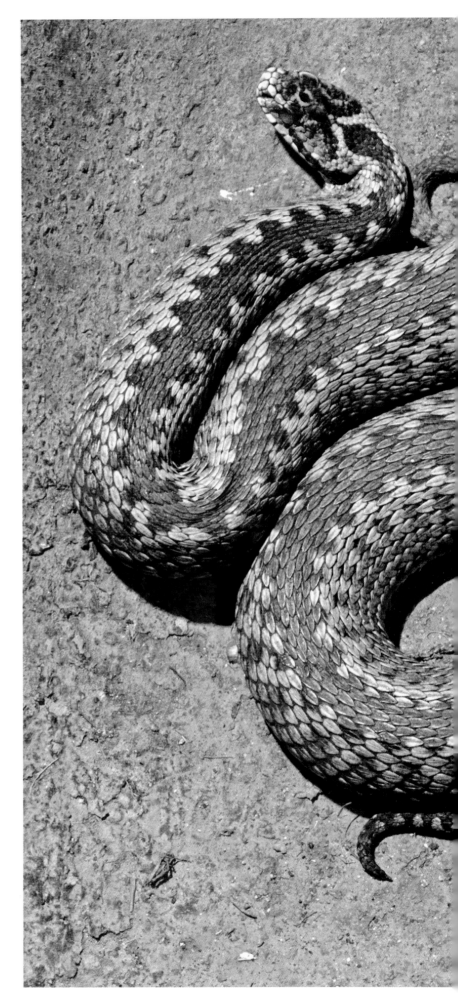

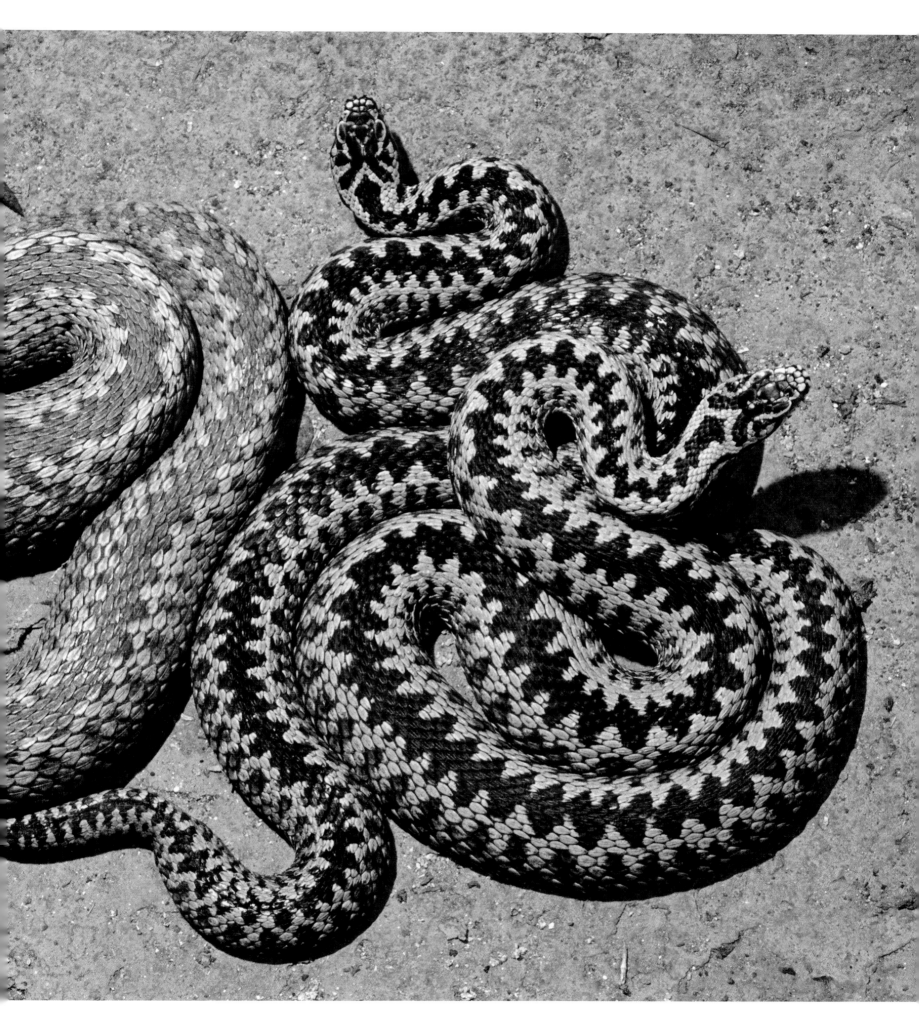

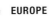

In the rest of Europe, there are several related species of viperids, including the Milos Viper (*Macrovipera schweizer*), Ottoman Viper (*Vipera xanthina*), and Nose-horned Viper (*V. ammodytes*). Perhaps the most significant, though, is the Asp Viper (*V. aspis*), with which Cleopatra is said to have ended her life rather than enter Rome as a captive. This species is found throughout much of the warmer parts of Europe. All of the viperids mentioned here have haemotoxic venom elements, which cause intense pain, tissue damage, blackening of the lymph glands and puffiness to local tissues.

RIGHT *Vipers have characteristically slanted pupils, as evident here with this Milos Viper* (Macrovipera schweizer).

BELOW Vipera xanthina, *the Ottoman Viper, is a beautiful but fierce little snake, which hisses and bites quite readily if annoyed.*

OPPOSITE *Tests on the venom of the Asp Viper* (Vipera aspis) *suggest it may have even more powerful coagulant properties than that of the Russell's Viper* (Vipera russelli), *used since the 19th century as a treatment for haemophiliacs.*

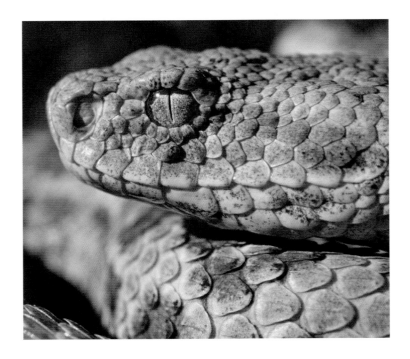

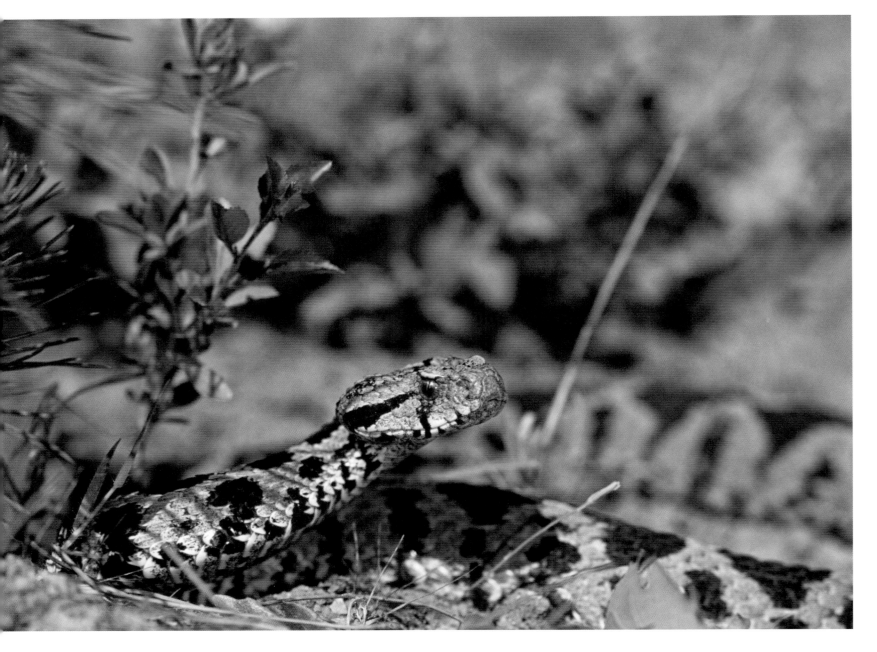

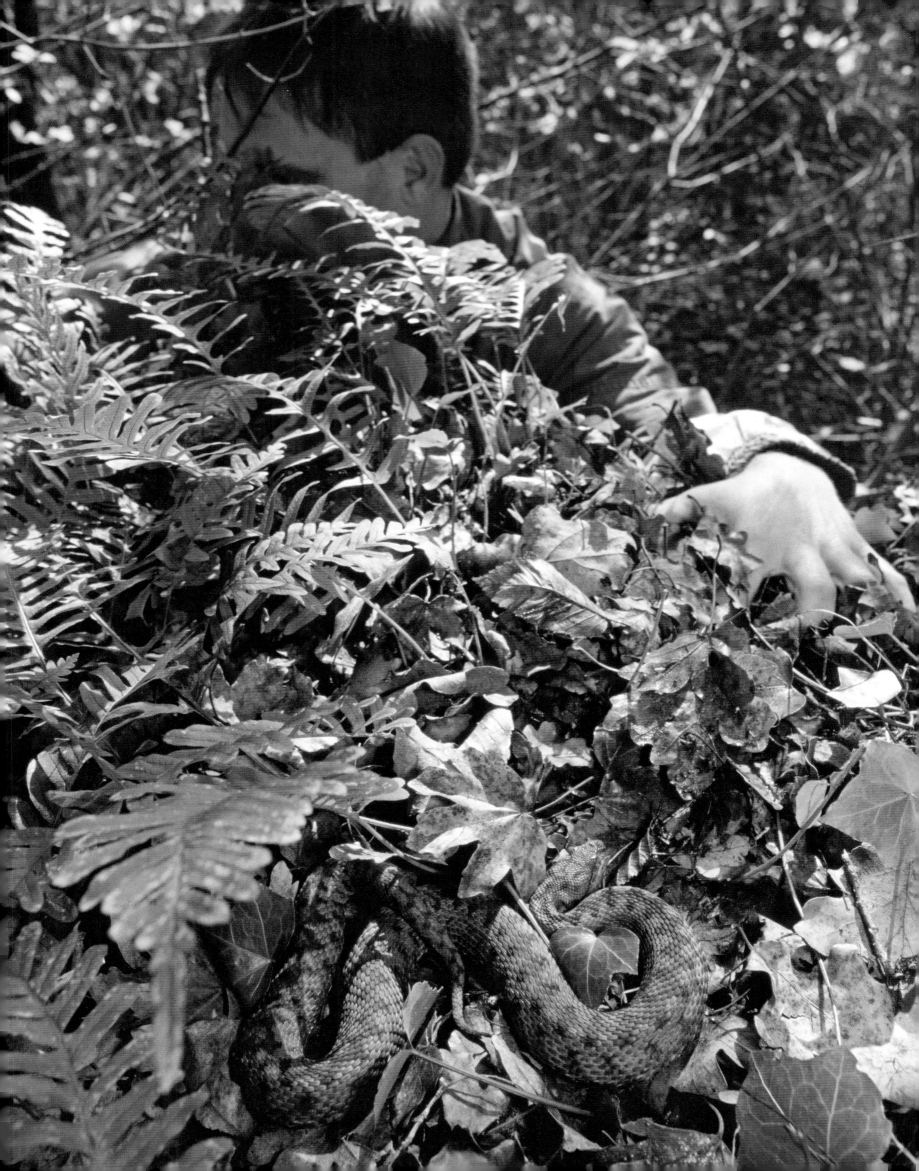

FIRE SALAMANDER (SALAMANDRA SALAMANDRA)

WHERE FOUND: FORESTS IN THE HILLY PARTS OF SOUTHERN AND CENTRAL EUROPE.

The Fire Salamander is pretty much the archetype of aposematic coloration, the technical way of saying they have developed lurid outfits to warn predators that they are not good to eat. They're the most colourful of all salamanders and newts, with vibrant blacks contrasting with about the brightest yellow you'll find in nature, and occasionally oranges and reds. If a predator takes too extreme an interest in the salamander, it can quite actively defend itself, generally beading with toxic skin secretions. Get a little taste of those and it'll cause strong muscle convulsions and high blood pressure combined with hyperventilation in vertebrates! It can also squirt these toxins short distances, which is especially dangerous if it makes contact with the eyes. The toxin-emitting glands are centred around the head and the dorsal skin surface. It is thought these secretions could prevent bacterial and fungal infections of the salamander's skin, but there's no doubt they function mostly for protection, and could potentially endanger a human.

It's assumed that the name and legend of the Fire Salamander derived from one emerging from a log (in which the creature was hibernating) when it was thrown into a fire. Obviously to see as dramatic a beast as this emerging from a winter fire must have been impressive, because for hundreds of years afterwards it was commonly believed that salamanders were actually born in the flames. While they usually live for about 12 to 15 years, in a German natural history museum a salamander lived for more than 50 years, which is not bad for an amphibian! Whether on land or in water, and despite their extravagant coloration, Fire Salamanders remain fairly inconspicuous. They are mostly nocturnal, spending their days hidden beneath stones or wood. Their diet consists of various arthropods, earthworms and slugs, but they'll also take newts and froglets.

BELOW *The secretory glands on a salamander's back are mostly concentrated around the areas of most dramatic colour.*

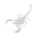

WATER SHREW (*Neomys fodiens*)

WHERE FOUND: THROUGHOUT MOST OF EUROPE AND ASIA.

Venomous mammals are few and far between in the modern world, though many paleozoologists suggest they may once have been far more numerous. However, there are four species of shrew, including the semi-aquatic European Water Shrew, that possess venomous saliva. This runs down grooves in their teeth and is chewed into wounds. The teeth themselves have red tips, giving them the appearance of regular vampire fangs, and a shrew bite that breaks the skin will hurt or itch for days afterwards. It's believed that the venomous saliva may well have an effect in helping to paralyze the shrew's mostly invertebrate prey, caught in its preferred habitat – normally fast-flowing rivers and streams. The toxin from one species, the Short-tailed Shrew, has been isolated and named Blarina toxin. When injected into mice, this toxin causes respiration to shut down, and eventually causes death.

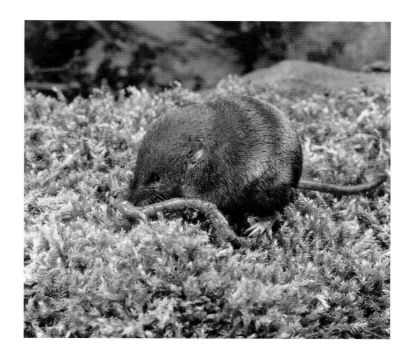

BELOW *Water Shrews are skilful swimmers and good divers. They are mainly nocturnal, and least active during the middle of the day.*

ABOVE *A voracious predator, the Water Shrew consumes an enormous amount of invertebrate prey every day.*

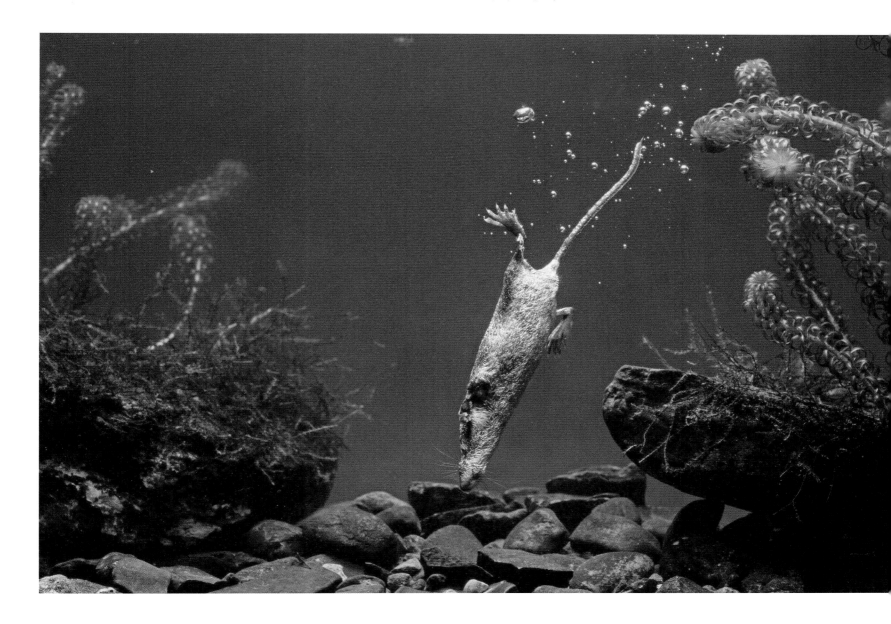

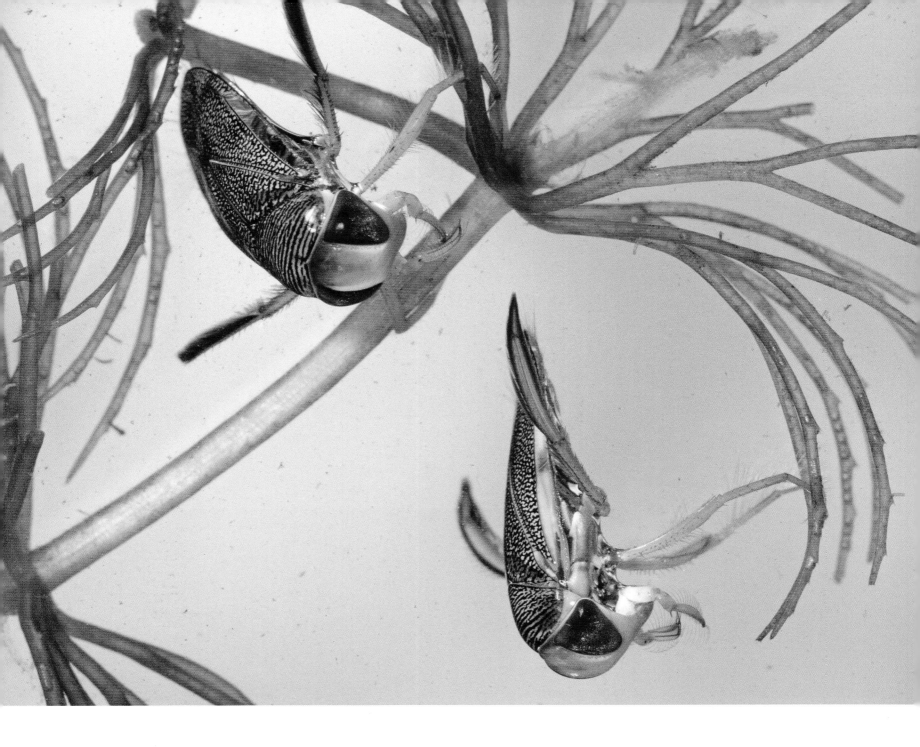

WATER BOATMAN (*Notonecta glauca*)

WHERE FOUND: THROUGHOUT EUROPE.

Propelled by two long legs which paddle like oars, these creatures are a common sight in any local pond. Most of the time, they rest at the surface, sensing vibrations in the surface tension of the water; if the water is at all disturbed, they will dive to investigate, carrying a silvery bubble of air to maintain them in their dives. Water Boatmen are fearsome predators, eating tadpoles, small fish and aquatic insects. When the boatmen get reasonably close to their prey, they switch from their vibration-sensing mechanisms to those huge blood red eyes, tracking their luckless meal like tiny submarine wolves. As with all hemiptera or true bugs, water boatmen are equipped with mean mouthparts called rostrums. The rostrum acts almost like a hollow spear; the water boatman jabs it into prey, injecting a toxic saliva, which paralyzes the animal, before turning the insides into a meat milkshake. Then the rostrum turns into a meat vacuum cleaner and

sucks up all the contents. Water boatmen will also eat airborne insects that have accidentally fallen onto the surface of the water. Adults can fly and will move between ponds in search of prey.

Never be tempted to handle one of these harmless-looking little beasts; the bite feels something like pushing a white hot knitting needle into your finger… or so I've been told. I was going to get bitten for the purposes of research, but completely lost my nerve!

This description is for the Water Boatman or Common Back-swimmer, *Notonecta glauca*. Its relative, the Lesser Waterboatman, *Corixa punctata*, is smaller, feeds on algae, and its bite is said to be far less severe.

ABOVE *The Water Boatman is the British invertebrate that most surprises people when I tell them it's venomous – but it is, and should be handled with care.*

OPPOSITE ABOVE *Spanish Fly, possibly the most spurious aphrodisiac in history. If you buy it nowadays it's probably nothing stronger than ginseng.*

OPPOSITE BELOW *The beetle itself is one of the family* Meloidae, *the blister beetles. All can secrete chemicals that cause nasty blistering to human skin.*

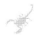

BLISTER BEETLE OR SPANISH FLY

(*Lytta vesicatoria*)

WHERE FOUND: From Mediterranean Europe east to Asia.

Spanish Fly is not a fly. And it's not only found in Spain. It's actually the Blister Beetle, a brightly coloured flying insect commonly found on honeysuckle or olive, particularly in Mediterranean countries, though I've found them as far east as India, and their toxins were used as medicine in ancient China. The reason this otherwise innocuous insect has enjoyed such an extraordinary degree of notoriety is its chemical defences, and the nefarious and misguided uses people have put them to.

When the Blister Beetle is molested, it secretes a substance from its leg joints, which proves extremely irritating. Indeed, contact with these chemicals causes blisters that can remain on the human skin for a very long time. The colourless, odourless chemical is called canthardin; a French chemist called Roviquet isolated it in 1810 and when trying out its effects, found it actually caused extended priaprism (erections) in cattle. Yet for many years before, the Blister Beetle had been prized for its role as an aphrodisiac; the insects were gathered, crushed and taken orally. King Henry IV is known to have been a passionate advocate of the drug, and Madame de Montespan slipped some into the food of Louis XIV to try to secure his affections. They would probably have been less keen had they known how it worked. When canthardin is excreted by the body in urine, it causes irritation to the urogenital tract (basically doing exactly what it does to skin, but inside the urethra), which causes itching and swelling of the genitals. The kidneys also suffer, in response to this powerful poison

in the system; in extreme cases it leads to severe stomach problems, and even coma. A tough price to pay for a little fun!

One person who certainly didn't mind a little pain with his pleasure was the infamous Marquis de Sade. In 1772, he procured a number of courtesans for an evening's cavorting, and fed them aniseed sweets laced with canthardin, believing it would 'set them on fire' with passion. Instead, two of the women nearly died of poisoning. A case was brought against de Sade and he fled France, but was found guilty in his absence and sentenced to death. As de Sade wisely stayed abroad, the authorities made do with hanging a wooden effigy of him instead. In 1954 Londoner Arthur Ford tried to use Spanish Fly as an early form of 'date-rape' drug on office colleague Betty Grant. Unfortunately, she shared the laced sweets he offered her with another colleague, and the next day both women were dead. Treat with extreme suspicion, therefore, adverts in modern-day newspapers offering Spanish Fly as an aphrodisiac. The chances are this is nothing more than cayenne pepper powder, ginseng and ginger!

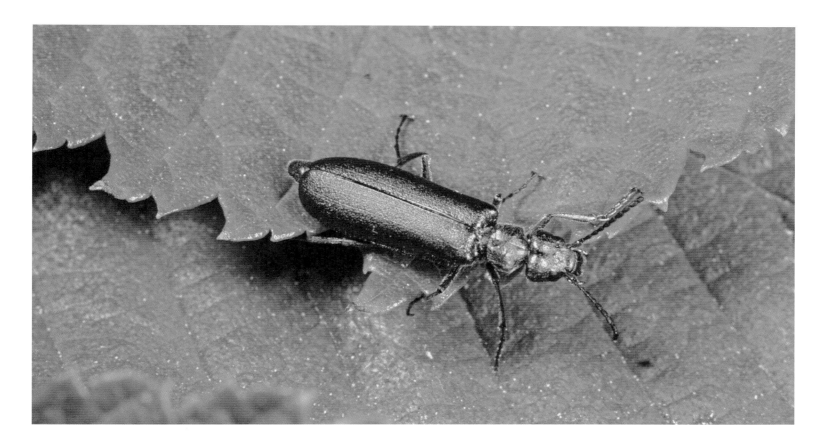

DEVIL'S COACH HORSE BEETLE

(STAPHYLINUS OLENS)

WHERE FOUND: THROUGHOUT EUROPE.

Ever since the Middle Ages this small creature has been associated with the Devil. Its alternative names are the Devil's Footman or the Devil's Steed, and in Ireland it is known as darbhadal – the Devil's Beast. Traditionally it was claimed that Beelzebub assumed the form of this beetle to eat sinners, and reapers used to tie these beetles to their scythes to improve their cutting prowess. So where did this incredible reputation come from? The eating sinners idea is probably down to the Devil's Coach Horse's grisly habit of chomping carrion, and the rest is probably linked to its fearsome appearance and the toxic weaponry which justifies its inclusion in this book.

Another common name for this species is 'cock tail'. This is due to the beetle's habit of twisting or cocking its tail up over its head like a scorpion when threatened. In the ever-superstitious Middle Ages this was considered this to be a sign that the beetle was making a curse, whereas in actual fact it is preparing to emit a foul-smelling fluid from the white glands at the end of the tail. At the same time it also emits a disgusting brown gloop from its mouth and anus, enough to convince pretty much anything that this beetle is not going to make good eating.

The Devil's Coach Horse is one of around 1,000 species of rove beetles in Britain, so-called because they are never found inactive, but are always on the go. It is carnivorous, feeding on other insects and small creatures, both in adult and larval stages. It has large pincer-like jaws, which can crush and kill its prey (and give a nasty nip – watch out!). These are used to cut and manipulate its food into a bolus, which is repeatedly chewed and swallowed, being smeared with a brown secretion from the mouth until it is reduced to a liquid form that can be sucked up.

OPPOSITE *This Vapourer Moth caterpillar is an archetype of the spiny or hairy caterpillar. It is certainly handsome, but those urticating hairs sting.*

BELOW *The Devil's Coach Horse beetle in classic 'cock tail' threat posture, preparing to let rip with its pungent cargo.*

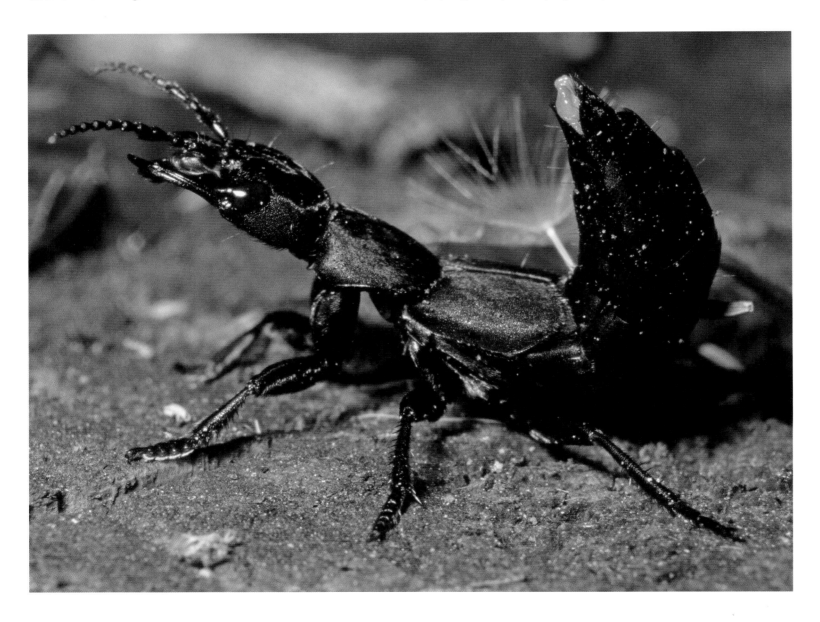

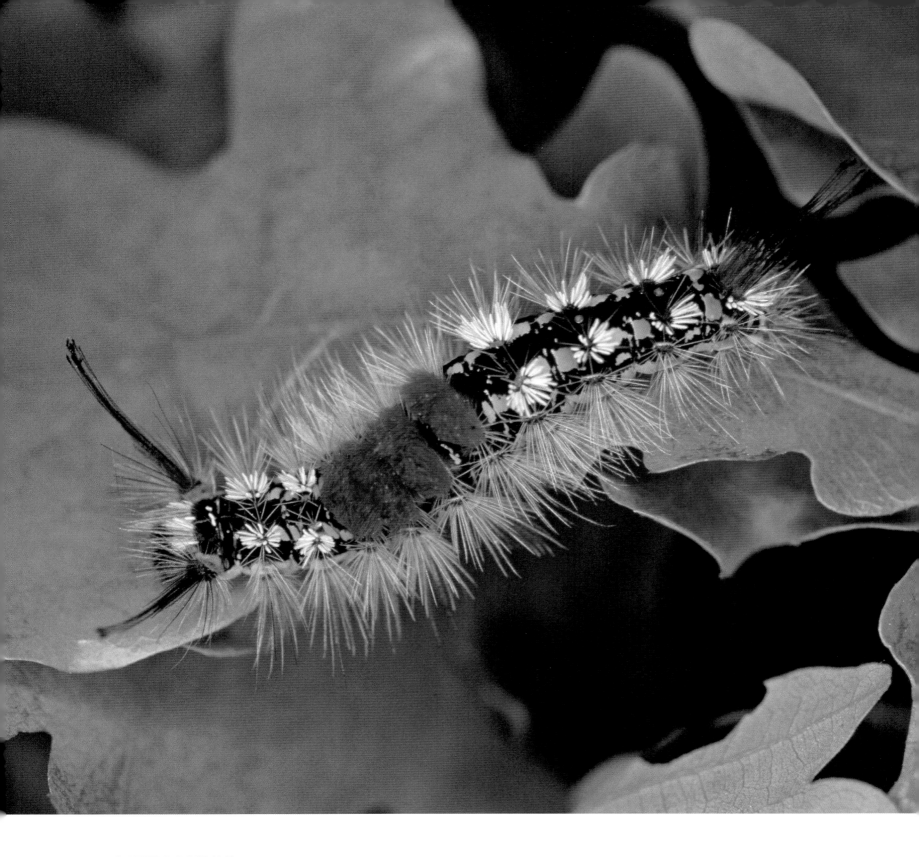

LEPIDOPTERA LARVAE

WHERE FOUND: WORLDWIDE, EXCEPT FOR THE ARCTIC REGION.

When on a recent filming trip in Borneo, members of the television crew started going down with fiercely itching rashes, so debilitating that in some cases they turned tough men into whimpering fools! Eventually we figured out that this wasn't due to a poisonous plant or biting insect, but that hairy caterpillars were the culprits. The larvae of certain moths are absolutely bristling with stinging hairs, some of which are hollow and connected to poison glands. These hairs either secrete venom on contact with the skin or are similar to glass fibres, and so break off easily in the skin. Depending on the individual, reaction to the sting ranges from the mild, with swelling, burning, itching and local reddening, to the severe, with incapacitating pain. If the hairs should make contact with the eyes, then blindness is not out of the question.

Even here in Britain we have our fair share of caterpillar irritants. The larvae of the Garden Tiger (*Arctia caja*), Vapourer (*Orgyia antiqua*), Sycamore Moth (*Acronicta aceris*) and Pale Tussock (*Calliteara pudibunda*) are just some of the most dramatic, and whilst not exactly highly venomous, they can cause irritation to the skin and rashes if handled excessively.

CHAPTER THREE

NORTH AMERICA

North America covers a vast area and has an incredible diversity of habitats, ranging from the Arctic north to the sub-tropical waters of the Caribbean. The latter environment provides some interesting subjects for this chapter, but there are some surprising candidates from the frozen north too. For example, there are three species of cetacean that are reputedly poisonous to eat – the Sei, Sperm and White Whales – and Polar Bears are said to have highly toxic livers and kidneys. However, if you're on a venom hunt in North America, it's probably off to the deserts of the south-western United States that you'll head. With venomous lizards, rattlesnakes, scorpions and spiders, this is definitely 'Venom Central'!

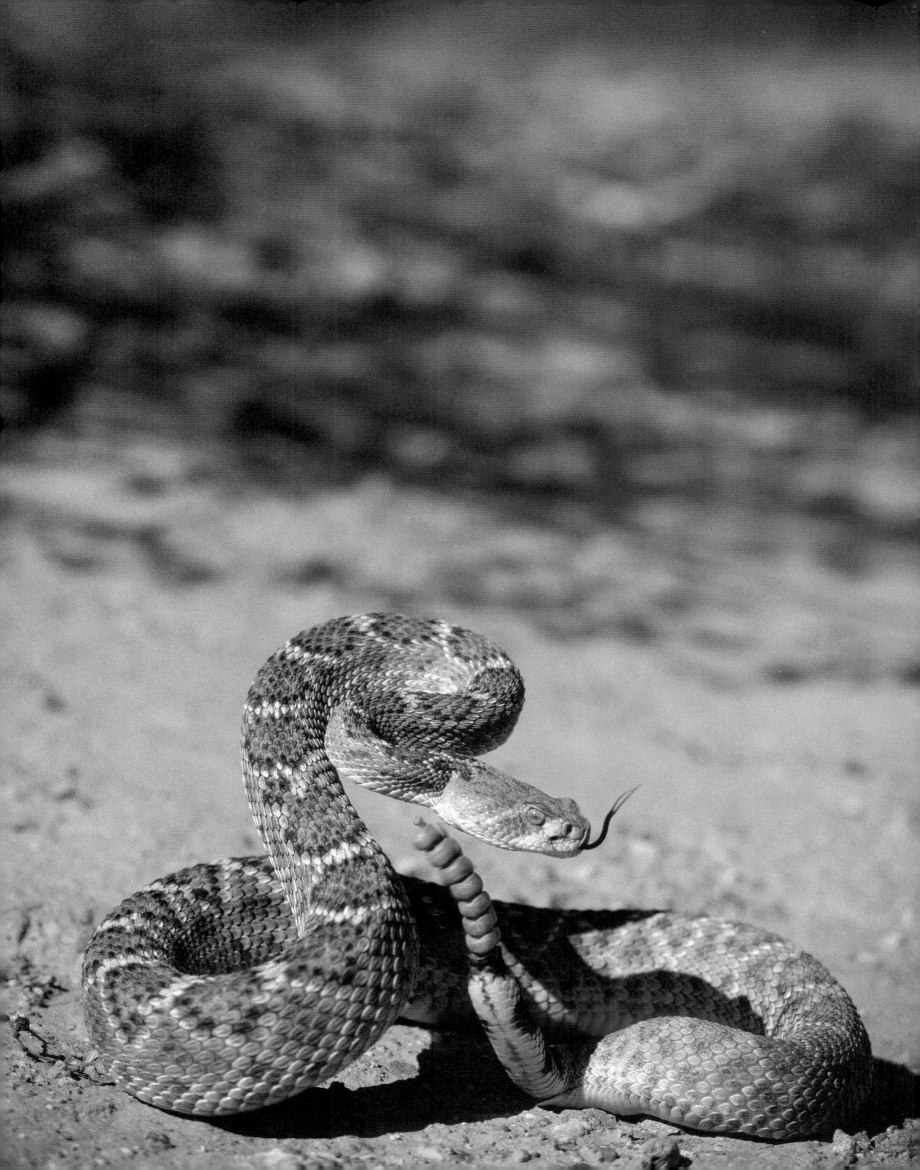

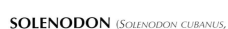

SOLENODON (Solenodon cubanus, S. paradoxus)

WHERE FOUND: Cuba, Haiti and the Dominican Republic.

One of the very few toxic mammals, the Solenodon is a real oddity. Like some of the shrews (which they resemble without being closely related), Solenodons have poisonous saliva and grooved teeth with which to deliver it. Solenodon actually means 'grooved tooth', and at the bottom of each tooth is a gland that secretes the toxin, which is certainly powerful enough to kill other Solenodons when they scrap. As if the mouth glands were not unusual enough, these creatures also have glands in the armpits and groin, which give off a smell like damp goat! When they're hassled they make little pig-like grunting sounds or bird-like cheeping sounds.

The Solenodon's body is about 30cm long, its near-naked tail about the same again, and it has an unusually long snout. Its face is covered in bristles, whilst its forefeet are larger than the rear feet and have longer claws. They are used for digging up mainly invertebrate prey, although Solenodons will also eat roots, leaves and small reptiles. There's fossil evidence of Solenodon-like creatures in North America 30 million years ago, suggesting that they were primitive insectivores, which were killed off elsewhere but survived on the two Caribbean islands of Cuba and Hispaniola due to the paucity of predators there. As a result, the animal is slow and often seems uncoordinated, sometimes even seeming to struggle to run in a straight line. The arrival on their island homes of imported rats, dogs, cats, mongooses and other feral animals has had a severe impact on their numbers. Indeed, the days of the Solenodon may well be numbered unless efforts are soon made to protect them.

PREVIOUS PAGE *The stuff of a cowboy's worst nightmares: a rattlesnake in classic coiled attack pose, rattle raised and shaking.*

BELOW *One of the few known photographs of the critically endangered Solenodon.*

BARK SCORPION (*Centruroides exilicauda*)

WHERE FOUND: SOUTHERN STATES OF USA, SOUTH TO MEXICO AND OTHER COUNTRIES OF CENTRAL AMERICA.

Scorpions haven't changed much from the 350 to 400 million-year-old fossils of their ancestors, which emerged from the seas to be one of the earth's first terrestrial arthropods. Although there are many different species in the Americas, the sting of scorpions from the *Centruroides* genus are the only ones considered to be dangerous to people. Its long, delicate pincers reveal that its sting is its main weapon; its small size and almost translucent coloration certainly don't give it an overly intimidating appearance, but don't be fooled. In the 1960s and '70s, there were as many as 100,000 scorpion stings reported annually, with 700–800 fatalities in Mexico alone, where it represents a significant public health issue. The humble Bark Scorpion would certainly have been responsible for a high proportion of those.

Whilst most scorpions tend to spend their entire lives firmly on terra firma, the Bark Scorpion likes to climb, and may be found high up on trees and rock faces; it particularly enjoys living between the bark and trunk of trees.

This love of climbing and cool damp places often brings Bark Scorpions into human habitations, where they may reside in outbuildings, in lumber piles or garbage, or even inside the house, where they get trapped in sinks and bathtubs or hide in dark corners of the house. This brings people and scorpions into close contact, especially when people are wandering about at night or sifting through garden junk; it's not that the scorpions are aggressive, but if they're hiding in a shoe and a foot comes in to join them, they have a tendency to look after themselves! When stinging in defence, the scorpion will jab quickly and repeatedly, and then make a getaway.

Bark Scorpions are quite social, or at least tolerant of others, and can be found in large aggregations, especially during their winter hibernation. Even at this time, when they are seemingly asleep, they should be given a wide berth.

BELOW *The fairly innocuous-looking Bark Scorpion is actually one of the few arachnids that really has an impact on human health, probably killing several hundred people a year.*

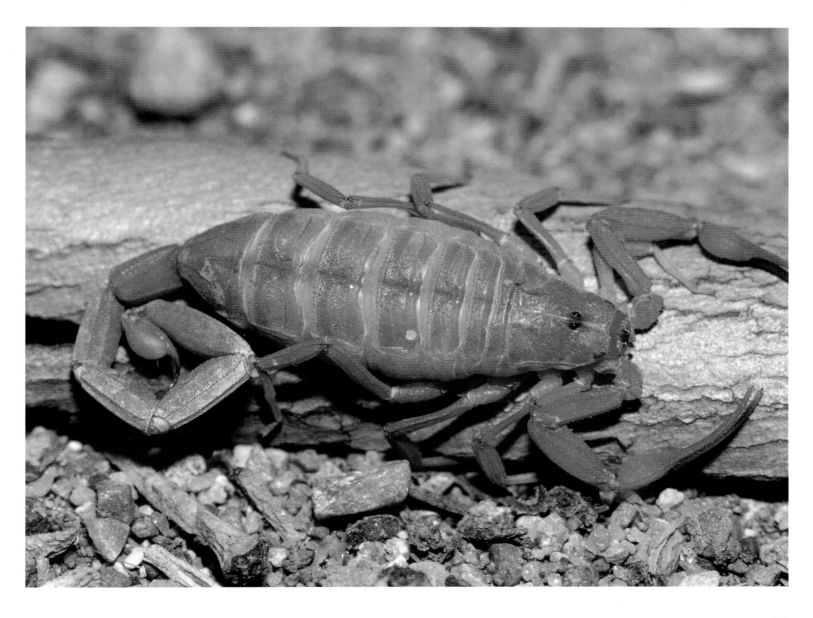

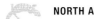

PORTUGUESE MAN-OF-WAR (*Physalia physalis*)

WHERE FOUND: WIDELY DISPERSED, WITH STINGS COMMON ON THE ATLANTIC COAST OF NORTH AMERICA, AUSTRALIA, SOUTHERN AFRICA AND WESTERN EUROPE.

The two species of *Physalia* (the Portuguese Man-of-War and the Pacific Bluebottle), are – and it always boggles my mind to hear it – not actually single animals at all. In fact, they are actually colonies of symbiotic animals, which work together to collect food, digest it and to reproduce. The blue translucent float or pneumatophore, which bobs like a bottle or pear-shaped balloon on the surface of the water, is, however, a single individual and has the job of supporting the rest of the colony. While it may seem that this leaves the organism at the mercy of the tides and winds, there is evidence that *Physalia* adjusts its position in the water, and can change the curvature of its 'sails' to tack in different directions. The tentacles are polyps, which catch and digest food. As *Physalia* drifts downwind, the long tentacles fish through the water for small crustaceans and surface plankton. Muscles in the tentacle contract and convey their prey to the other polyps that have the job of digestion – the stomachs of the colony. Reproduction is carried out by the gonozooids, another type of polyp;

these are hermaphrodites, with both male and female parts, and the fertilized egg develops into a planktonic larva.

The Portuguese Man-of-War is very widely dispersed, and responsible for more serious human stings than any other type of 'jellyfish'. Thousands of stings happen globally every year, and fatalities have been recorded. By contrast, the smaller Pacific Bluebottle (*Physalia utriculus*) stings more people than could possibly be counted, but no fatalities have been recorded. The sting is very characteristic, with angry wheals surrounded by fierce red inflammation; pain may subside after just a few hours, however.

BELOW *As with all jellyfish, the Man-of-War is composed almost entirely of water, and this photo emphasizes its seeming lack of substance.*

OPPOSITE *This beautiful photo shows the elegant 'sail' of the Man-of-War floating on the surface, as well as the deadly nematocyst-loaded tentacles hanging deep into the water column to catch unfortunate prey.*

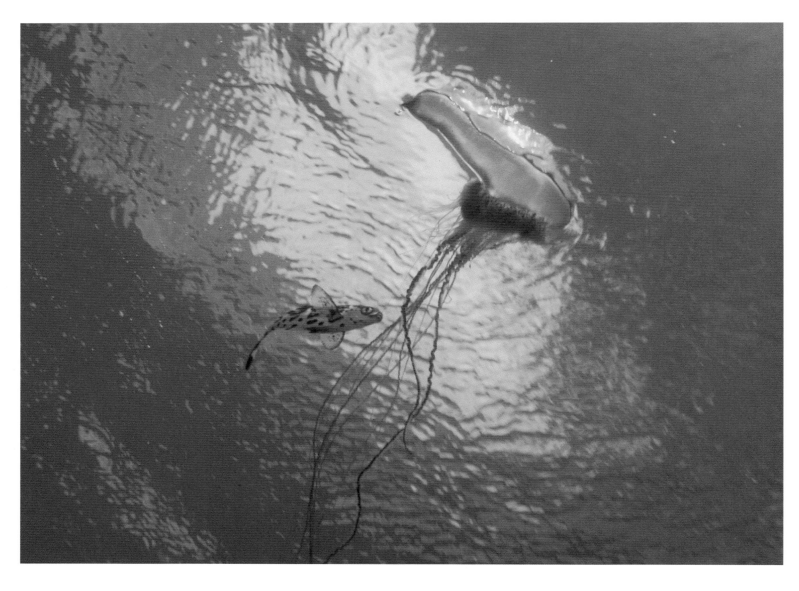

STINGRAYS (*Dasyatis* spp.)

WHERE FOUND: WORLDWIDE IN TROPICAL AND TEMPERATE SEAS, AND WITH FRESHWATER SPECIES IN SOUTH AMERICA, AFRICA AND INDOCHINA.

Although stingrays occur throughout the world, I've included them in this section as there are so many sites in the Caribbean where tourists can encounter giant stingrays in the water, including at feeding sites such as Stingray Alley in the Caymans and Stingray City in Belize. Generally speaking, these encounters are magical for the tourists and productive for the rays, but with nervous swimmers thrashing around in the presence of potentially dangerous rays, accidents can and do happen.

Giant stingrays can have a diameter of two metres and weigh 300kg. It is worth remembering that their closest relatives are all sharks, although the first thing to say here is that the only way stingrays actually attack people is by giving over-enthusiastic 'love bites' when tourists are attempting to hand-feed them (stingrays chow down on rock lobsters and crabs and have powerful crushing plates in their jaws – so these love bites can leave quite a wheal!). In fact, about two minutes after the picture opposite of me feeding a Southern Stingray was taken, I managed to lose a big chunk of hair and scalp to one of these, which left me walking round looking like a Franciscan monk for weeks!

Stingrays do not attack people using their venomous sting. Rather, injuries occur when people step on them whilst they're hidden in sand or mud, or when anglers haul them in. The long whip-like tail

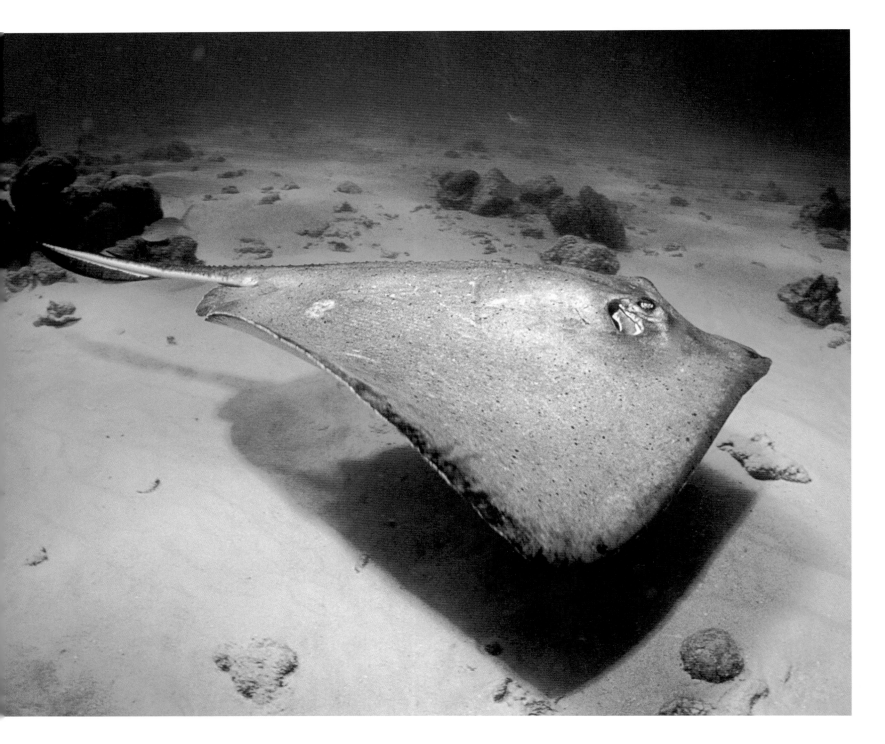

has a spine at the base on the dorsal surface, which is serrated and can cause deep wounds. Venom is injected from the glandular tissue underneath the spines, and causes excruciating pain. Several deaths have been recorded in Australia from the direct stings of stingrays, as well as several other deaths from complications (ie. tetanus or septicaemia) in the wound. If you're wading in water where stingrays are known to be, shuffle your feet along the bottom instead of picking them up – this'll give the rays a chance to make a swift exit. It is believed that the venom is broken down by heat, so treating with hot water is a good idea, as long as you're careful not to scald the victim.

Stingrays have had some bad press in recent times, most particularly over the death in September 2006 of the television wildlife presenter, Steve Irwin. Whilst filming with stingrays he was stung in the chest and the venom delivered straight to his heart. He died soon thereafter. Sadly, after this event there were reports of people butchering stingrays in some sort of bizarre retribution. Irwin's death is best viewed as a freak accident, but it does flag up the dangers these creatures can pose if interfered with. However, Irwin would have known the inherent dangers in swimming closely with them, and it must be said that the chances of a similar incident happening to a recreational swimmer or diver are extremely low.

OPPOSITE *In motion, the stingray is much like a flying carpet, gently gliding over sandy seabeds. Its mouth is situated under its body and equipped with crushing plates designed to crunch up the crustaceans it uncovers in the sand.*

BELOW *Despite the freak accident that ended Steve Irwin's life, stingrays sting only if seriously agitated, and generally make excellent swimming partners. I fed this one for nearly an hour and it behaved like a large, friendly dog!*

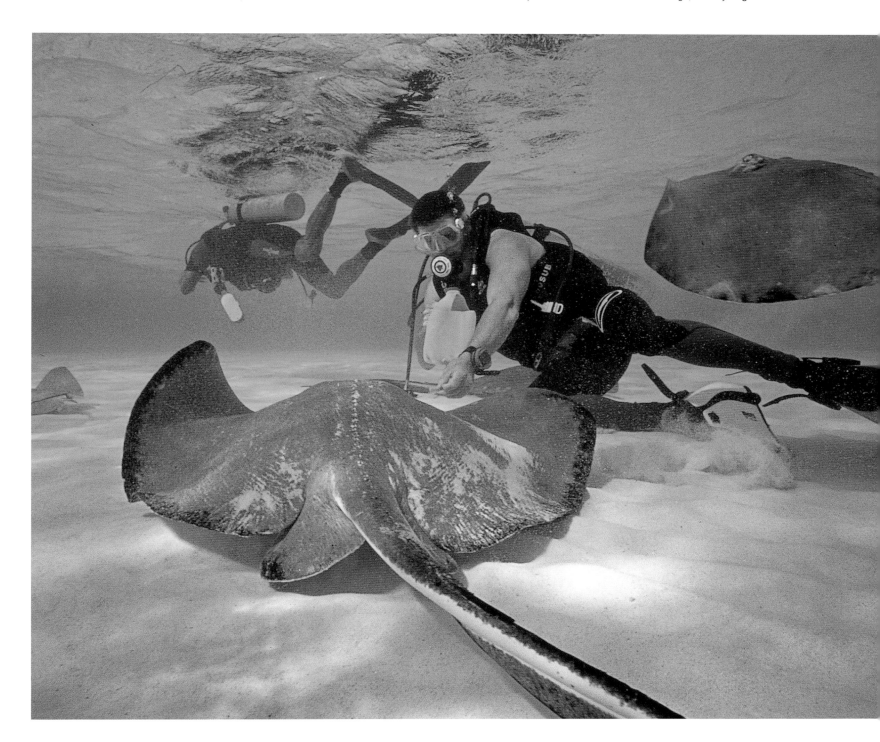

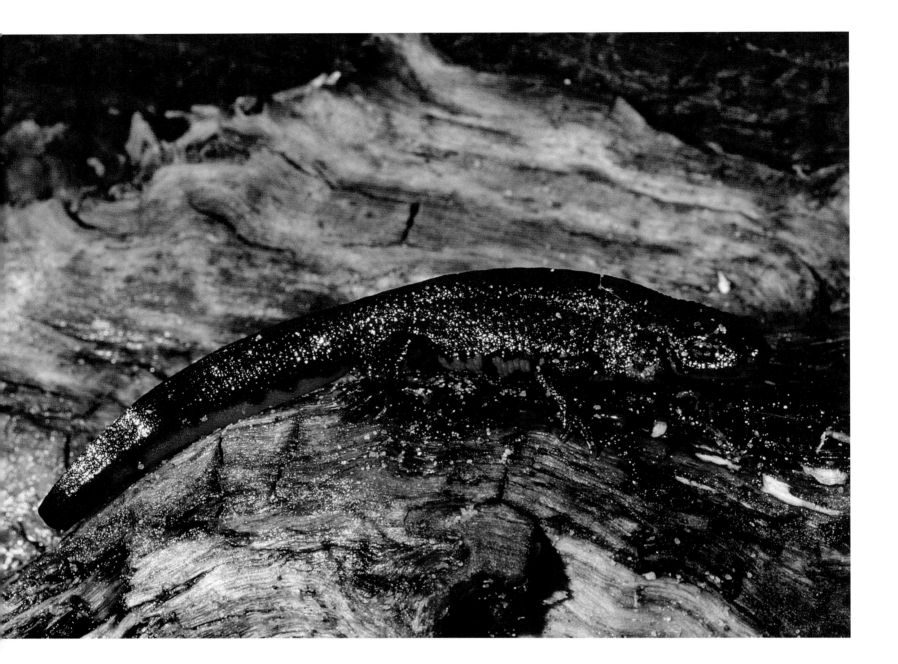

PACIFIC NEWTS (*TARICHA* SPP.)

WHERE FOUND: WESTERN COASTAL STATES OF NORTH
AMERICA AS FAR AS ALASKA.

Often known as toxic salamanders, newts of the genus *Taricha*
secrete highly toxic chemicals from glands in their skin. They spend
a good deal of their time out of the water, but good places to go
looking for them are rock crevices and logs, and during the breeding
season (December to May) they can be found in pools near the coast.
They are certainly the most poisonous of all the newts, and contain a
toxin known as tarichatoxin or tetrodotoxin, the same neurotoxin used
by the Blue-ringed Octopus (see p.115) to paralyze its prey.

If you (or, more likely, your dog) are unwise enough to threaten the
safety of a California Newt (*Taricha tarosa*), it'll curl its tail towards its
head and secrete this toxin through its skin glands. A perfunctory lick
will be enough to make your dog very sick indeed, and a whole newt
could well kill a human. While I'm sure you're wondering who would

ABOVE *With its blood-red belly serving as a warning, most adult animals know*
better than to take a bite out of the California Newt. Juveniles are less
experienced, however, and often come to grief.

be crazy enough to eat a newt, there is a documented case of a
toddler eating part of the tail of an Oregon Rough-skinned Newt,
Taricha granulosa (which is rather less toxic than the California Newt).
Unfortunately, the child did not survive.

It is believed that California Newts generate toxicity by ingesting
bacteria such as *Vibrio* spp. In a somewhat ironic twist of evolution,
some Common Garter Snakes, *Thamnophis sirtalis*, are able to
withstand eating these newts with the same mechanism that allows
the newts to tolerate their own toxins. These snakes can therefore
prey on the newts, and in doing so store their toxins in their liver.
Eventually, the Garter Snake will become poisonous (as opposed to
venomous; most subspecies don't have any venom glands, and can't
harm with a bite, but try and eat one and you'd get a nasty shock!).

GILA MONSTER (*Heloderma suspectum*) AND
BEADED LIZARD (*H. horridum*)

WHERE FOUND: The Mojave, Sonoran and Chihuahuan Deserts of extreme southwestern Utah, southern Nevada, southeastern California, western Arizona and southwestern New Mexico into Mexico.

These are hefty lizards, with a maximum length of nearly one metre, great fat tails and thick heads. With their hissing open-mouthed threat displays, most people soon realize that this is a creature to be avoided. Until recent investigations into the Komodo Dragon's 'venom', it was believed the Gila Monster and Beaded Lizard were the only two venomous lizard species in the world. While their venom certainly has what it takes to kill a human, no deaths have been reported in recent times, and all recorded bites have occurred when the lizards have been provoked or carelessly handled.

ABOVE *The characteristic tracks of a Gila Monster in the sands of the Sonoran Desert in Arizona, USA.*

BELOW *The Beaded Lizard's range extends further south than that of its cousin the Gila Monster, and its skin pattern is rather less bold (see photo on p.61).*

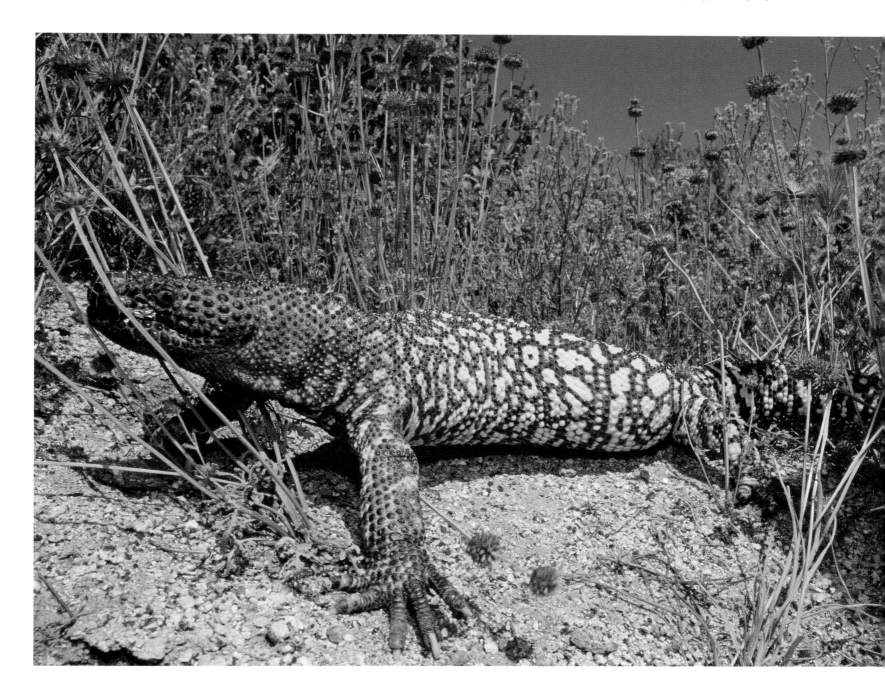

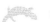

Unlike snakes, in which the venom glands are located in the upper jaw, these two lizards have their venom glands in the lower jaw. Venom is released at the base of the teeth and mixes with the saliva; grooved, curved sharp teeth inject the venom into the typical prey of small mammals and ground-nesting birds. Once it has attacked, the lizard doesn't relinquish its hold on its prey, in order to ensure the continued injection of venom into the subject. This being the case, should you ever get bitten by a Gila Monster, the advice is – don't yank your hand out of its mouth as it'll hang on like a pit bull terrier and some of its teeth will probably break off in the wound. Instead, get a stick and lever its jaws open.

The large tail in these two species is due to fat deposits that are laid down in times of plenty to tide the lizard through famine. Largely nocturnal, they hunt mostly with their senses of taste and smell rather than eyesight, and hide in rock crevices or burrows during the day.

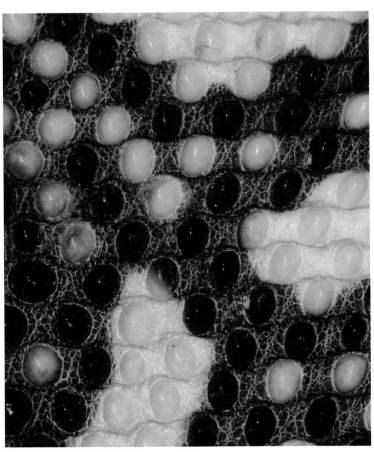

ABOVE *Up close, the Gila Monster is an awesome sight. It was once believed to have poisonous teeth.*

RIGHT *The scaled skin of the Gila Monster is waterproof, which means the lizard loses no water through its skin as sweat – a real boon for desert living.*

OPPOSITE *A Gila Monster in classic habitat. Despite their distinctive markings, they are rarely seen and much remains to be discovered about their lifestyle.*

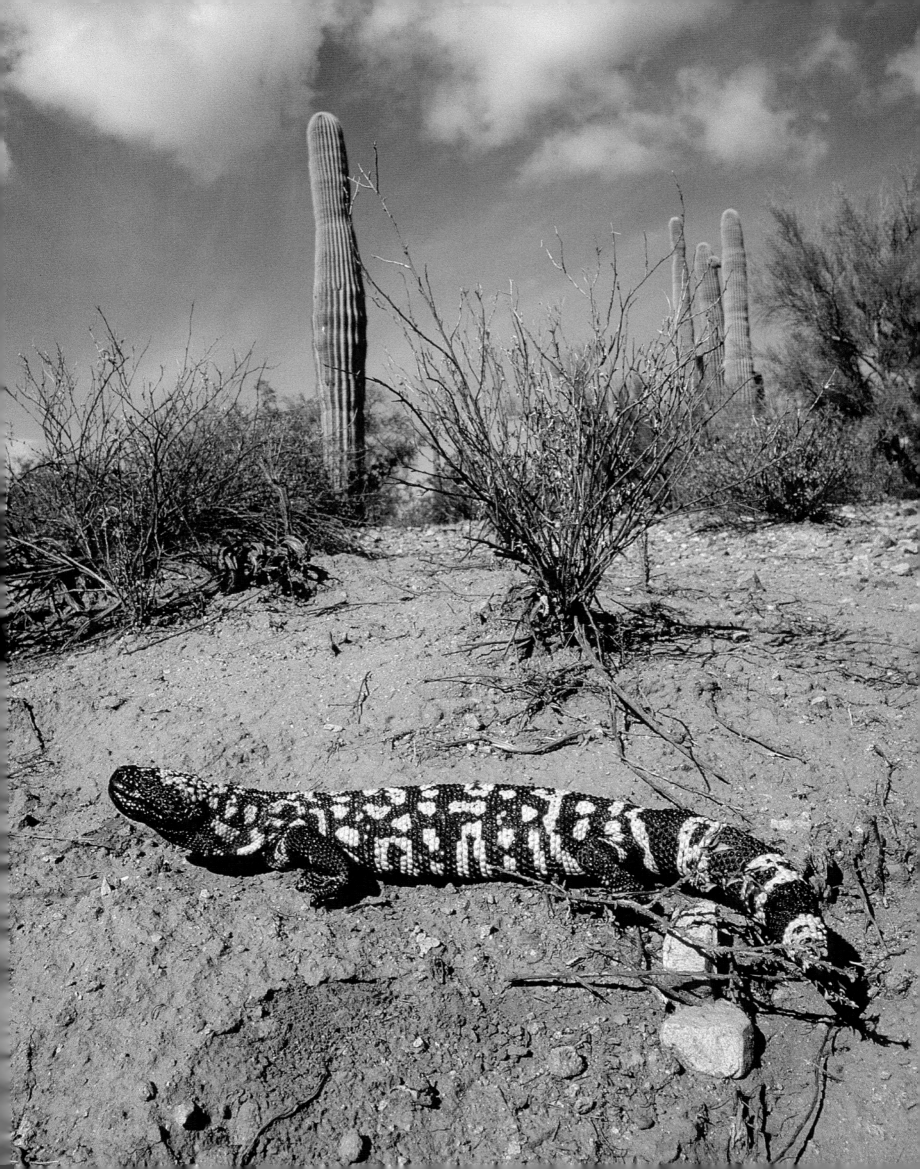

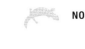
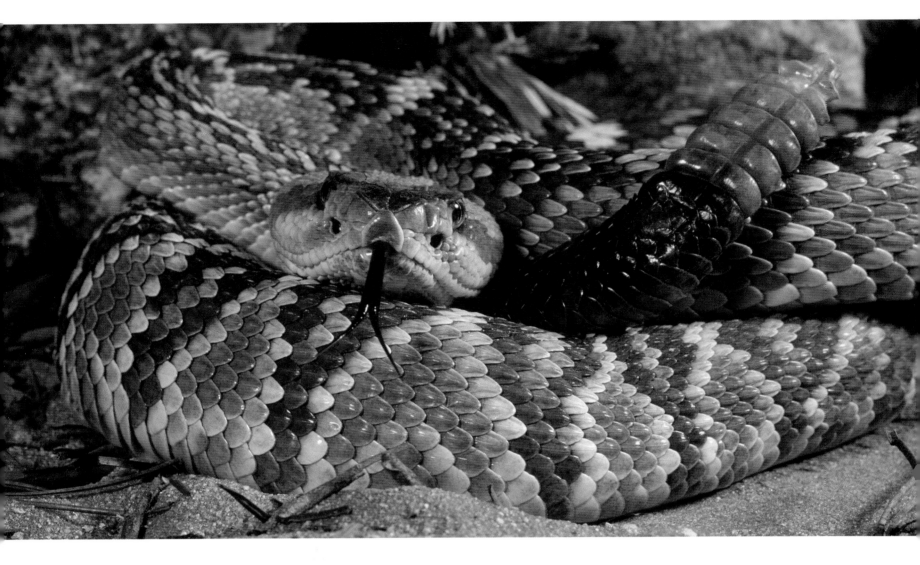

RATTLESNAKES (Crotalus spp.)

WHERE FOUND: North, Central and South America.

The sixteen species of rattlesnake are all members of the Crotalid family, which makes them pitvipers. This name comes from the heat-sensitive depressions or pits (properly known as the loreal pits) between and slightly below the eye and the nostril, which function like an infra-red super sense, locating the heat generated by the moving muscles of their mammalian prey. This organ works accurately up to about half a metre in distance (although it is said to be able to detect the heat from a candle at nine metres!), but is very sensitive and is the main means used to guide the strike. These snakes have two long, hinged fangs, which lie flat against the roof of the mouth whilst the mouth is closed, and swing open when the snake strikes.

The rattle is formed by the remains of successive moults of the scales, and covers the very end of the tail. The rattle builds up throughout the snake's life but, as the skin is so brittle, it rarely gets bigger than six or seven rattles before it breaks off. There's nothing actually inside the rattle – it's merely the action of the brittle skins rubbing against each other, as much as sixty times a second, that causes the sound. Contrary to popular belief, the rattle is not used to serenade females or to communicate with other snakes. It is purely

ABOVE *The stunning Black-tailed Rattlesnake occurs in a wide variety of habitats from sea level up to 3,000 metres or so. Like most snakes, it is shy and will keep out of sight whenever possible.*

and simply a defence mechanism, the rattler's version of the cobra's hood or the mamba's black-mouthed gape. Unfortunately for the snake, this sound actually helps human hunters – with the snake's destruction on their mind – to identify and locate it.

In the northern parts of their range, and at altitude, rattlers congregate in the autumn, in crevices between rocks, to hibernate. This is pretty much the only time rattlers will tolerate each other, and these places are known as rattlesnake 'dens'. For years it was assumed that rattlesnakes showed no parental care, until eminent herpetologist Harry Greene demonstrated that female Black-tailed Rattlesnakes (*Crotalus molossus*) will stay with and guard their young until they're successfully through their first moult.

One of the sadder aspects of man's interaction with rattlesnakes involves the infamous rattlesnake 'round-ups'. These have a long tradition, back to the days in the 1600s, when America was still a fledgling society, with European settlers trying to 'pacify' the indigenous people and the wild environments in which they wanted to make their new homes. For several hundred years thereafter men were paid to exterminate rattlesnakes, a practise which developed

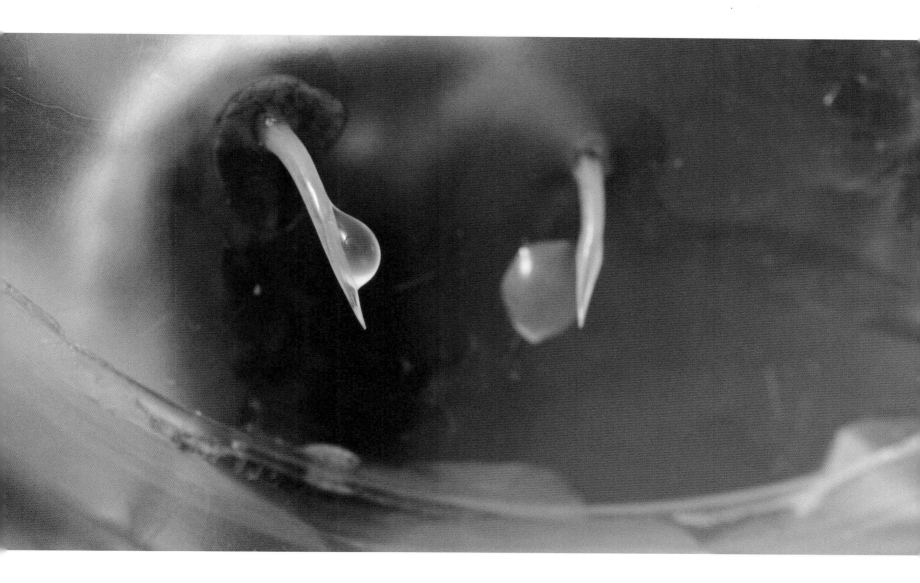

into specific dates being set aside every year as snake-hunting days. As communities grew, so these snake hunts evolved, until they became festivals with prizes awarded to the greatest snake-killers. Thousands of snakes were slaughtered at each event, and spectators would take their children along to watch, complete with picnics and pom-poms to cheer on the competitors.

Amazingly, rattlesnake round-ups are still held in states like Alabama, Florida, Georgia and Oklahoma. In Sweetwater, Texas, the extraordinary total of 70,773 snakes were killed in a 16-year period of the local round-up. Nowadays, the hunts focus on finding hibernation dens, often pouring gasoline into them to drive out the snakes. As well as killing the rattlers, this also kills or injures whatever other wildlife may be there, and is horribly polluting.

With just 9–14 deaths a year reported in the whole of North America from snakebite, and not all of those from rattlesnakes (and most of them being people who were trying to handle or kill the snakes), the remorseless slaughter of so many snakes seems disproportionate. Bearing in mind that these extraordinary creatures feed on pests like rats, that fewer than 25 per cent of rattlesnake bites actually result in envenomation, and that those intent on catching and destroying the snakes are the only ones genuinely in danger, these round-ups seem illogical.

ABOVE TOP *A rattlesnake being 'milked' through a membrane. Despite the potential value of their venom in medicine, rattlesnakes are still persecuted mercilessly across much of their range.*

ABOVE *Haemotoxic rattlesnake venom can result in some truly horrific necrosis (skin and cell death). Even a minor bite can result in an amputation.*

CHAPTER FOUR

LATIN AMERICA

Central and South America are probably the most exciting places on the planet for a naturalist. The sheer quantity and diversity of plantlife there has led to fierce battles for ascendancy, and the development of some virulent chemical weaponry. Cassava, for example (a major local food source), contains so much cyanide in its roots that it has to be boiled and treated extensively before it can be eaten. In a peculiar twist in the food chain, many of the protective chemicals gathered in the plant tissue are sequestered by the invertebrates that eat them. These can in turn be used by the vertebrates that eat the 'inverts', and in extreme cases this results in the most caustic natural chemicals known to science.

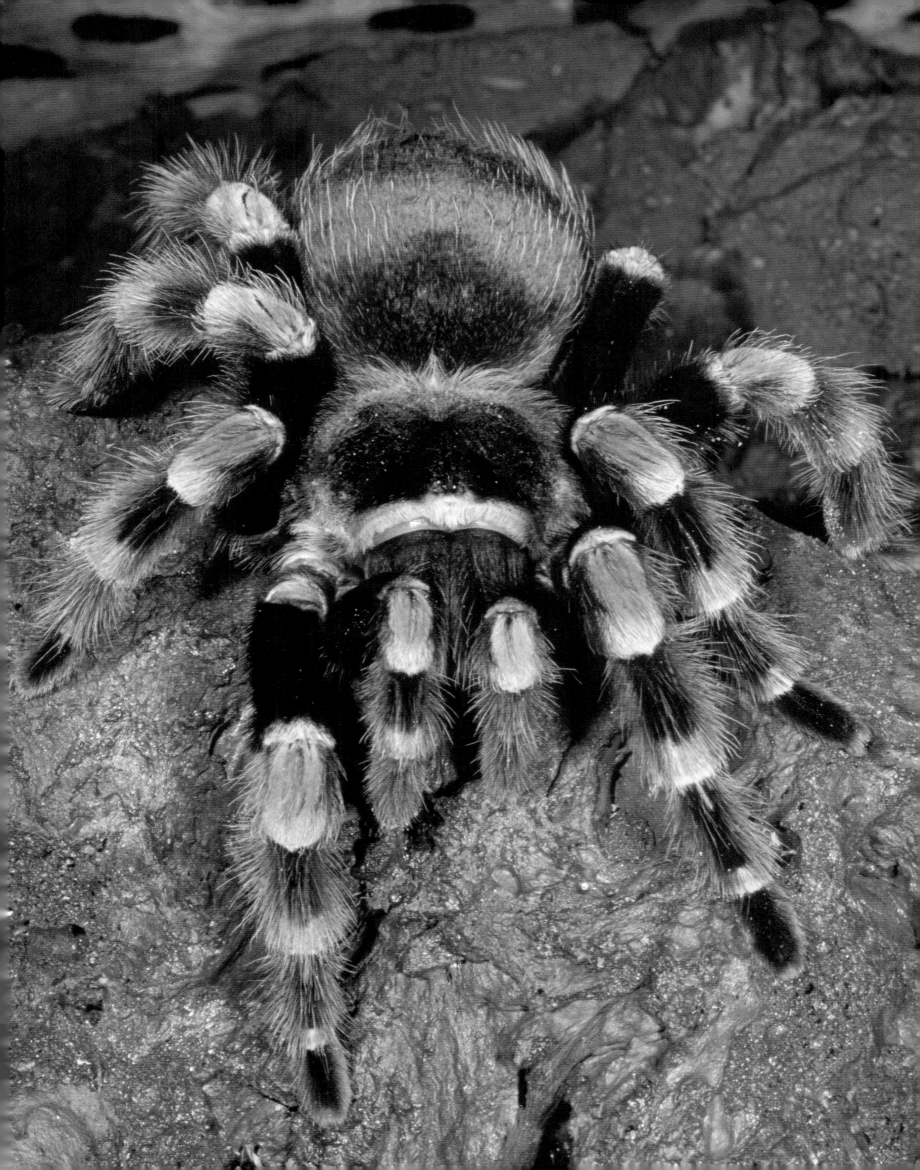

BUSHMASTERS (*LACHESIS* SPP.)

WHERE FOUND: Central America south to subtropical Amazonia.

The bushmasters are arguably the snake family that bears the closest resemblence to dragons, with vast, overlapping armoured scales, great forked tongues and cold, dispassionate eyes. They are the largest pitvipers, with a huge bodies which are triangular in cross section, but they are less aggressive and more easily handled than their relative, the ferociously fizzing Fer-de-lance *(Bothrops atrox)*. Certainly the only bushmaster I have ever caught was very docile, moving slowly and powerfully through my hands, and never giving any sense that it might strike or cause me any harm – provided that I didn't harass him. Bushmasters are far less likely to be seen than the lanceheads, shying away from human presence and living deep in the forest. Some sources state the bushmasters to be the second-longest venomous snake in the world, with the longest being just over three metres, but I reckon the Black Mamba takes that title.

These snakes inspire such dread and awe amongst people that they have acquired over fifty common names. Some Brazilians say the snake can put out fires with its flickering tongue, and that it suckles milk from cows and sleeping village women.

Legendary herpetologist Harry Greene radio-tagged three bushmasters to discover more about how they live. He found his subjects to be remarkably lazy in habit and the archetypal 'sit-and-wait' predator, which finds a productive place to lie up and feed when the opportunity arises, i.e. when a likely prey animal passes by. In a month and a half the snakes he was studying barely moved, having taken up feeding sites under palm trees, where rodents occasionally gathered to eat their seeds. One of the snakes ate only once in all that time – a meal that was almost half its own body weight. After eating it didn't start hunting again for nine days.

PREVIOUS PAGE *The Mexican Red-kneed Tarantula* (Brachypelma smithi) *is one of the most beautifully marked of all spiders.*

OPPOSITE *The most dramatic thing you notice when handling a bushmaster is its amazing bulk, unprecedented among the vipers, and the dramatic ridgeline that runs along its back, giving its body a pyramidal cross-section.*

BELOW *The magnificent bushmaster may look like a monster among snakes, but it is rarely seen, tending to live in deep forest far from human contact.*

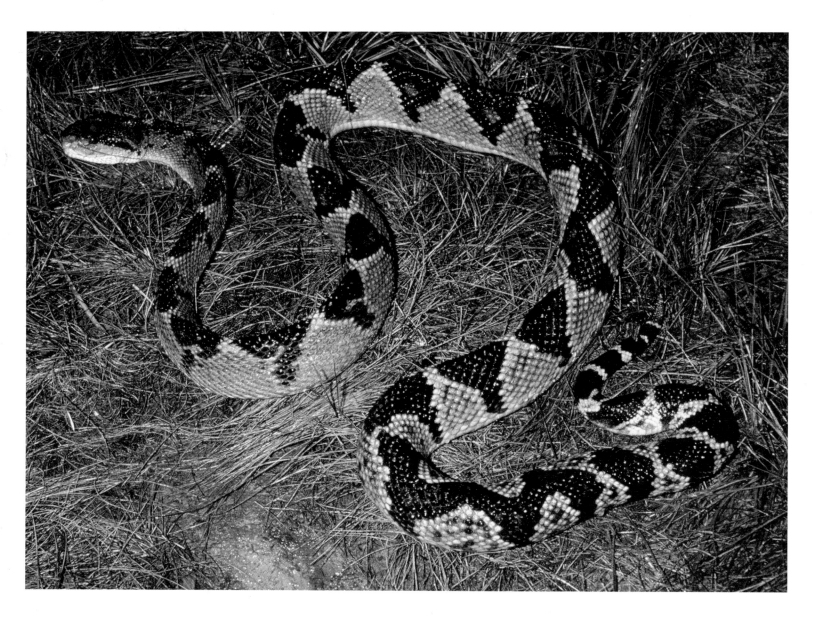

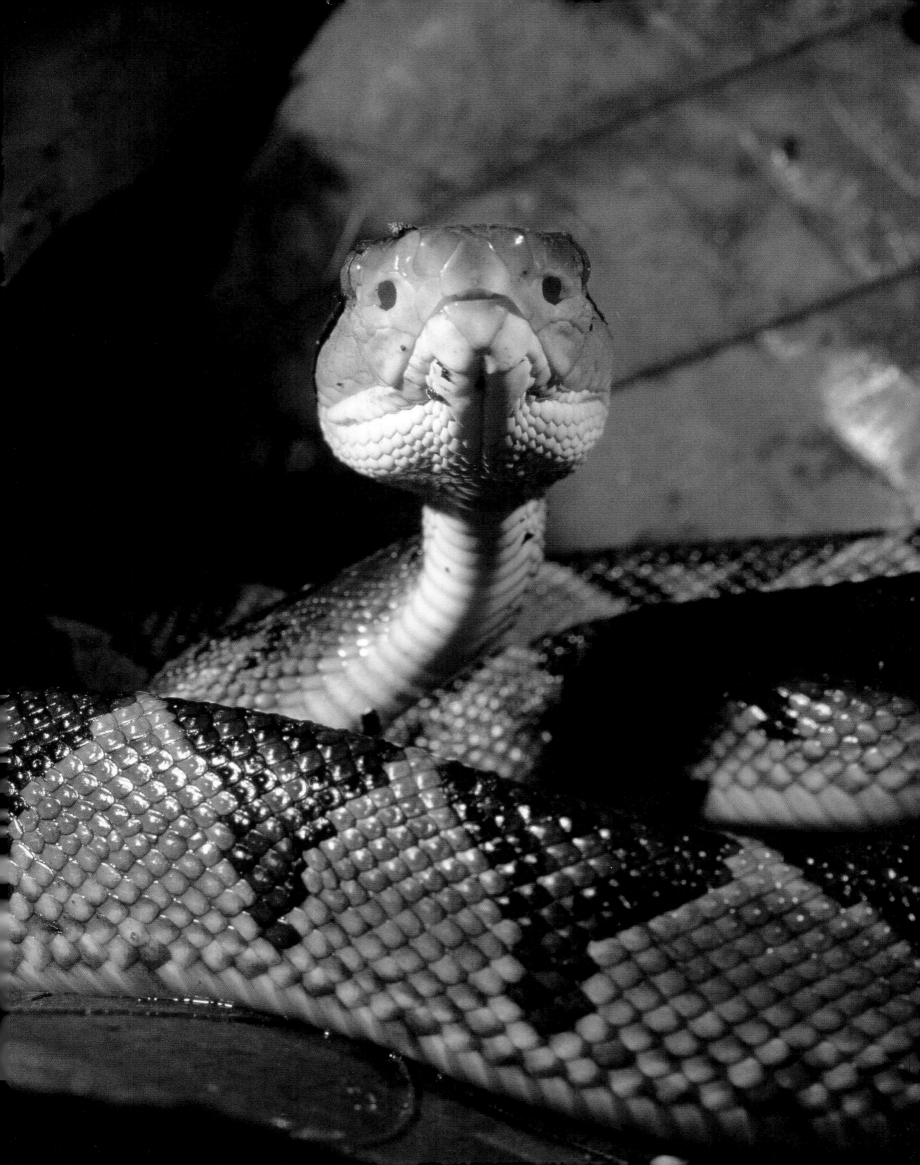

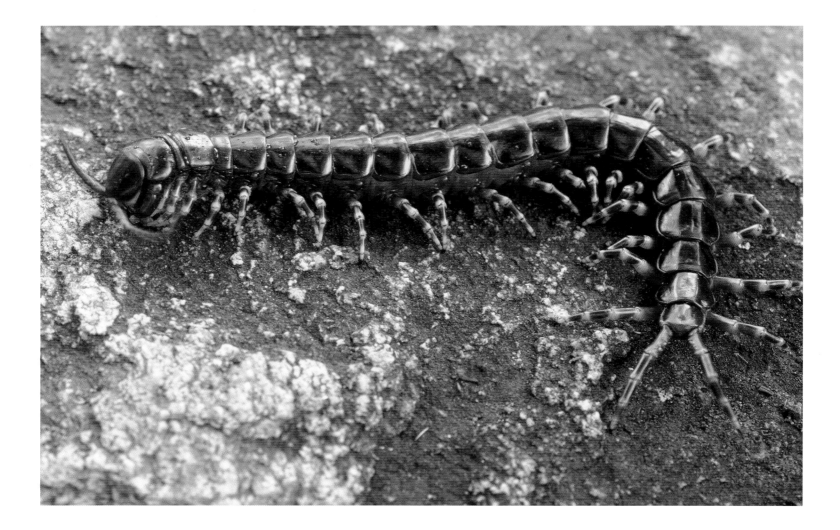

GIANT CENTIPEDES (*SCOLOPENDRA* SPP.)

WHERE FOUND: TROPICAL AREAS AROUND THE WORLD, WITH THE LARGEST SPECIES FOUND IN SOUTH AMERICA.

There are some sizeable centipedes to be found in various parts of the tropics but the biggest of all is the Amazonian Giant Centipede (*Scolopendra gigantea*). Adult specimens can reach as much as 30cm, as long as a standard ruler and about as thick. They feed not only on other invertebrates but also on lizards, frogs, small mammals and even birds. Amazingly, a population was recently discovered living in a cave system in Venezuela, where they hang upside down from the roof of the cave and grab bats in mid-flight! Studies revealed that the centipedes would cross barren areas of rock (with no prey) regularly to set themselves up in prime bat-nabbing locations in time for the bats' nightly hunting forays, indicating a certain degree of 'forethought' or premeditation in the *Scolopendra* hunting technique.

They would have to be one of the scariest arthropod predators, fast moving, aggressive, and with an extraordinarily painful bite. There is no snake on the planet that is as challenging to handle as a large *Scolopendra*. Whilst centipedes can run the full range of colours from bright yellows and oranges to dull browns and black, *S. gigantea* is usually a sort of coppery red or maroon in colour, with banana-coloured legs. The body consists of 21–23 segments with one pair of legs per segment; this is a good way of telling them apart from

millipedes, which have two pairs of legs for each body segment. The species lives in northern and western regions of South America, as well as in Trinidad and Jamaica. Female *Scolopendra* are excellent mothers, and will steadfastly tend to and protect their nests of eggs.

Centipedes use their jaws and modified front claws, which curve around the head, to deliver their powerful venom, which is high in acetylocholine, histamine and serotonin. In humans this leads to localized extreme pain, vomiting, severe swelling, fevers and weakness; necrosis to the tissues at the site of the bite can follow, and at least one fatality has been reported. If you're unlucky enough to be struck by a centipede of the *Scolopendra* genus, you'll be suffering from scolopendrism.

In addition to their bites, centipedes may exude alkaloid-containing haemolymph from their joints when handled, and potentially scratch this into the skin with their sharp claws. This could easily result in dermatological irritation, but then if you willingly hold a *Scolopendra*, you're pretty much getting exactly what you deserve!

ABOVE Scolopendra gigantea *not only has venomous spurs that inject ferociously potent toxins from its business end, but it also exudes nasty chemicals from its leg joints. All in all, this is a highly dangerous creature.*

OPPOSITE *Many people look at me in disbelief when I mention that a centipede may be able to kill birds, rats, bats and other small mammals, but the giant scolopendrids are quite capable of tackling such prey. Here a* Scolopendra *has incapacitated a tarantula with its potent venom.*

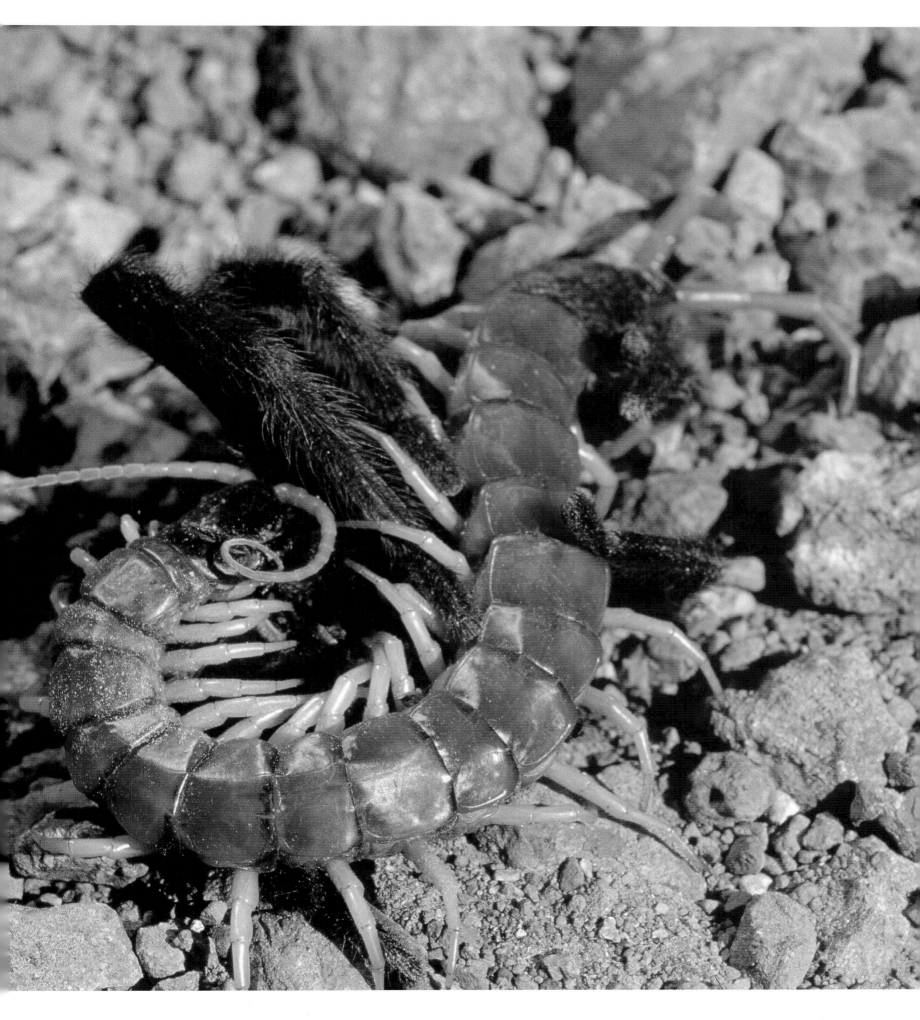

BRAZILIAN WANDERING OR BANANA SPIDER (*PHONEUTRIA* SPP.)

WHERE FOUND: BRAZIL.

This group of spiders feed on cockroaches and crickets, and so are highly attracted to areas of high human habitation, where they can be very common. They don't use a web, but hunt actively with lightning speed and aggression, particularly at night, and this is when they most often come into contact with people. This habit of wandering about whilst hunting obviously lends them their first common name, whilst the 'Banana Spider' moniker comes from cases of these spiders appearing on banana boats heading for parts of the world way beyond Brazil. In 2005, for example, a 65-year-old man from Newport in South Wales was bitten by one in his local supermarket, whilst picking out a bunch of bananas. This is certainly a very unusual occurrence, though, and you shouldn't find yourself getting fearful every time you pass the fruit counter!

These large spiders are certainly among the most venomous spiders known to man, and the most venomous in the New World. The venom is potently neurotoxic – acting on the nervous system – and causes little skin damage, but it does result in immediate pain, cold sweats, excessive salivation, priaprism (endless painful erections), cardiac perturbations and occasionally death.

BELOW *Due to the high amounts of agitating elements in their venom, the wandering spiders of the* Phoneutria *genus give what are claimed to be the most painful of all spider bites.*

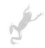

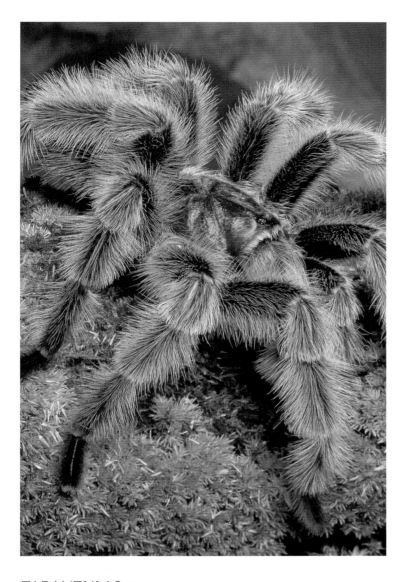

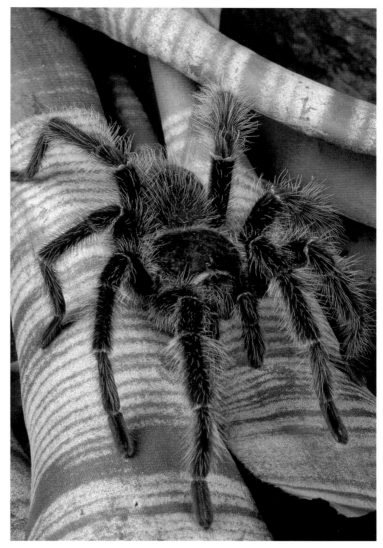

TARANTULAS (Theraphosidae spp.)

WHERE FOUND: Much of the temperate and tropical Americas.

Tarantula is not really a scientific name, but is generally applied to species of large, hairy, primitive spider (scientifically of the infraorder Mygalomorphae) that live in Central and South America. Similar spiders in Africa tend to go under the heading of baboon spiders. The name 'tarantula' was once used to describe European wolf spiders; in the Italian city of Taranto, people thought a bite from these arachnids could be fatal and, in order to get rid of the poison, would perform a frenzied dance called the tarantella to purge themselves. When the Americas were colonized, the tarantella name was applied to virtually any large hairy spider, and it's very much stuck.

With a record-breaking leg span of 28cm – about the size of a dinner plate – the Goliath Bird-eating Tarantula (*Theraposa blondi*) of South America is probably the largest.

In reality, though most people expect tarantulas to have deadly venomous bites, they rarely have particularly potent venom. In fact, people are far more likely to have reactions to the irritant 'urticating' hairs that cover the abdomen. Even my own pet tarantulas – if taken by surprise – will scrape their rear legs against their abdomen, and

kick these hairs up into the air at a perceived threat; one which I accidentally kept in an overly dry vivarium kicked every single hair off its abdomen and ended up looking like a bald snooker ball! The hairs all came back with the next moult though. When viewed under a microscope, these hairs have a structure similar to the hairs on a stinging nettle, and they will work their way into the skin, being particularly painful in tender areas such as the eyes, mouth and nose. This is often a consideration with species like the Mexican Red-kneed (*Brachypelma smithi*), the Brazilian Salmon Pink (*Lasiodora para-hybana*), and the Chilean Rose (*Grammostola rosea*), which are all commonly kept as pets. However, though the abdomenal hairs are the greatest concern, it is worth knowing that these species also have enormous fangs, potentially much longer and stouter than those of a good-sized venomous snake, and that some of them are capable of feeding on birds and small mammals. Any bite is going to hurt.

ABOVE LEFT *A favourite of arachnophiles, the Chilean Rose Tarantula is one of the most beautiful of all large spiders, and not a great danger to humans.*

ABOVE RIGHT *The Brazilian Salmon Pink Bird-eater is another species popular with spider-lovers. Although often kept as a pet, it is not ideal for beginners.*

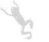

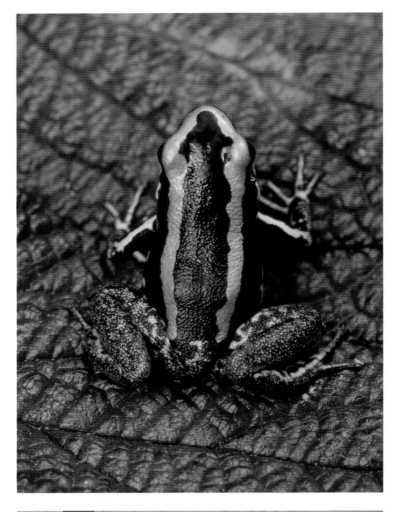

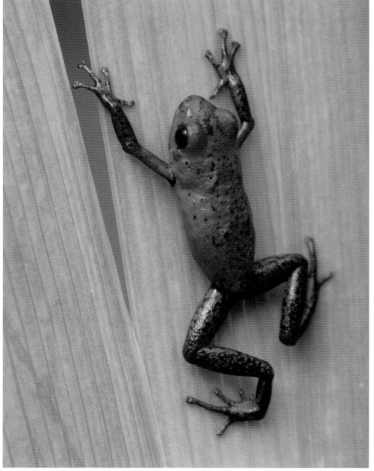

POISON DART FROGS (DENDROBATIDAE SPP.)

WHERE FOUND: TROPICAL AND SUBTROPICAL CENTRAL AND SOUTH AMERICA.

As the Lethal Dose 50 table (Appendix Two) shows, the most toxic animal known to science is not actually venomous at all, but poisonous; a remarkably pretty, surprisingly tiny, utterly inoffensive-looking little jewel, with the impressive scientific name of *Phyllobates terribilis*. So far as is known, this is the most chemically significant species of a legendary group of creatures – the poison dart frogs. Although there are many poisonous frogs around the world, the Dendrobatidae are the only ones that can really be called poison dart or poison arrow frogs, and of those only frogs of the genus *Phyllobates* contain the most lethal batrachotoxins.

The common name comes from the famous way in which Native Indians make use of the frog's deadly defences. The Noanama, Choco and Cuna Indians all tip their darts with toxins garnered from the frogs – whether by boiling the whole frog up into a virulent 'goop', or merely by rubbing the dart over the back of the frog, where granular skin glands secrete the poison. These darts – generally fired from blowpipes – will bring down monkeys in a matter of minutes.

The frogs do not actually manufacture these toxins themselves; they acquire them from alkaloids occurring in their invertebrate prey, which in turn have presumably obtained them from vegetable food sources. However, in a poorly understood mechanism, these alkaloids increase dramatically in toxicity inside the frog, which appears to be a living chemical factory. It is obviously a complex procedure which relies on all the vagaries of environment to manifest itself – bring up a poison arrow frog in a vivarium with a standard frog diet, and its toxicity will vanish!

Although very little of this toxin would be required to kill a human being (an estimated two micrograms – one *P. terribilis* contains about one milligram, 500 times this amount), this is much more dramatic when administered under the skin than when taken orally. The poison is destabilized by cooking, which explains why Indians can safely eat animals they have killed with batrachtoxin. Interestingly, this is the same toxin that can be found in certain species of poisonous New Guinean birds (see p.116), and in many of the invertebrates they prey upon – particularly the Choresine beetles, which have been found in the stomachs of both poisonous birds and poison dart frogs, and seem to contain similar chemicals.

Personally, I've never actually seen a specimen of *P. terribilis* alive, but have handled many of their relatives. Unbelievably, even holding these far less toxic cousins results in intoxication, the glandular secretions penetrating the skin through the sweat glands and putting the handler in a state akin to having drunk a pint of tequila!

CLOCKWISE FROM TOP LEFT Phyllobates vittatus, *a common Central American species;* P. terribilis, *the most toxic species known in the world;* Epipedrobates *spp., a species only recently discovered in Peru's Yavari Valley; the ubiquitous* Dendrobates pumilio, *a widespread species known either as the Strawberry or Blue-jeans Poison Dart Frog.*

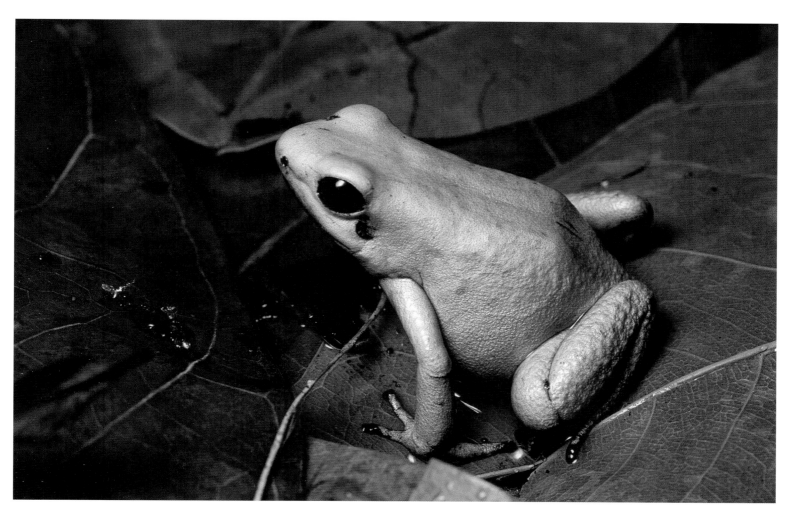

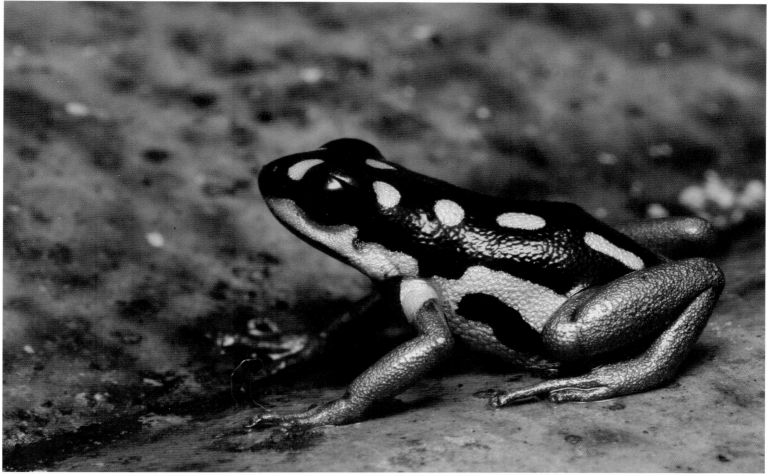

TROPICAL LANCEHEADS (BOTHROPS SPP.)

WHERE FOUND: FORESTS AND ADJACENT AREAS FROM SOUTHERN MEXICO THROUGH NORTHERN COLOMBIA, VENEZUELA, AND THE PACIFIC EDGE OF THE ECUADORIAN ANDES.

These particular species are some of the largest of all of the vipers, and would have to be some of the most dangerous of all snakes, accounting for 90 per cent of all venomous bites in Central America. However, having successfully caught snakes such as the Black Mamba and King Cobra, which have truly appalling reputations, my first encounter with one of the lanceheads – a Fer-de-lance (*Bothrops atrox*) – was, out of ignorance more than anything, rather casual. Luckily, I was in the company of Julio Madriz, a Costa Rican naturalist of considerable experience; otherwise it could well have been the last snake encounter I ever had.

This particular Fer-de-lance was a truly impressive beast, fully two metres long and as thick as my arm, jewelled with deep maroon diamonds down its back and with disconcertingly scary eyes. It lay curled up beside a small game path, waiting for a small mammal to make an unwise appearance nearby. As I lifted its head with my snake stick, it started to twitch violently in sequence all along its muscular body, before – without a second's warning – striking at me. From its coiled position, the snake struck nearly its entire body length in the blink of an eye, using its unusual body weight and size as an anchor to hurl its arrow-shaped head forward like a missile. Indeed, if I hadn't leapt backwards, I would certainly have been bitten.

The snake then proceeded to chase me for a full ten metres or so, violently striking in a manner that I have always assured people snakes definitely do not do! Fortunately, my companion Julio was quicker with his snake stick and managed to get the monster under control.

However, Julio had acquired his Fer-de-lance knowledge the hard way. In his twenties, he was bitten whilst out walking in the forest and barely managed to get to civilization before falling into a three-day coma. He actually believes that he died, and only came back to the light after having an unfulfilling conversation with God (who, it turns out, is a woman, according to Julio!).

The name Fer-de-lance (meaning 'iron of the spear') refers to the arrow shape of the head and is of French-Creole origin. As with all the pitvipers, the species possesses a pair of heat-sensing pits between nostril and eye, which it uses to detect the warmth given off by muscle movement in its prey.

BELOW *Waxy-looking flesh, blackening (particularly through the lymph system), and blistering are all symptomatic of lancehead bites.*

RIGHT *This photograph is very graphic evidence that snakes can eat things much bigger than their own heads! Here a Fer-de-lance is eating an Agouti, a large rodent rather like an oversized Guinea Pig.*

OVERLEAF *This spectacular image shows not only the venom-injecting fangs in the maxilla (upper jaw), but also the needle-like teeth of the mandible (lower jaw).*

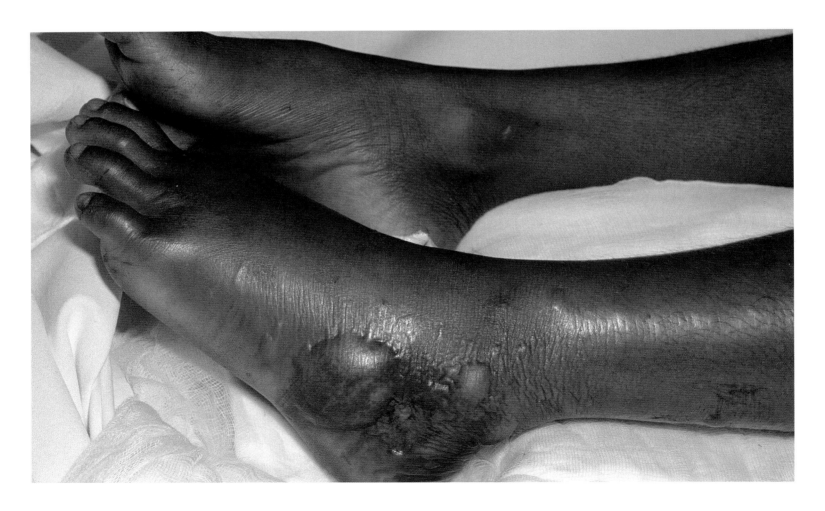

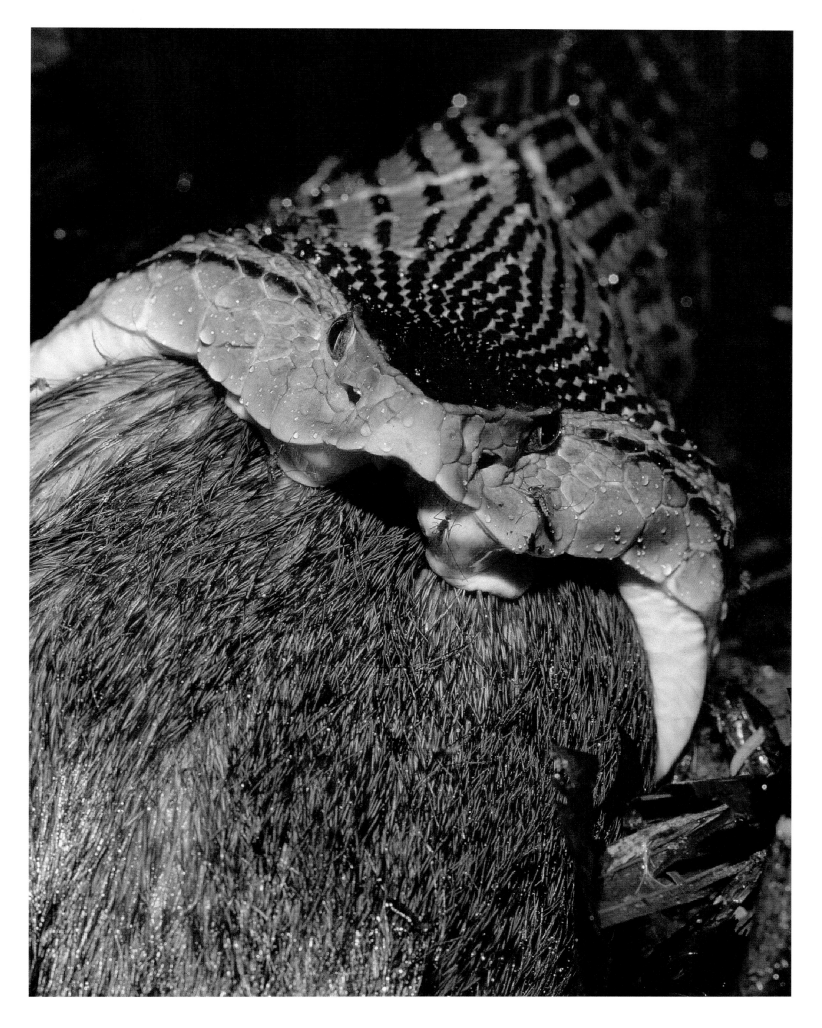

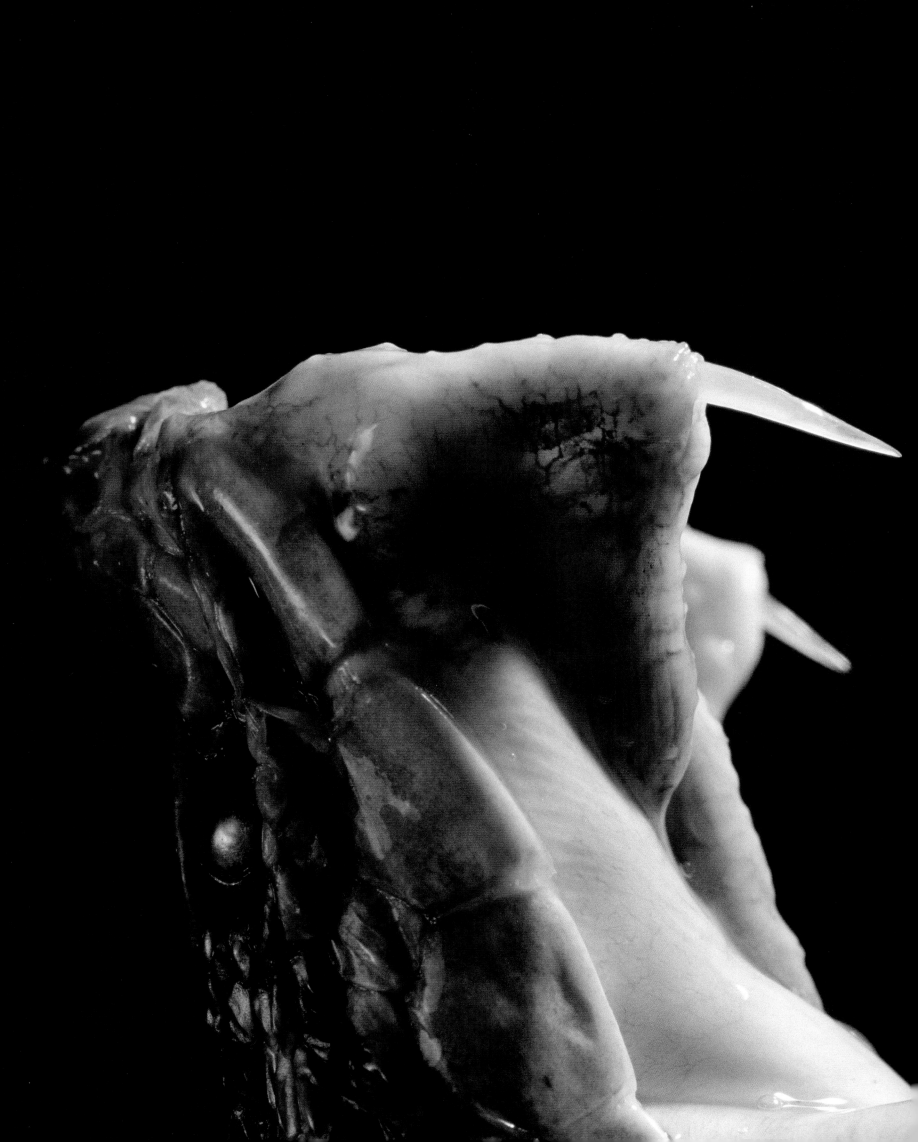

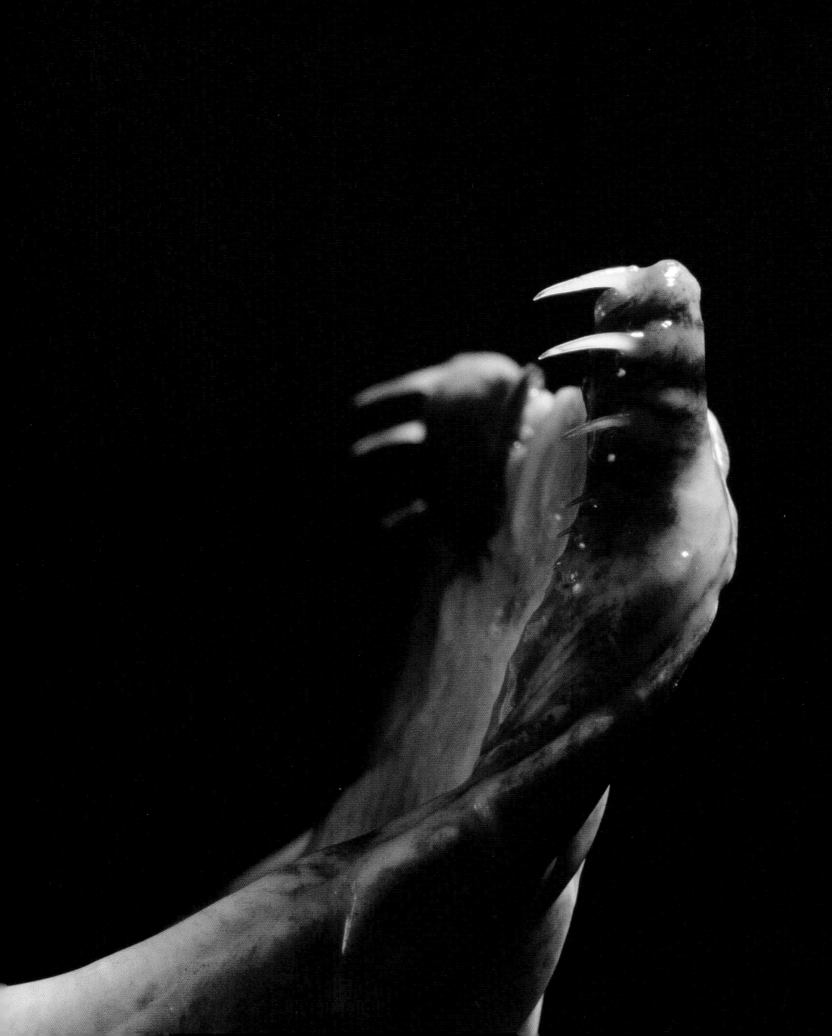

ASSASSIN BUGS (*Reduviidae* spp.)

WHERE FOUND: THROUGHOUT THE TEMPERATE AND TROPICAL WORLDS.

With a name like the assassin bug, this creature hardly sounds like an inoffensive vegetarian insect. Assassin bugs are serious predators, with most species feeding on other invertebrates such as flies and caterpillars, or even other assassin bugs. However, others are parasites that suck the blood of mammals, including humans. Like other hemipterans or true bugs, the assassin bug sucks its food up through a curved beak called a rostrum. It will plunge this rostrum into its prey, then inject a toxin which paralyses the victim's nerves. The insertion of the rostrum is supposedly the most painful 'bite' of any invertebrate – a friend of mine who was bitten likened it to having a white hot knitting needle pushed into his hand.

Once its prey is immobile, the bug can start to feed by sucking up the prey's insides through its rostrum. Whilst many other invertebrates that feed through external digestion in this way have two tubes, one for introducing the toxin and another for sucking up the food, the assassin bug has just one, much larger tube. This allows it to inject a larger amount of toxin and therefore tackle bigger prey. Assassin bug toxins are incredibly powerful and get to work instantaneously. Famously tough cockroaches may die within three or four seconds of being bitten, and caterpillars 400 times the size of the bug may last only ten seconds. A meal of this size could last an assassin bug for several weeks, however.

There are nearly 3,000 species of Reduviid bugs found all over the world, the largest of which can be 4cm long. The reason they are included here in this section is that some local species, such as *Panstrongylus megistus* and *Triatoma infestans,* are vectors for the dreaded Chagas disease, which kills about 50,000 people a year in Latin America. The parasites that carry the virus are present in the bugs' faeces, and infection of humans occurs when they are introduced into open wounds or accidentally rubbed into the eyes. The results can include facial swelling, anaemia, loss of nerve control and complete muscle shutdown. Children have been known to die in just a few weeks.

In parts of South America certain species of Reduviid are known as 'kissing bugs', due to their habit of extracting blood from the lips of sleeping people. Apart from Chagas disease, these bites can also cause life-threatening allergic reactions. However, assassin bugs also need to protect themselves. When caught, some will scratch their rostrum along a special groove in the underside of the thorax, which makes a weird noise not unlike that of a cat's high-pitched miaowing! Other species can actually squirt their venom as far as 30cm, and with amazing accuracy. They have been recorded as firing directly into human eyes, which can cause temporary blindness.

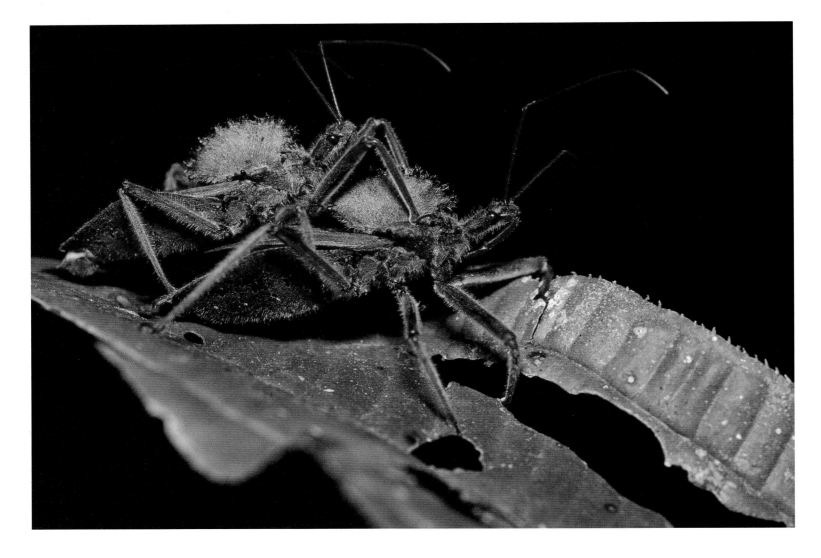

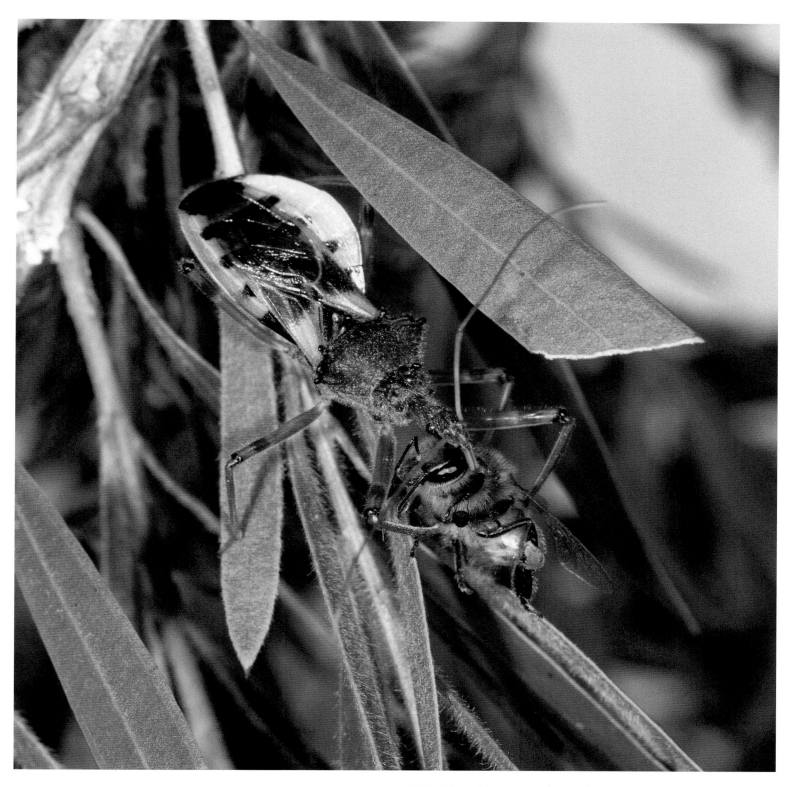

ABOVE Prithesancus papuensis *is an Australasian species. This individual has managed to catch a bee, a seemingly unusual victim but in fact assassin bugs prey on a wide variety of invertebrates and are great opportunists.*

OPPOSITE *Two assassin bugs mating. The female will lay her eggs in cracks and crevices in bark and plant matter.*

RIGHT Panstrongylus megistus *is also known as the 'kissing bug', because it often takes a blood meal from around the lips of its human victims. It is one of the vector species of the fatal Chagas disease.*

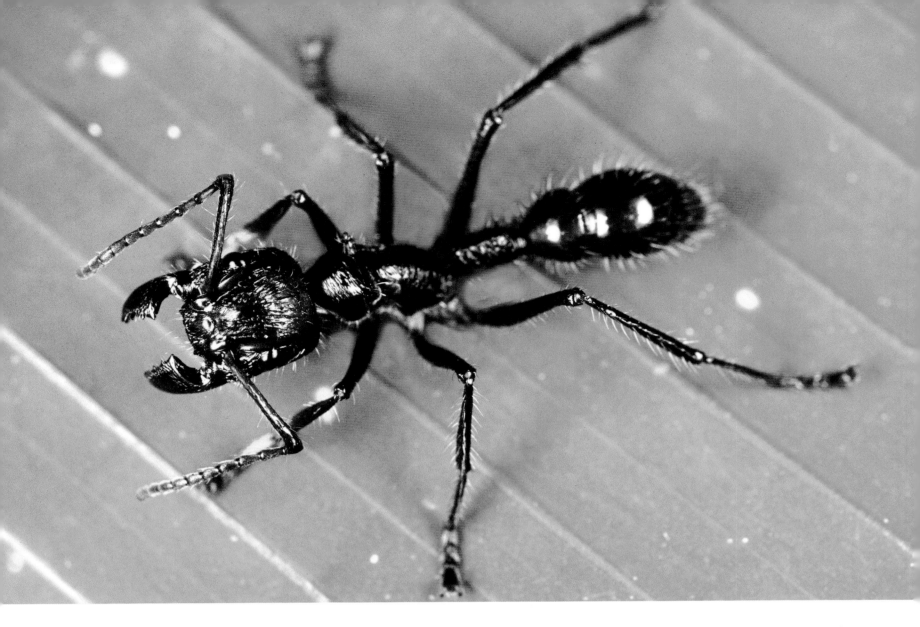

BULLET ANT (*Paraponera clavata*)

WHERE FOUND: ATLANTIC COASTAL LOWLAND RAINFORESTS FROM NICARAGUA SOUTHWARD TO, AND THROUGHOUT, THE AMAZON RIVER BASIN.

When you're strung out in a hammock in the sweaty jungles of this part of the world, you're not too concerned about snakes and scorpions; it's actually the ants that have you spraying your guy lines with bug spray (or Vaseline, which also keeps them from traipsing down the lines into your hammock) and emptying out your boots every morning. The large *P. clavata* soldiers are the biggest ants I've ever seen – about the size of an AAA battery, with enormous jaws. And there's a very simple reason that these sizeable insects are called Bullet Ants. First of all, they're ants. Secondly, to be stung by one certainly feels like being shot. It's said to be the most debilitating and painful of any insect attack.

In actual fact, they not only sting, but bite too, just to create a bit more damage and pain to the victim. After being stung by just two ants, my aforementioned naturalist friend Julio passed out cold, and he's a really tough guy! That being said, a certain South American tribe actually practise an initiation ritual in which young boys have to put on a glove stitched together with palm fronds, with bullet ants sewn inside. The repeated stings put the boys into a coma, and when – or if – they are revived, they are considered to be true men.

Although Bullet Ants are social ants, it's in a fairly primitive sense and they don't appear to have the tight bonds of other eusocial ants. Lone, huge monster ants are regularly seen out wandering far from their nests, hunting for themselves. Queens are only slightly larger than workers and not greatly modified for egg production, while mature colonies (producing reproductive forms, winged males and new queens) contain only a few thousand ants, which is rather small in ant terms. Labour is divided on a size basis, with smaller ants staying in the nest as nursemaids, and larger workers guarding the nest and going out foraging for food.

ABOVE *The ferocious jaws of the Bullet Ant can give a brutal nip, but it's the rear end and the virulent sting that really pack a punch. It can take up to 24 hours for the pain from such a bite to subside.*

OPPOSITE TOP *The Blue Tang possesses two extremely sharp spines at the base of the tail (between the end of the anal fin and the base of the caudal fin), which in some species is connected to a venom gland. This is a juvenile specimen, yet to attain its darker adult coloration.*

OPPOSITE BELOW *Although Blue Tang generally stick to groups of only six to ten or so, they will aggregate in larger shoals to graze on zooplankton and algae over the corals.*

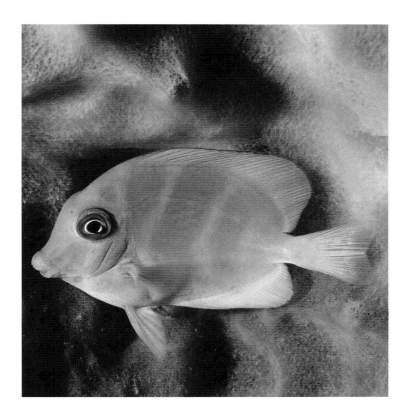

TANG OR SURGEONFISH (*Acanthuridae spp.*)

WHERE FOUND: TROPICAL SEAS AROUND THE WORLD AND ESPECIALLY OFF THE COASTS OF LATIN AMERICA.

There are so many fish in the sea with venoms and poisons in their repertoire that it's difficult to choose which species to include here. One of the most familiar is perhaps the Blue Tang (*Acanthurus coeruleus*), represented in popular culture so charmingly by the fish 'Dory' in the Disney film *Finding Nemo*!

Tang or surgeonfish are tropical marine fish with the characteristic thin, deep body of reef fish, which makes them manoeuvrable and fast in short sharp bursts, enough to speed out of the reach of a barracuda and into the safety of a nearby coral head. They tend to stick in small shoals of around ten individuals, and mostly spend their days grazing on algae. The name 'surgeonfish' comes from the two scalpel-sharp spines either side of the tail base. They may be fixed or mobile, and can inflict a very impressive wound on anyone unwise enough to grab hold of them. In some species the scalpel is connected to a venom gland, which can inject enough venom to at least make the wound unpleasantly itchy and cause swelling.

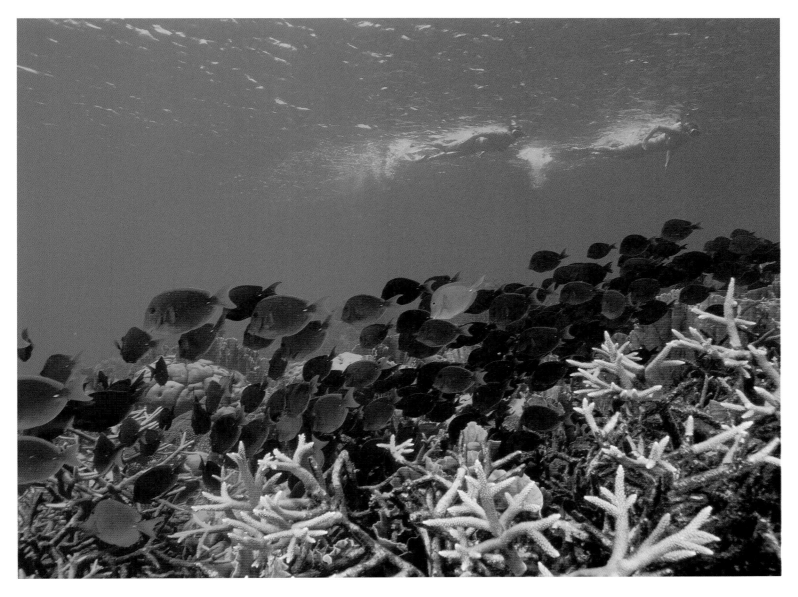

SPONGES (VARIOUS FAMILIES)

WHERE FOUND: GLOBAL SEAS, BUT ESPECIALLY THE CARIBBEAN.

It may seem odd to include the humble sponge in an index of toxic animals, but these seemingly lazy creatures have some very interesting chemicals at work in their tissues and the Caribbean can lay claim to some of the most virulent species. The Fire Sponge (*Tedania ignis*), stinging sponges (*Neofibularia* spp.) and Green Sponge (*Haliclona viridis*) all secrete substances that irritate the skin of anything touching them. Some species of sponge even emit sharp silica spicules from their skeletons; these may remain in the skin for weeks, causing inflammation.

Although most sponges on tropical coral reefs are poisonous to eat, their toxicity is not permanent. In evolutionary terms it would cost the sponge too much energy to be continually synthesizing toxins in its tissues. Instead, many sponges generate these toxins in response to a threat or attack. So, if a turtle nibbles part of a sponge, within seconds the sponge creates poison in the tissues that are being eaten, giving the turtle a mouthful of foul-tasting fodder. It is like a human feeling a mosquito biting their ankle, and instantly turning the blood in their foot into poisons that would kill the mosquito.

Sponge toxins are extremely complex and have been proposed as possible cures for a variety of human ailments. Firstly, some of them have anti-tumour properties and are being developed as possible cancer cures. Whereas most are so powerful that they just kill everything they come into contact with, others are more specific and may well be able to isolate cancer cells whilst leaving others healthy. Other sponge cells have the capacity to eternally regenerate and metamorphose, and are being touted as possible stem cells that could be introduced to humans to end or stall the ageing process.

BELOW *Although sponges may look rather like idle plants, they actually belong to the animal kingdom, and their defence mechanisms may be quite active.*

OPPOSITE *Sponges come in a spectacular range of colours and forms. The dramatic Fire Sponge is one of the more striking species, and widely distributed throughout the Caribbean.*

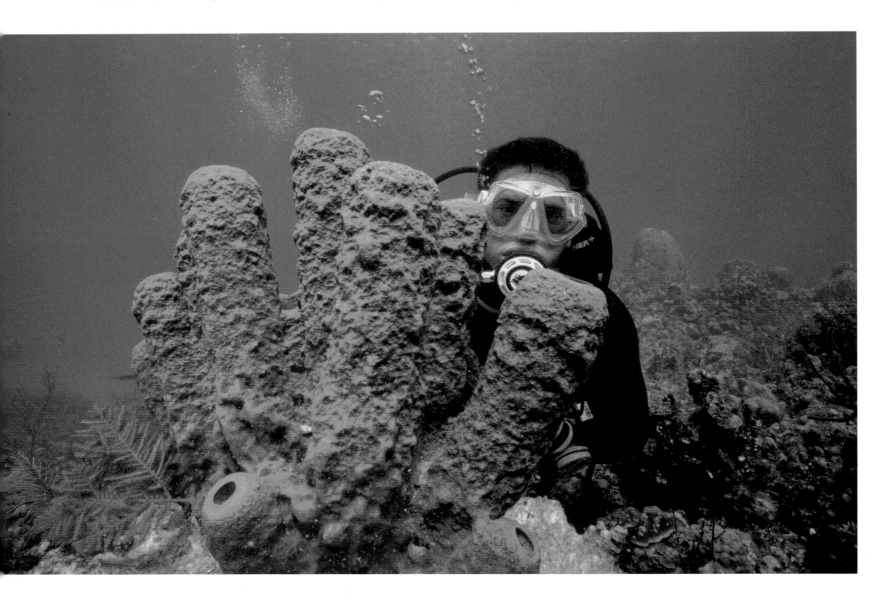

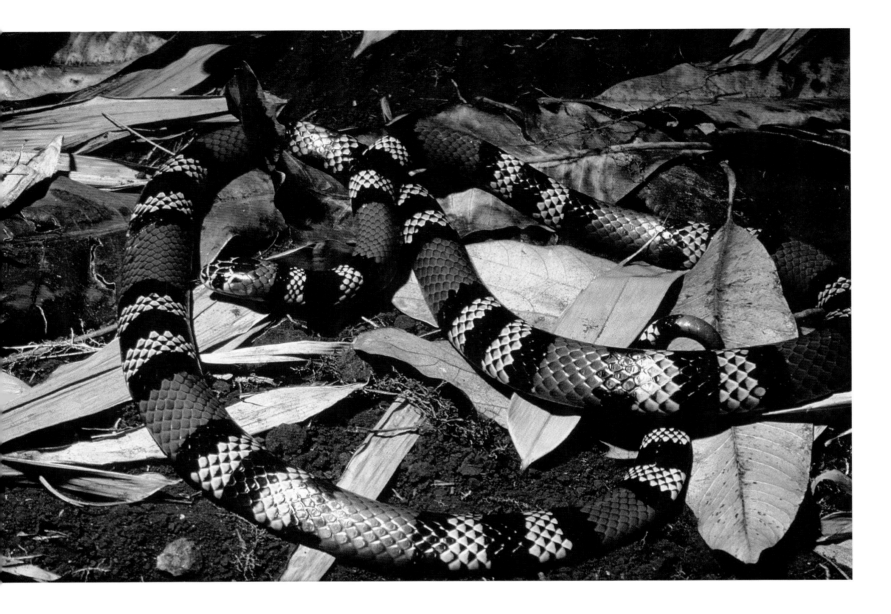

CORAL SNAKES (*Leptomicrurus* spp., *Micrurus* spp. and *Micruroides* spp.)

WHERE FOUND: North, Central and South America; also parts of Asia.

You don't need to be a zoologist to recognize that these are snakes that shouldn't be messed with! After all, bright reds and yellows don't occur often in nature, and when they do, they mean one thing; leave me alone, I'm dangerous!. This is called aposematic coloration, and it's no surprise that so many animals in this book sport these lurid warning hues.

The coral snakes are elapids – in the same family as the cobras and mambas – and are armed with equally deadly neurotoxic venom. However, thanks to their virulent colours, they very rarely have to use their venom in defence, as larger creatures just leave them alone. This development is so effective that other species of totally harmless snakes have developed near-identical colours, and in so doing have improved their own chances of survival. Over millions of years, this has led to what is known as mimicry – one species resembling another in order to usurp the benefits that the physiology of the copied species confers. This has led to some extraordinary physical forms, such as beetles and spiders dressed up to look like biting ants, moths with striped bodies and clear wings so they resemble wasps, and milk and king snakes that have assumed football scarf-style colours to look like coral snakes!

Of course, these creatures have hardly made a conscious decision to mimic another species; this is not how evolution works! What happened is that mutations in particular individuals, which rendered them minutely more similar in appearance to venomous species, also made them more likely to survive and thereby pass on their genes to their offspring. Over thousands of years these traits became 'protected' and so developed into the permanent states of mimicry that we find today. This idea was first proposed in 1862 by British naturalist Henry Bates, and thus is known today as Batesian mimicry.

Telling the difference between the genuine and the false is always a challenge. Various popular rhymes claim to help, such as 'Red on black venom lack, red on yellow kill a fellow'. However, there are coral snakes with red stripes touching black (and with no yellow stripes at all), and even with close-up looks at the head 100 per cent identi-fication can be hard. If you're not sure of an ID, the answer is clear – if the snake is saying to you that it's dangerous, then take its word for it!

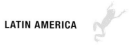

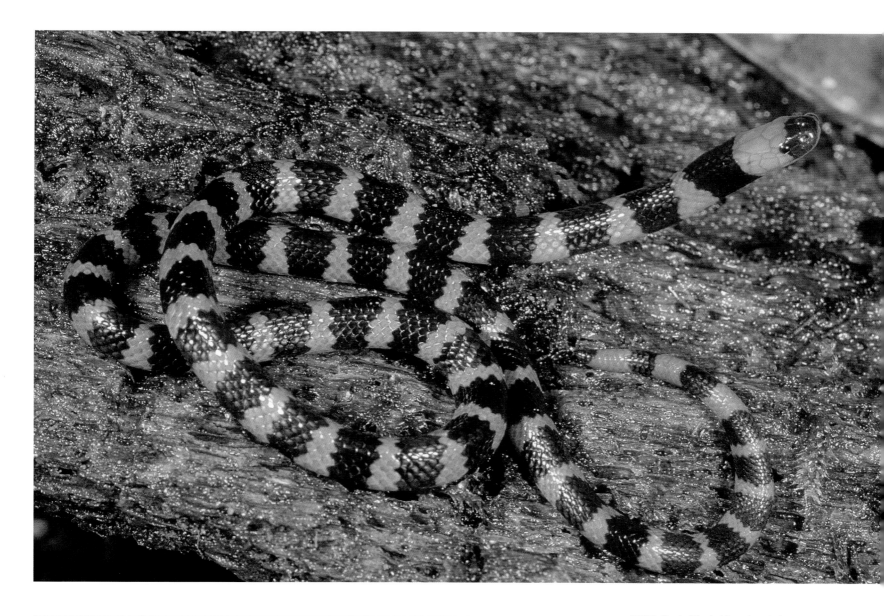

ABOVE *Costa Rica's Many-banded Coral Snake (*Micrurus multifasciatus hertwigi) *would have to be one of the most obvious breakers of the old coral snake law, 'red on black, friend of Jack...'*

LEFT *A False Coral Snake (*Erythrolamprus aesculapii) *from French Guiana. The fact that it has a distinct neck separating the body from the head and that its head isn't black should be good indicators that it's a fraud, but one can never be sure...*

OPPOSITE *The Southern Coral Snake (*Micrurus frontalis brasiliensis) *is perhaps one of the most typical of the 65 recognized species of coral snake. It preys on other snakes and possesses very virulent venom.*

CHAPTER FIVE
AFRICA

The first explorers who travelled to the so-called Dark Continent came back with stories of huge snakes with dreadful toxic venoms and giant spiders that could kill in the blink of an eye. Most such tales were largely nonsense of course, but some did have their basis in fact. Rumours of a terrible sleeping sickness were indeed true. Even today, as many as 40,000 people die annually from trypanosomiasis or sleeping sickness, which is spread by the Tsetse Fly (*Glossina fuscipes*). The mosquito (*Anopheles* spp.) is still by far the most dangerous animal in Africa, spreading deadly malaria, dengue fever, yellow fever, encephalitis and filariasis. Around a million people a year die from malaria alone, which makes the threat posed by all the wildlife in this book put together pale into insignificance.

KILLER BEE (*Apis mellifera scutellata*)

WHERE FOUND: Much of Africa and now the New World also.

Over the last decade or so, the Americas have periodically been gripped in panic, as swarms of 'killer bees' have spread their way north out of Brazil, terrorizing an unsuspecting populace. Specifically designed for its high honey yield, the Killer Bee is actually a hybrid of one African subspecies of honeybee and several European subspecies. Unfortunately, it is not just better at making honey but is also rather more aggressive than its New World counterparts.

The Hymenoptera (bees, wasps and ants) probably all evolved from wasps, but many species – including all of the bees – passed up their wasp ancestor's predatory instincts and instead became peaceful pollen collectors. Even so, most bees still have a specialized ovipositor which has developed into a stinger, and which they will use in defence. Indeed, some of the social species have sufficiently venomous stings – and can sting in large enough numbers – to be considered a threat to people. Their sting rips clean out of the abdomen, and then gets stuck deep into the dermis of the victim, continuing to inject venom. As the honeybee stings, it also releases

alarm pheromones (isopentyl acetate) which, oddly enough, smell like ripe bananas. Other bees react instantly to the signal and come to the aid of the attacking bee. The way the sting detaches appears to be designed specifically to work against vertebrates, and it actually remains intact when the bee is attacking other insects.

The stings of ants, wasps and bees cause exceptional amounts of pain considering that the damage done is actually pretty negligible. This enables the Hymenoptera to repel even large mammalian predators. The venom activates pain receptors, convincing the attacker that considerable tissue damage is being done; this ability has almost certainly developed exactly for the purpose of repelling vertebrates, evidenced by the fact that worker bees have allergens in their venoms that the queens do not have. The majority of fatalities from Hymenoptera stings occur due to anaphylaxis, and can be caused by just a single sting. Death can occur in as little as an hour after a sting to the neck or head.

OPPOSITE *A swarm of 'killer bees' on the move, in this case in the Kalahari Desert, Namibia.*

BELOW *Bee stings are extremely dangerous to humans due to large quantities of allergens in their venom. This individual is* Apis mellifera adansonii, *one of the African varieties of 'killer bee'.*

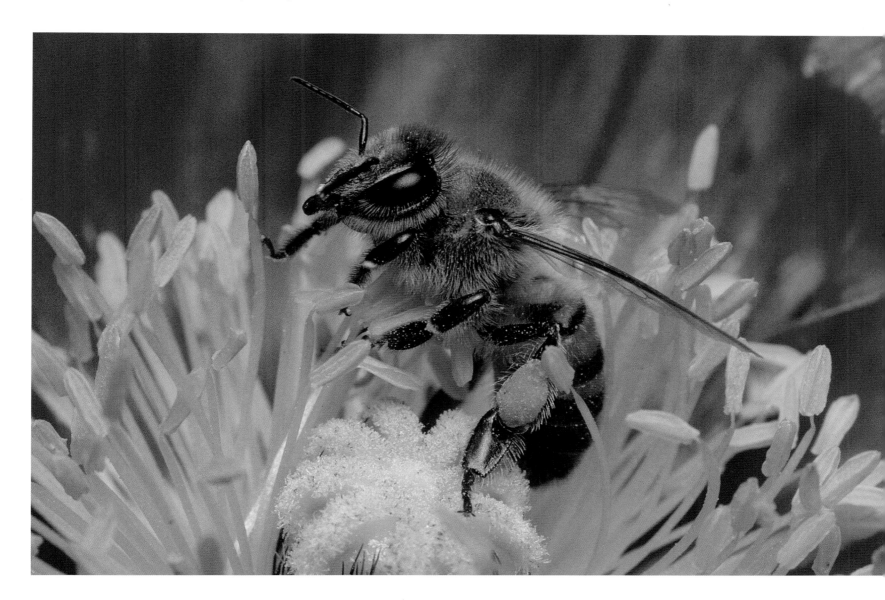

STONEFISH (*Synanceiidae* SPP.)

WHERE FOUND: Tropical and warmer temperate waters from the Central Pacific through the Indo-Pacific to the East African coast, where it is particularly common.

The first trick in dealing with stonefish is to actually find them. With their warty protruberances, coloration that exactly mimics the substrates they live upon, irregular outline, and the ability to accumulate slime and other muck on their skin, they are among the most cryptic creatures in the sea. This is obviously not for the purpose of conning unwary waders into treading on them, for they spend their days mostly immobile on rocks or corals, waiting until prey-sized fish swim too close, and then grabbing them in their powerful jaws. They can move alarmingly quickly, with sudden, extreme bursts of speed.

However, it's not the stonefish's jaws that pose a danger to humans, but their 13 dorsal spines, all of which have two associated venom glands at their base. Generally speaking, these spines lie flat against the fish's dorsal surface, but contact with the fish causes the spines to erect; they can then easily pierce skin, and even wetsuits.

Stonefish belong to the scorpionfish family, which also includes the true scorpionfish, and the zebrafish. The venom itself is very complex, containing neurotoxins and myotoxins, as well as antigenic proteins (which cause a massive release of antibodies). There have been four confirmed human fatalities from stonefish envenomation in Africa, some of whom died within an hour of the sting. Most encounters are caused by divers handling or accidentally touching these incredibly well-camouflaged creatures. The sting is reputedly an excruciating experience and it seems that this pain may be the direct cause of death through stress or heart attack, rather than the venom itself. Hot water treatment is recommended, and there is also an antivenin, although at present this is only available in Australia.

OPPOSITE *This stonefish has made an unwise choice of location to hunt from, in the sense that it is standing out against its background! Generally speaking, they are exceptional at choosing a hunting ground that is best matched to their own camouflage.*

BELOW *This lifeless-looking mask of a stonefish gazing out from under a sandy covering shows quite how expert the fish can be at adding to its own camouflage by twitching its 'skirts' and burying itself.*

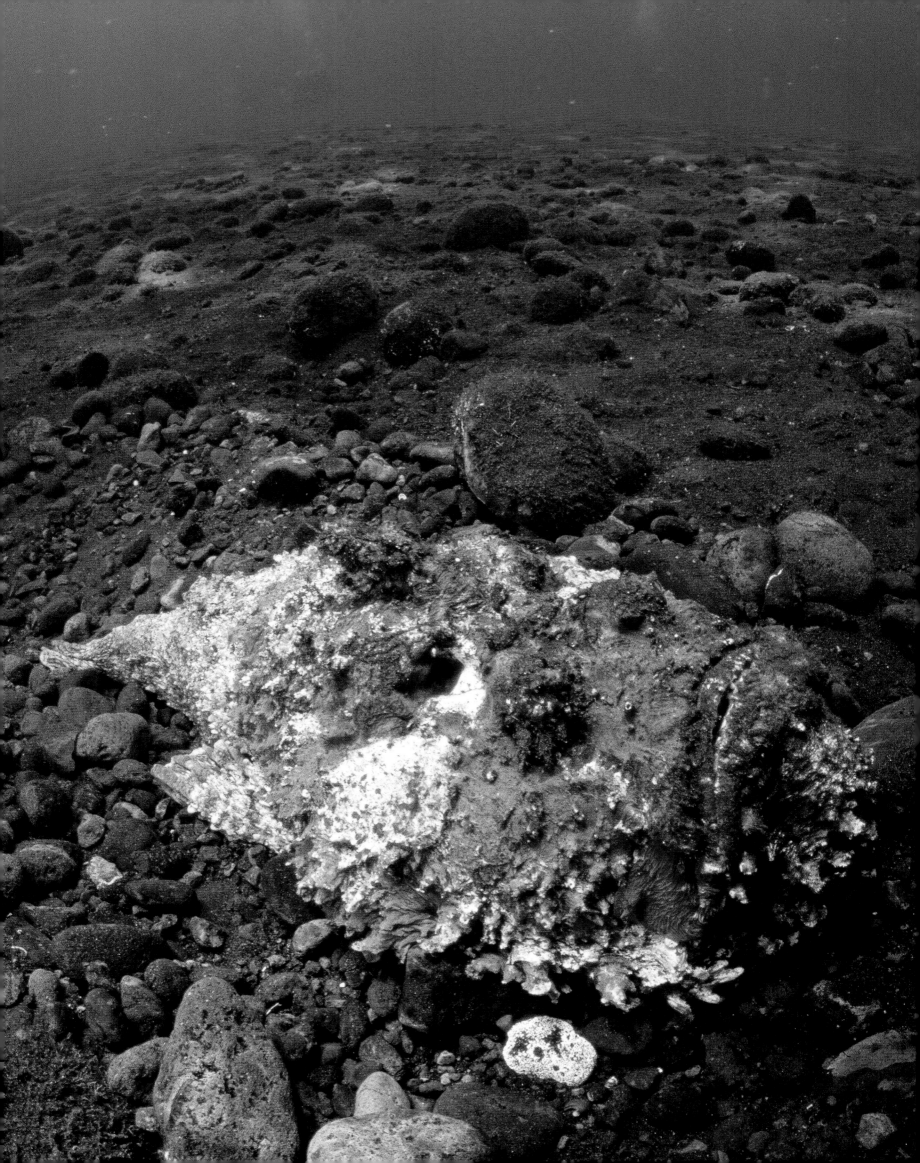

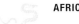

AFRICAN BOMBARDIER BEETLE

(*Stenaptinus insignis*)

WHERE FOUND: Sub-Saharan Africa.

Rarely has a beetle been more aptly named – the African Bombardier Beetle can aim its heavy artillery at its targets with pinpoint accuracy, unleashing one of the most explosive chemical weapons known to nature. When under attack, the beetle releases a spray containing p-benzoquinones, compounds which are well known for their irritant properties. It creates a boiling hot, toxic fluid that lets off a loud bang on detonation.

The initial chemicals (hydroquinones and hydrogen peroxide) have to be kept in separate parts of the abdomen, because if they were kept next to each other they'd blow the beetle apart! When the chemicals are brought together, they explode outwards at high speeds and temperatures exceeding 100 degrees Centigrade, in tiny pulses at a rate of 500 pulses a second. The beetle can let rip with 20 power blasts before its supplies are exhausted.

Females have a pair of shield-like deflectors at the opening of the 'gun barrel', which they use to control the direction of the spray. Male beetles have just one deflector. *Stenaptinus insignis* has developed its incredible armory as, due to its bulk, it takes some time for it to get airborne in response to a threat – a time during which it is extremely vulnerable, especially if it is under ant attack.

This incredible mechanism has attracted more than its fair share of human attention. 21st-century creationists, for example, have used it as 'proof' that evolution could never have developed something so advanced and perfect, whilst more rational researchers are investigating whether similar artificial mechanisms could be used to ignite aeroplane engines in mid-air.

BELOW *Bombardier beetles are impressive-looking creatures, and capable of firing their chemical artillery with sound effects to match.*

OPPOSITE *Those beautiful spines may look like the flowing sleeves of a underwater flamenco dancer, but the lionfish has a trick up those sleeves – each one bears a spine linked to a venom gland and is capable of inflicting severe pain.*

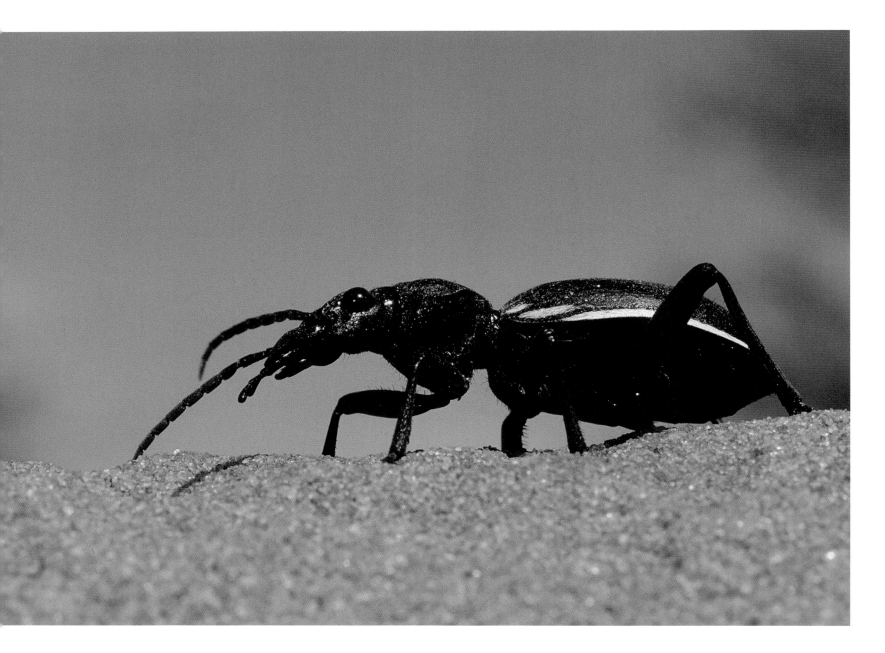

LIONFISH, ZEBRAFISH, SCORPIONFISH, BUTTERFLY COD (*PTEROIS* SPP.)

WHERE FOUND: TROPICAL AND WARMER TEMPERATE WATERS FROM THE CENTRAL PACIFIC THROUGH THE INDO-PACIFIC TO THE EAST AFRICAN COAST.

This is one case where it makes sense to use the Latin name if you want a precise identification, as this group of several species has more common names than most others. It's not surprising that they should attract so much attention, as they are among the most extravagant of all fish, with gaudy zebra-striped patterns, flouncy spines carried like a dandy's flowing shirt cuffs, and a marked indifference to any threats posed by divers or predators. Indeed, if they feel threatened they will readily swim towards an attacker, with their spines proudly erect. These fish certainly deserve to be treated with respect. Worldwide, they rank second only to stingrays in total number of serious marine stings, with an estimated 40–50,000 cases recorded annually.

Venom glands at the base of the dorsal, anal and pelvic fin spines produce a number of toxins that are injected into a potential predator, and cause a severe reaction in humans. Basic treatment includes immersing the afflicted area in hot water, as the venom may be inactivated by heat. Although the spines are not used directly to attack the lionfish's normal prey of small fishes, shrimps and crabs, they do serve a purpose when the fish is hunting: prey are stalked and cornered, or made to feel cornered, by the outstretched and expanded spines, and are then grabbed in a single, extremely rapid strike.

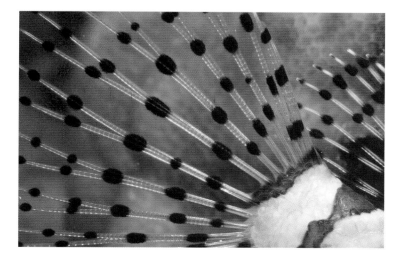

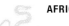

SCORPIONS (*Androctonus* spp. *and Parabuthus* spp.)

WHERE FOUND: Throughout the African continent.

The majority of scorpions in Africa are relatively benign – not overly aggressive, and with slight stings – but there are several species you really wouldn't want to tangle with. One of those is *Androctonus australis*, the Fat-tail Scorpion, found from Algeria and Tunisia to Libya and Egypt. It has venom as potent as that of the Black Mamba, and so should be treated with extreme respect. Although essentially a desert species, found in arid mountainous areas and on the steep slopes of sand dunes, it seems to have adapted well to living in human habitations, making its home in cracks in house walls. It's a good-sized scorpion with really thick tail segments, and a fairly bright yellow coloration.

The other scorpions I want to mention here are of the *Parabuthus* genus and are closely related. They come from southern Africa, and are also commonly known as fat-tailed scorpions (which is just one example of why common names can be such a waste of time!). *Parabuthus* scorpions are much darker, almost jet black, and bigger than *Androctonus* spp. by about half as much again, but they are otherwise quite similar in appearance. Although their venom is not as toxic, drop for drop, as that of *Androctonus*, *Parabuthus* stings have resulted in deaths. What is remarkable about them, however, is their amazing ability to 'spit' venom. Of course, they don't actually spit it at all; instead, the venom beads up on the end of the tail and the scorpion then flicks it towards the eyes of an aggressor. Some sources say that it can be flicked as far as one metre, and for this reason *Parabuthus* is sometimes known as the fat-tailed spitting scorpion.

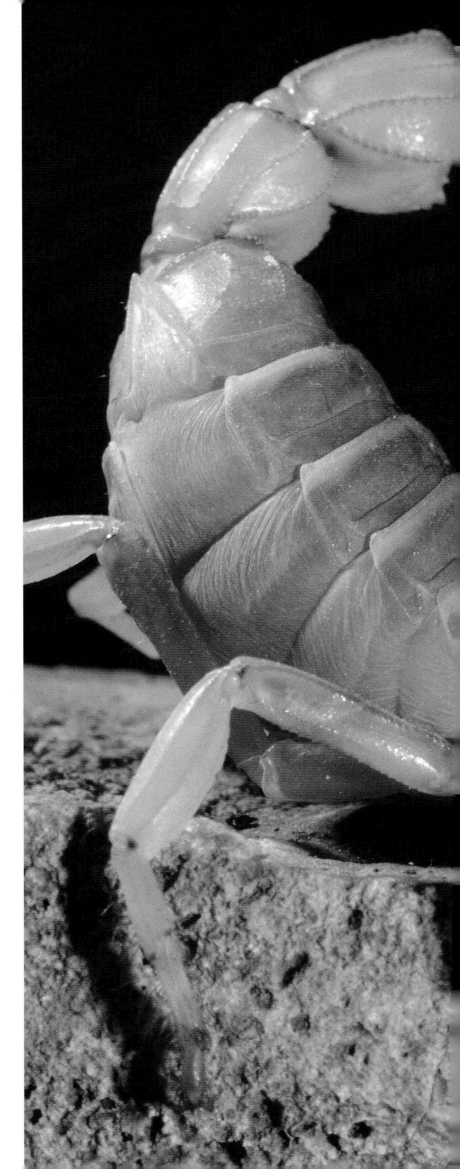

RIGHT Androctonus australis *has some fearsome weaponry and one of the most venomous stings of all scorpions.*

BLACK MAMBA (*DENDROASPIS POLYLEPIS*)

WHERE FOUND: EASTERN AND SOUTHERN AFRICA.

The Black Mamba is the largest of Africa's venomous snakes and known as being the fastest snake in the world. It certainly has a very bad reputation, and is claimed to strike repeatedly, injecting copious amounts of fast-acting venom. That said, this species is very rarely implicated in human fatality, and there is an antidote readily available in the more developed African countries.

The Black Mamba has an average length of 2.5 metres and a maximum of around 4.5 metres, making it the second longest venomous snake in the world. They are generally found in bush country with rocky outcrops. They are particularly fond of living in or near termite mounds, in which they will often make a lair. One of the first things that strikes you (!) about the Black Mamba is that it is not actually black, but generally a sort of dull grey or even olive-green colour. The 'black' of the name comes from the inside of the mouth, which is jet-black and a key part of the animal's threat display.

Although a Black Mamba can raise two-thirds of its body off the ground when striking, tales of mambas chasing victims for hundreds of metres or running down people whilst on horseback are utter nonsense. A Black Mamba may be able to keep up speeds of 10mph for a few metres, but I've run alongside a fleeing mamba quite keen to get away from me, and really only had to break into a gentle jog to keep up. It was also far more interested in getting up a tree to escape than beating me with pure pace.

With its bright green coloration, the related Green Mamba (*Dendroaspis angusticeps*) is actually a more dramatic snake. Not as long as the Black, it is more disposed to living in trees, and is often confused with the non-related Boomslang (*Dispholidus typus*). Although Green Mamba venom is more than strong enough to kill a human, an antidote does exist.

OPPOSITE *Probably as venomous as the Black Mamba but less aggressive, the Green Mamba is a highly arboreal species and rarely seen on the ground.*

BELOW *As I'm running alongside this Black Mamba trying to capture it on camera, you can see it spreading a rudimentary hood like its cobra cousins.*

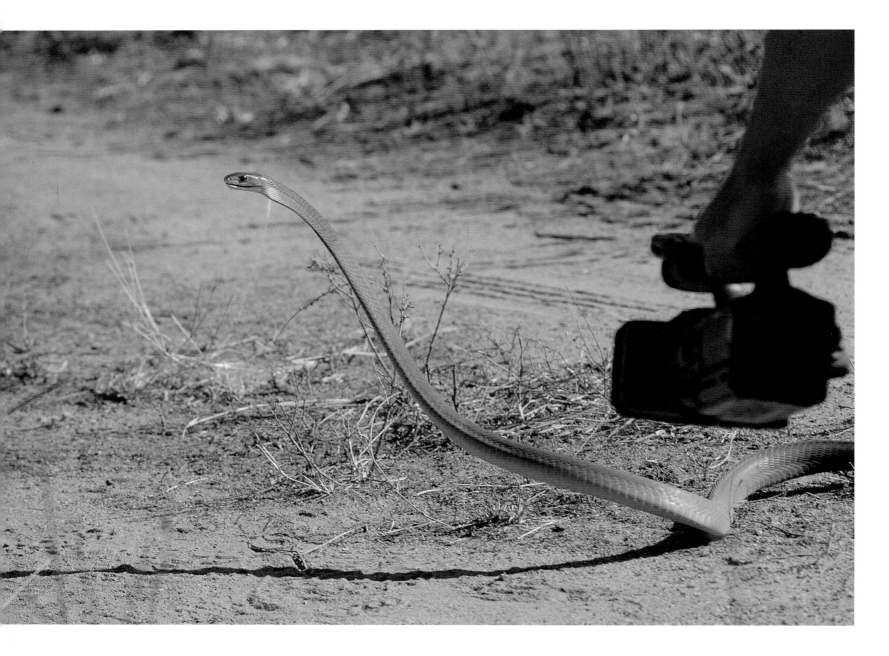

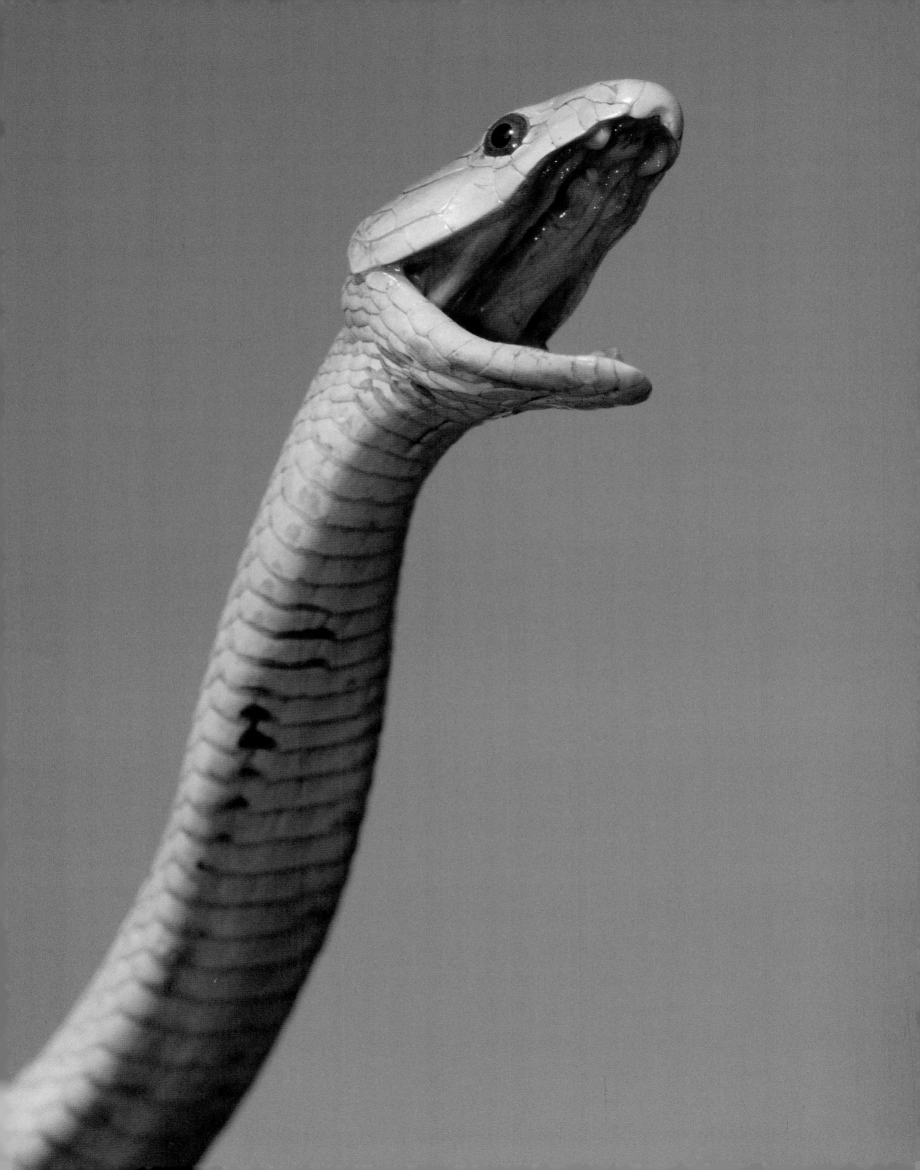

AFRICAN COBRAS (*NAJA* SPP.)

WHERE FOUND: MOST OF AFRICA, EXCEPT THE VERY NORTHWEST.

The cobras are related to the mambas, and both groups are elapids, i.e. front-fanged snakes. Cobras are very well represented in Africa, with a wide distribution, and they can be quite common. The Cape Cobra (*Naja nivea*) and Egyptian Cobra (*N. haje annulifera*) are both handsome and stately species with varied coloration, feeding primarily on lizards, toads and other snakes. Unlike the mambas, which tend to keep a low profile, cobras are not generally shy of people and quite often will enter a house to escape the heat of the midday sun.

The M'fesi or Mozambique Spitting Cobra (*N. mossambica*) is perhaps my favourite serpent 'performer', since one of them provided me with what was probably my most satisfying filming experience with any reptile. I guess the clue is in the name, but whilst all the other spitting cobras I'd encountered had done little more than dribble a bit and emit a few half-hearted gobbets of toxic fluid, the M'fesi practically drenched me in venom! The poison canal openings in this species are at the tips of the fangs, and the venom is liberally sprayed rather than spat, to a distance of up to two metres.

Their aim is also superb. On this particular occasion a few droplets went into my mouth and covered my face, but the vast majority sprayed over the safety goggles that were covering my eyes. The venom itself is also modified for this purpose – all the other cobras here have predominantly neurotoxins in their venom, but the M'fesi has cell-destroying cytotoxins, which allow the fluid to actually attack the fragile covering cells of the eyes on contact. If the eyes are not flushed with milk or clean water immediately, then blindness is virtually inevitable. Extreme pain goes without saying.

The Rinkhals (*Hemachatus haemachatus*) is another type of spitting cobra, probably best known for its ability to play dead when threatened, only to rear up and attack if it is harassed further.

OPPOSITE *An Egyptian Cobra standing to attention in classic threat pose. At this point it will also be hissing in rage and doing everything possible to convince its tormentor to leave it alone.*

BELOW LEFT *The attractively patterned Rinkhals is one of the spitting cobras and a widespread species in South Africa.*

BELOW *The slightly blurry shape in the bottom of this frame is a M'fesi or Mozambique Spitting Cobra. Shortly after this photo was taken, it let rip with a jet of venom, which drenched the goggles protecting my eyes.*

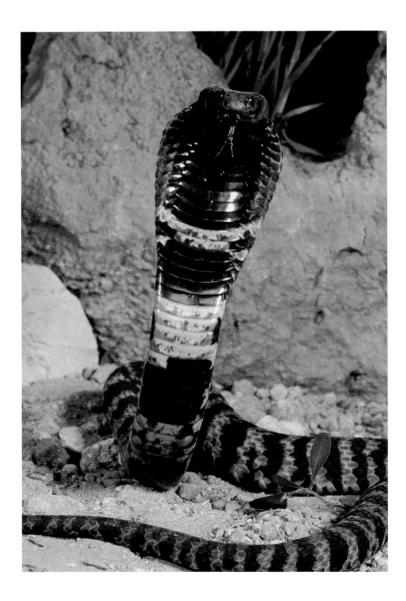

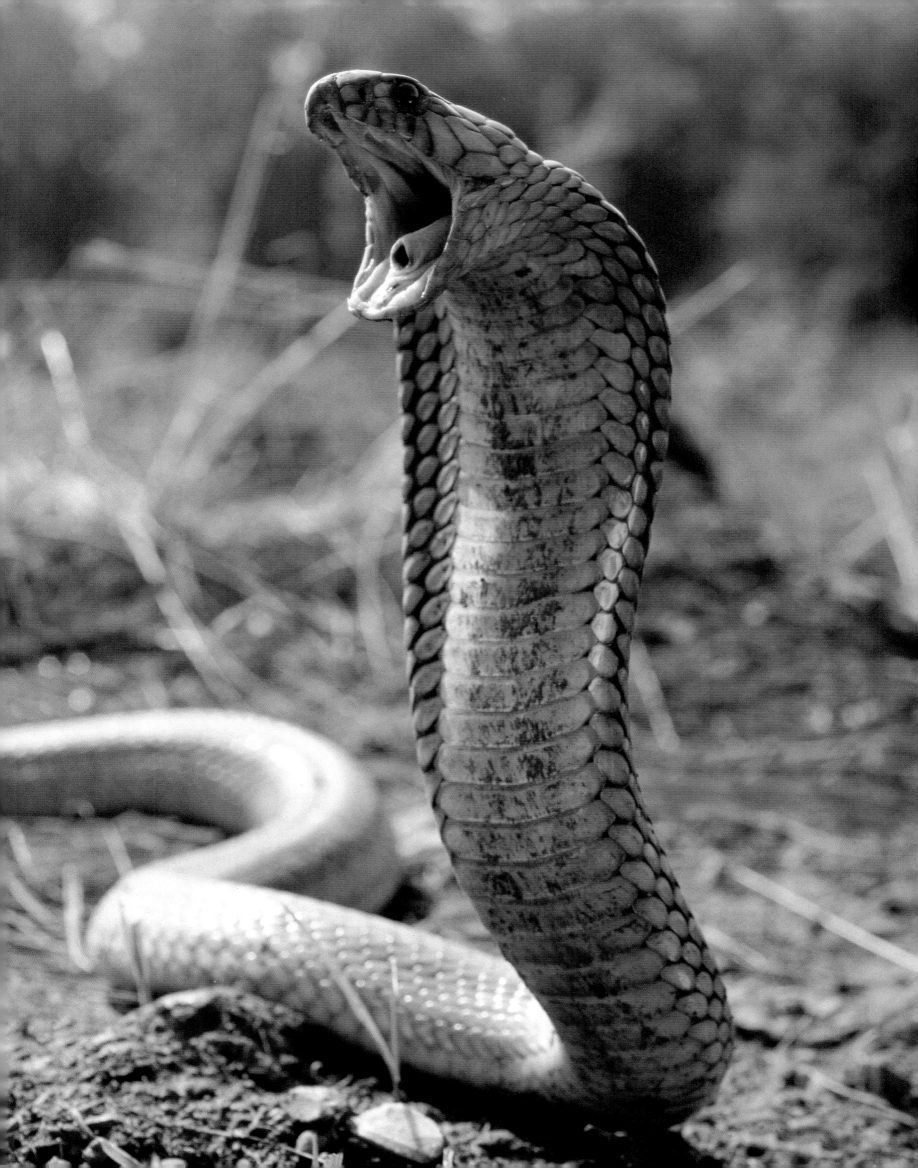

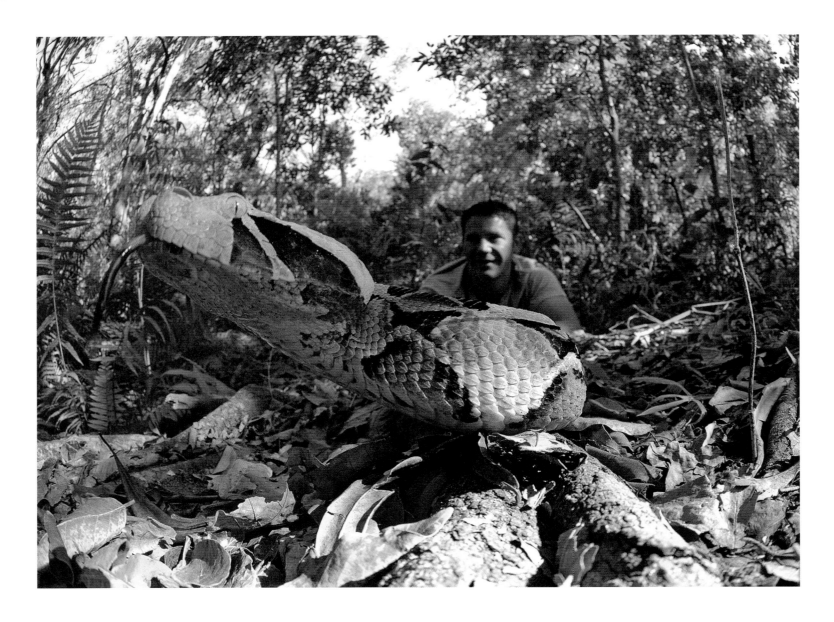

PUFF ADDER (BITIS ARIETANS) AND GABOON VIPER (BITIS GABONICA)

WHERE FOUND: THE PUFF ADDER OCCURS THROUGHOUT AFRICA AND ALSO IN PARTS OF THE MIDDLE EAST. THE GABOON VIPER IS FOUND IN SUB-SAHARAN AFRICA.

Although the Puff Adder does not enjoy the cachet or command the respect inspired by the African elapids such as the mambas or cobras, it's a much more common snake and causes far more bites than any other snake in Africa. This is probably due to its sluggish nature – unlike most other snakes, it simply doesn't get out of your way quickly enough. Its cell-destroying venom is equally slow-acting, however, and can take over 24 hours to result in fatality. With anti-dotes now available, this is often enough time to evacuate and save a casualty.

The Gaboon Viper is another serpent that ought to be a complete monster, but really isn't. It's certainly the heftiest of African vipers, and a dramatically patterned snake with a head that seems to be the size of a shovel, but it is not aggressive. I once caught one as thick as my calf, yet it responded exceedingly placidly. You wouldn't want to get

bitten though; the Gaboon Viper has the longest fangs of any snake – sometimes over five centimetres in length, and a bite will not only pass through boots or workmen's jeans but actually penetrate deep into the muscle, where it can do some serious damage.

Virtually every snake mentioned in this book is either a viper or an elapid. Until recently it was believed that they were the only types of snakes that carried venoms and therefore could be dangerous to humans. It wasn't until an unfortunate herpetologist, Karl Schmidt, was bitten by one of his pet Boomslangs and later died in hospital, that this was proved to be very much untrue. This colubrid snake (a family that contains well over half the snakes on earth) has rear, grooved fangs, and carries haemotoxic venom, which affects blood clotting, and may result in death from massive internal bleeding.

ABOVE *I sit gingerly holding this Gaboon Viper by the tail as it flickers its tongue around the camera lens. Although its strike is lightning quick, this is not an overly aggressive species, and a wonder of reptilian design.*

OPPOSITE *A Puff Adder shows off its formidable armoury: two needle-sharp fangs as long as a baby's fingers, and a jaw that hinges open so far that it can stab down with its fangs in a forward-striking motion.*

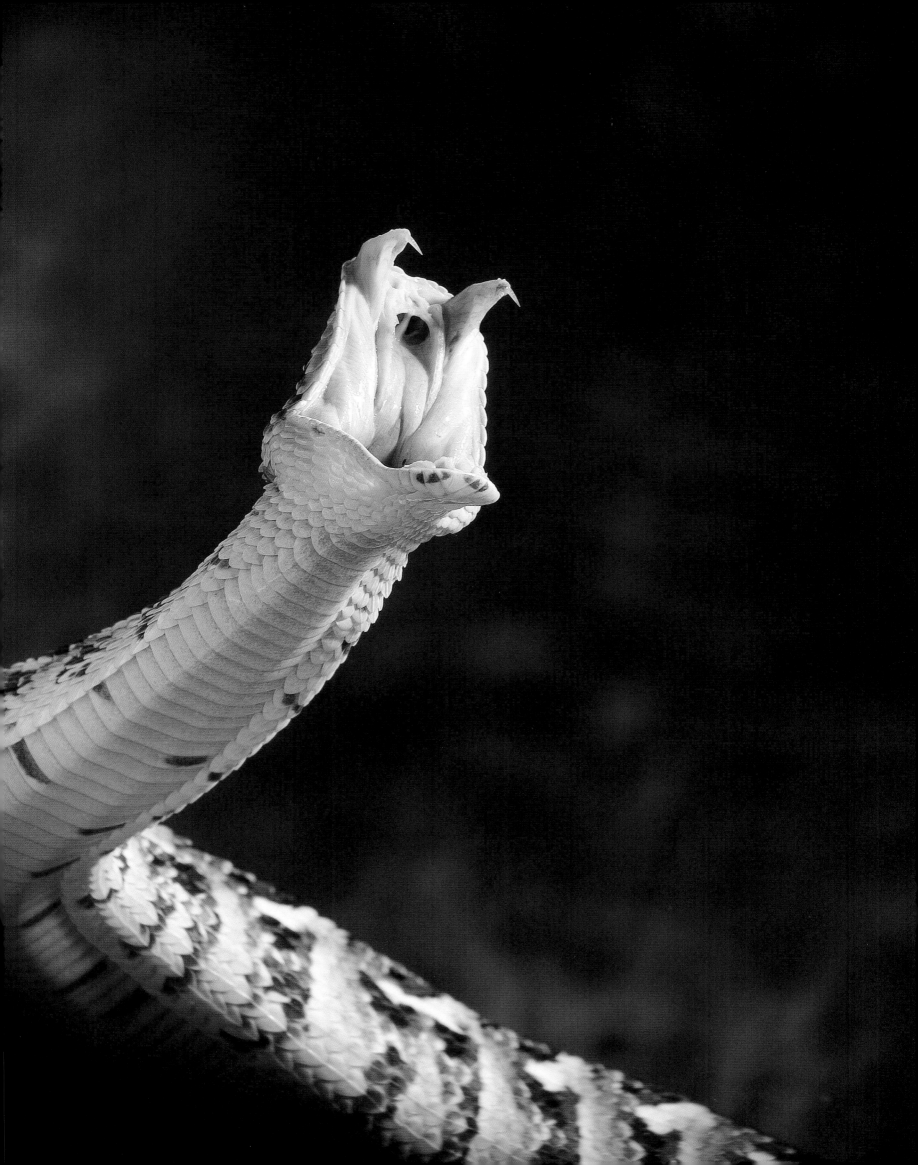

AUSTRALASIA

Australasia is the only continent where venomous snakes outnumber non-venomous ones, and with saltwater crocodiles, sharks and a vast array of biting and stinging invertebrates, it has acquired a reputation as the home of particularly dangerous wildlife. Despite this, it is worth remembering that many more people die each year in Australia from horse-riding-related accidents than from snakebite, and that the country's most deadly venomous animal is actually the introduced European Honeybee. Between 1980–90, for example, there were 20 fatalities in Australia from reactions to bee stings, 18 to snakes, 12 to marine animals, 11 to crocs and just one to a spider. In the same period 19 people were killed by lightning strikes, and 32,772 died on the country's roads....

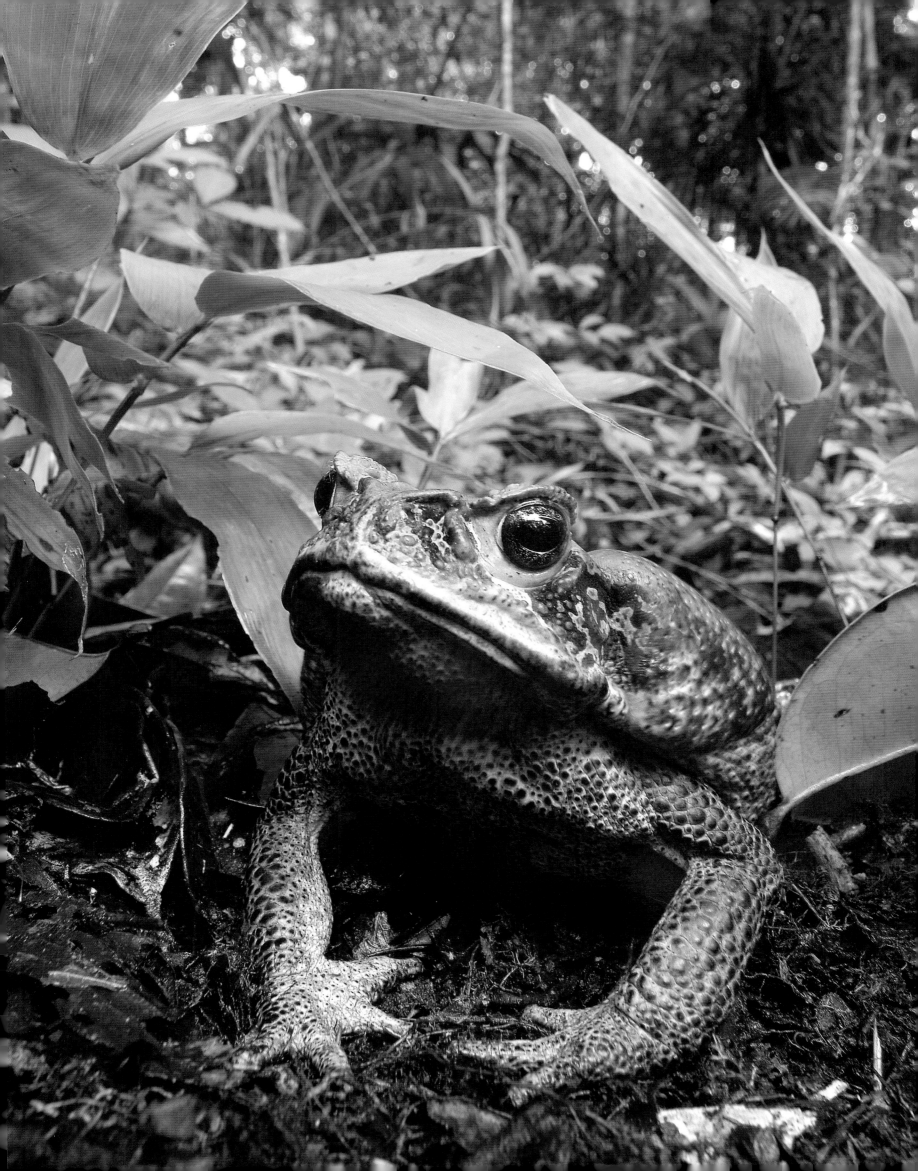

BOX JELLYFISH (*Chironex fleckeri*)

WHERE FOUND: Tropical and sub-tropical western Pacific.

Despite Australia's pride in the lethality of its spiders and snakes, there is no venomous creature that causes more disruption to Australian life than the Box Jellyfish. During the summer, its presence often renders beaches unusable in northern Australia, from Gladstone in Queensland across to Broome in Western Australia, and the creatures cause stings ranging from the merely excruciating to the definitely life-threatening. This is without doubt the most dangerous jellyfish in the world, and probably one of the most dangerous venomous creatures of all – quite impressive for something that comprises around 95 per cent water!

The Box Jelly can weigh as much as six kilos and its transparent bell can be the size of a large pudding bowl, with tentacles dangling up to two metres behind it in the water. Each tentacle carries millions of nematocysts or stinging cells, each one of these being loaded with venom, delivered by a sort of harpoon on a thread which is coiled inside the cell. Either mechanical stimulation of the cell (i.e. touching it) or a chemical signal will cause it to discharge, firing the harpoon and unloading the venom, all within thousandths of a second. A Box Jelly can fire its nematocyst 'harpoons' almost a centimetre into human skin, and may have as many as five thousand million nematocysts, so is capable of searing a large area with venom. The pain experienced

is extreme, and attempts to tear off any cloying tentacles may result in further nematocysts firing off and yet more envenomation.

Burn-like inflammations break out wherever the tentacles have touched the skin, and the resulting necrosis can cause unsightly permanent scarring. The venom itself contains both cardiotoxins and neurotoxins and attacks the respiratory system. Especially severe attacks have resulted in death after as little as five minutes. There have been at least sixty deaths reported in Australia, and many more from Box Jelly stings in the Indo-Pacific region.

In terms of treatment, applying vinegar to the sting site will deactivate nematocysts that have not yet fired and prevent them from stinging further; alcohol, paw paw juice and even human urine can also have positive effects, and there is also an antivenin available. Beaches in northern Australia, where the species is common, have signs warning bathers of the dangers, and often have nets designed to keep Box Jellies out. In such circumstances you are advised to wear a wetsuit in the water and keep vinegar and antivenin handy!

PREVIOUS PAGE *The introduced Cane Toad (*Bufus marinus*) has become a pest, and something of a hate figure, across much of Australia.*

ABOVE *Jellyfish are a seasonal hazard on many Australian beaches.*

OPPOSITE *The Box Jellyfish is probably the most dangerous jellyfish in the world.*

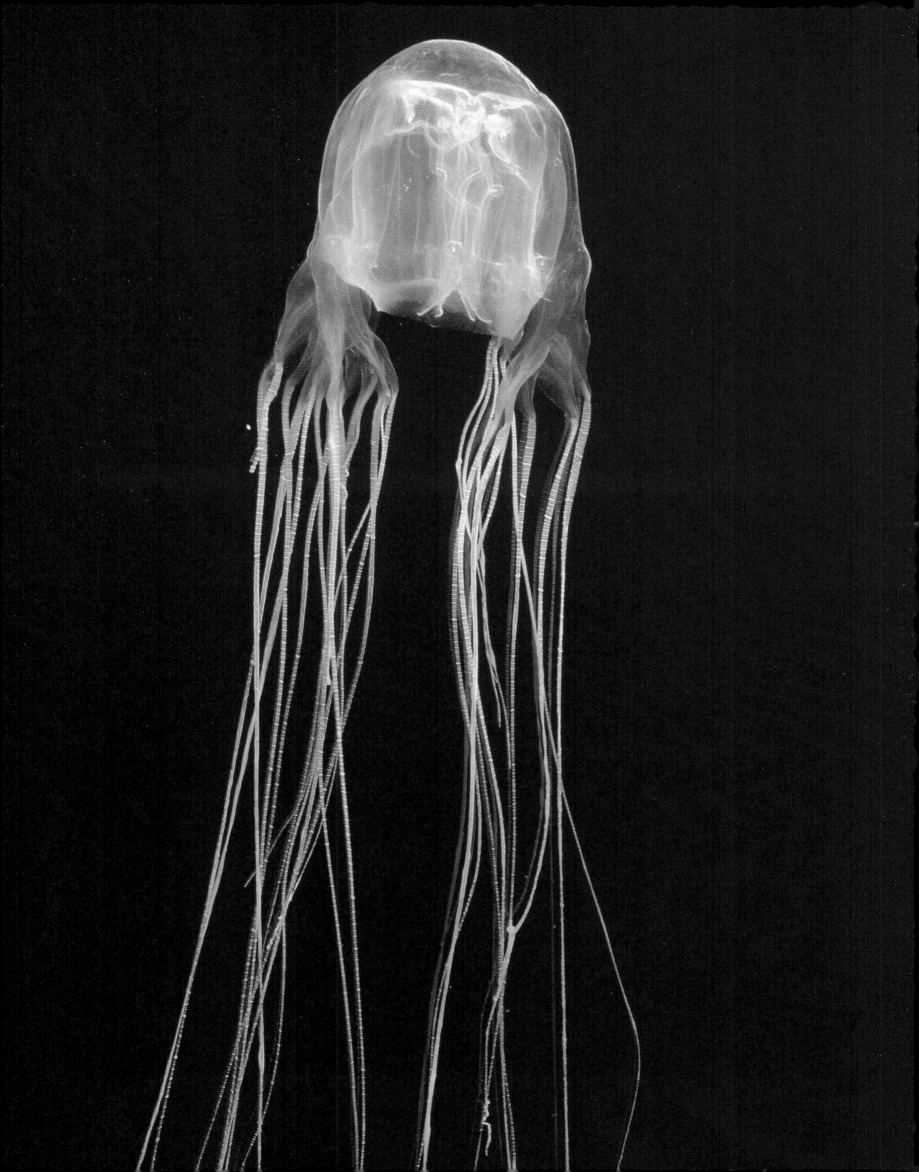

IRUKANDJI (*Caruki barnesi*)

WHERE FOUND: Tropical Australasian waters.

The Irukandji is a much smaller jellyfish than the Box Jelly, with a bell around the size of a watchface. It is also common in northern parts of Australia, especially north Queensland, but is found mostly in deeper waters (the majority of Box Jelly stings happen in very shallow water). However, Irukandji may be swept inshore by prevailing currents or in stormy weather, and during an average summer season over sixty people in Australia are hospitalized suffering from a potentially fatal syndrome arising from Irukandji stings. The sting itself doesn't hurt too badly and does little damage to the tissues directly affected, but about half an hour later the victim starts to suffer from acute back and abdominal pain, nausea and vomiting, numbness, profuse sweating and agitation. Due to the release of the neurotransmitter catecholamine, hypertension and tachycardia are common, and victims suffer extreme pain. Without treatment, this can lead to shock and possibly heart damage.

SEA ANEMONES, CORALS AND HYDROIDS

WHERE FOUND: Temperate, subtropical and tropical seas around the globe.

Jellyfish are not alone in using nematocysts to deliver venom. Many sea anemones, corals and hydroids of the phylum *Cnidaria* also possess similar stinging apparatus. *Actinodendron pulmosum* is probably the most venomous of the anemones, although all of them have nematocysts and will sting on contact. *Pulmosum*, which lives on the Barrier Reef, is one type that divers would not want to be sticking their fingers into. Anemones are most often the source of a photographer's attention when occupied by clownfish (of the Pomacentridae family), also known as anemone fish because of their habit of using anemones as a protective home. To avoid being stung, it's believed that the fish secrete a special mucus on their skin, which prevents the anemone nematocysts from firing.

All corals, both hard and soft, possess nematocysts and can sting at the touch. Corals cover many substrates and may be visually

attractive, so most stings result from divers either brushing the corals accidentally, holding on to them to resist currents, or touching them purely to see how they feel. Very few corals produce significant effects on human skin. However, cuts and abrasions will almost certainly become infected and should be thoroughly cleansed to prevent this happening. Heat irritation and sunburn make the stings worse, whilst washing with seawater and the use of steroids or antihistamines can help alleviate the pain. *Millepora* species are known as fire corals because the stinging cells are powerful enough to cause a reaction in humans. Furthermore, touching coral can also damage the mucous membrane that protects the living polyps, thereby introducing foreign matter and potentially killing off the organism.

ABOVE *Spinecheek Anemonefish (Premnas biaculeatus) in a classic view among anemone tentacles. A mucus on their skin protects them from injury.*

OPPOSITE *Whilst you should never touch corals of any kind, as you can cause damage to them, Fire Corals like this one should certainly be left alone. I accidentally kicked one once whilst diving and spent an evening in hospital.*

OVERLEAF *A close-up view of jellyfish cells, showing lines of nematocysts. Inside each one is a coiled thread attached at one end to a venom sac and at the other to a sort of harpoon.*

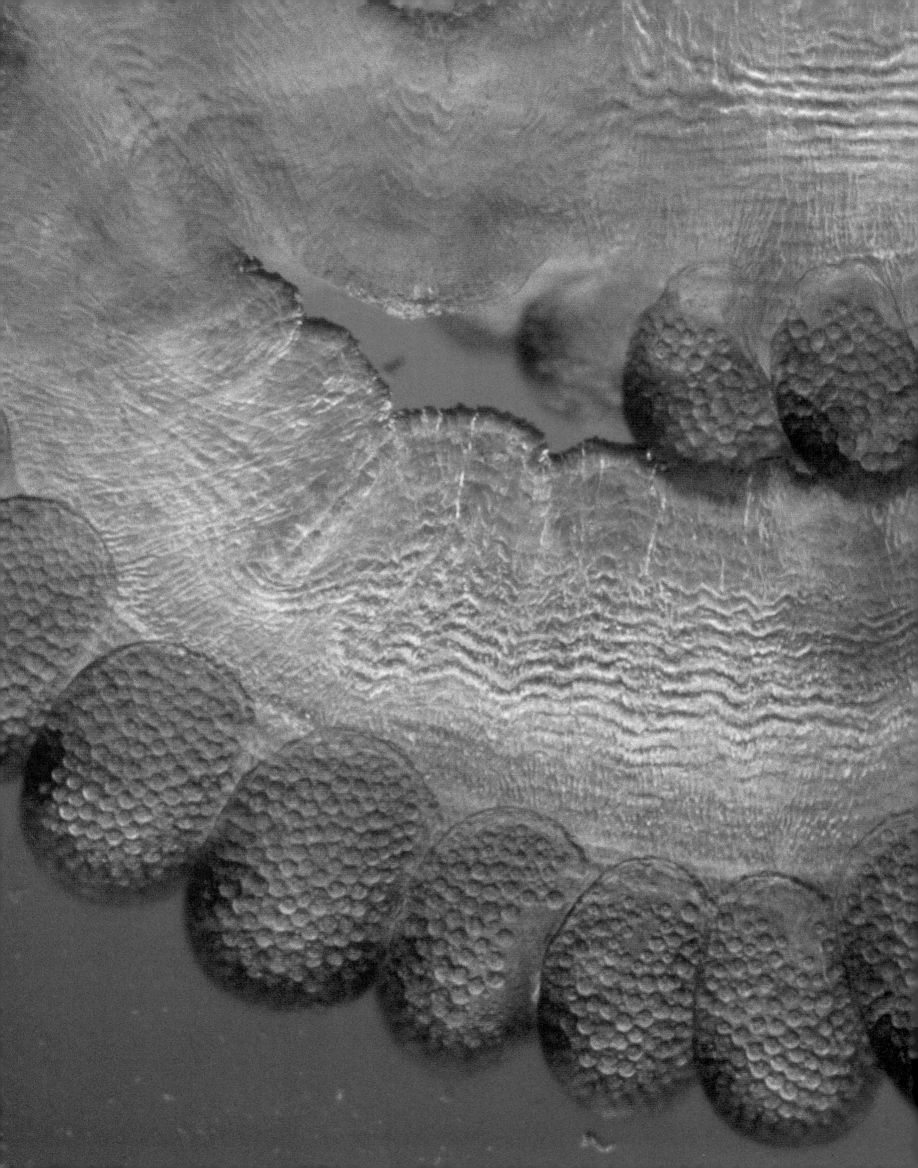

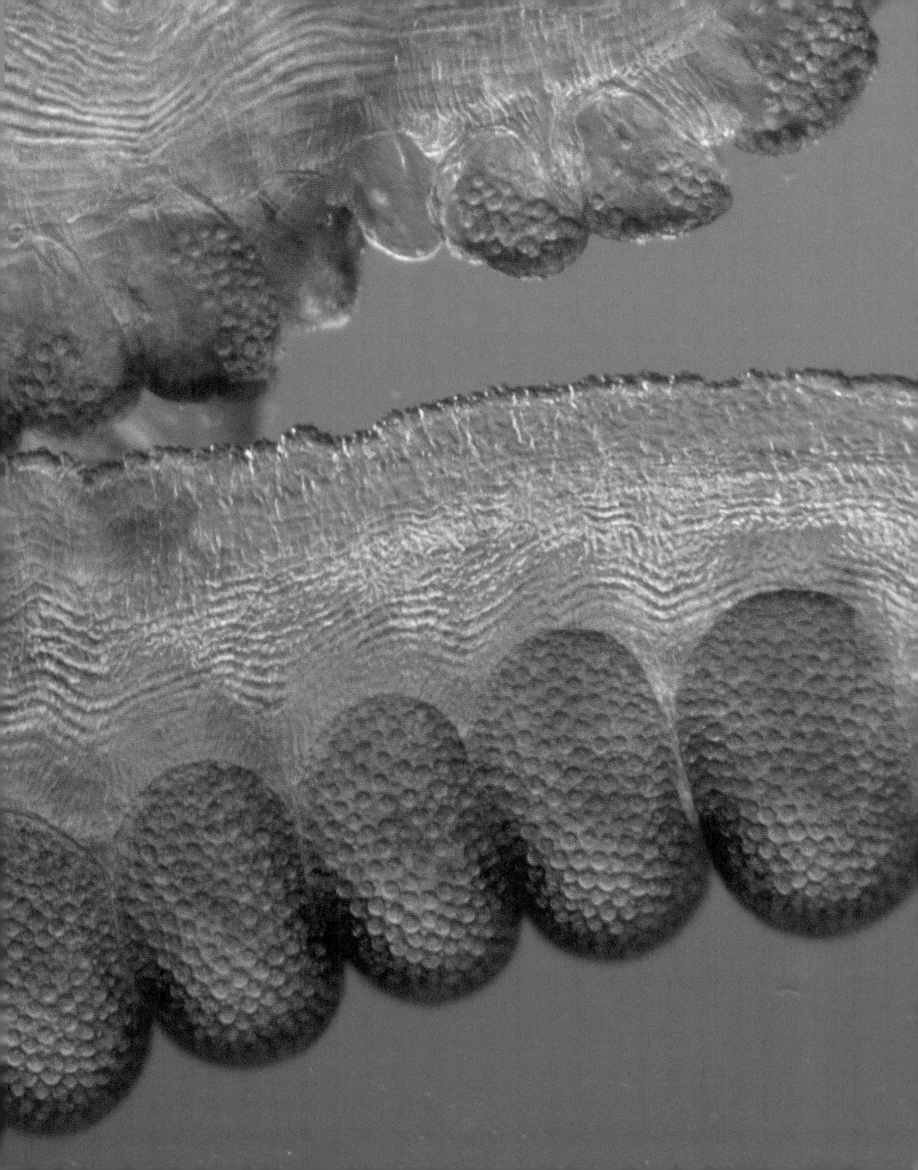

AUSTRALIAN PARALYSIS TICK (*Ixodes holocyclus*)

WHERE FOUND: EASTERN AUSTRALIA.

Thankfully, this creature is more of a danger to other mammals such as dogs and livestock than to humans. In particular, it causes mass mortalities among fruit bats and bandicoots in eastern Australia, but it will feed on any mammalian host and so is a potential danger to people. The female needs a blood meal to complete each stage of her reproductive life cycle, but unfortunately she has a toxin in her saliva that causes the onset of paralysis in the victim by interfering with motor nerve transmission.

This toxin is unusual in that it seems to serve no purpose; it doesn't help defend the tick, and the paralysis is certainly not necessary for the tick to feed. The tick may remain feeding on its host for as long as five days, during which time enough toxic saliva may accumulate to cause severe paralysis. Human deaths due to tick poisoning are rare, but in the State of New South Wales at least twenty were recorded during the twentieth century, which makes paralysis ticks more dangerous than either the Sydney Funnel-web or Redback Spiders.

SYDNEY FUNNEL-WEB SPIDER (*Atrax robustus*)

WHERE FOUND: EASTERN AUSTRALIA.

Think of venomous Australian creatures, and you'll probably think of the Sydney Funnel-web Spider. The male of this species is certainly Australia's most dangerous spider, and, with the possibility of causing death in as little as fifteen minutes, is a strong contender for the title of the world's most lethal arachnid. There are related species found all the way up the eastern coast of Australia, but the true *Atrax robustus* occurs only within a 160km radius of Sydney. Although, as in most spider species, the female is larger than the male, the Funnel-web is unusual in that the male is far more dangerous, his venom being 4–6 times more toxic than that of the female. It also seems to have an especially virulent effect on primates, with other mammals such as mice suffering far less dramatic systemic effects.

The Funnel-web is a large, black, aggressive mygalomorph spider with large, powerful fangs. These bead up with venom, before opening up like a flick knife. The spider then drives its fangs (about the size and shape of a cat's claw) downwards into its victims with a scything motion, at the same time as elevating and then dropping the whole body to power the fangs home. Watching a Funnel-web strike is a mightily impressive sight.

BELOW *Paralysis Ticks may be tiny, but this is an arachnid to be truly wary of. I once spent a day working with fruit bats which were very affected by tick toxin and lay almost comatose as a result.*

OPPOSITE *Arguably the world's most feared spider, the dreaded Sydney Funnel-web. The hairs along its legs are perhaps its most efficient sensory mechanism; just a slight vibration in the air, and the spider is up and ready to strike.*

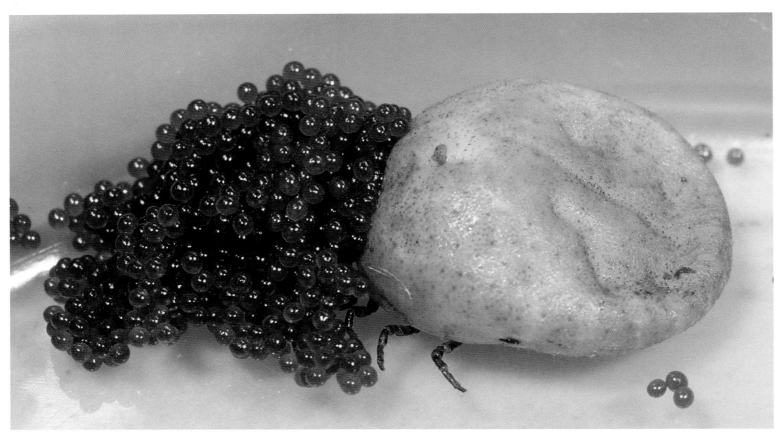

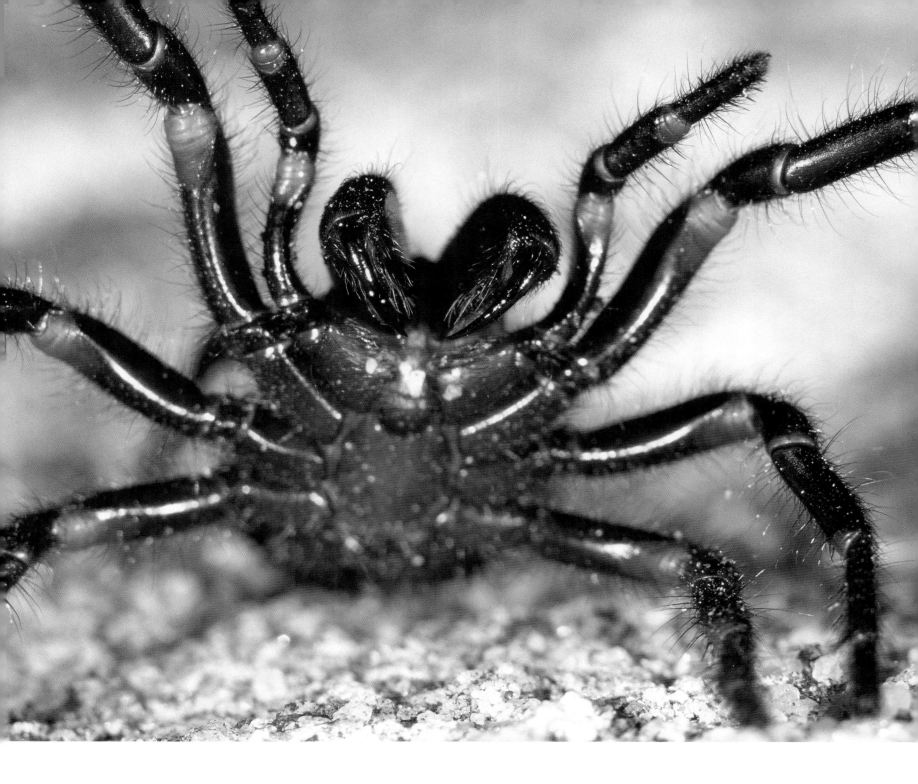

Funnel-webs live in burrows and crevices in rocks, and around house foundations, lining their burrows with silk. Colonies of more than 100 spiders may be found. Whereas female spiders are more likely to stay in or close to their burrows, male spiders will wander far from their burrows whilst searching for a mate, and may stray into houses in the summer, especially in wet weather.

Sydney Funnel-web antivenin only became available in 1981, and before that there were 14 recorded fatalities. Today there is no reason for a bite to result in death so long as the victim seeks medical attention quickly. The creation of the antivenin is an amazing process – the spider is agitated by gentle prodding, whereupon it rears up, its huge fangs dripping with venom. At this point a tiny vacuum cleaner is used to suck the drops of venom off the fangs. The purified venom is then injected into beagles in order to get a hold of the antibodies they generate. As with all other dogs, beagles seem to be pretty resistant to Funnel-web bites; those living in the Sydney area must

get bitten quite regularly, but few, if any, fatalities are reported.

It has been suggested that related species *Hadronyche formidabilis* and *H.infensa* are even more venomous than *Atrax robustus*, but as these don't occur so often in urban environments, there have been no recorded fatalities. Most male spider activity is recorded in the summer and autumn, as well as when heavy rains flood their burrows, or pesticides are used in an attempt to drive them out of their homes.

Funnel-webs are easily mistaken for mouse spiders such as *Missulena occatoria*, which also possess huge, formidable chelicerae and are dangerously venomous, and also for the trapdoor spiders (genus *Aganippe* or *Misgolas*), which are not reported to be as serious. Both have been treated successfully with Funnel-web antivenin.

White-tailed Spiders (*Lampona* spp.) are another type of large mygalomorph spider found in Australia, and their bite may have necrotic effects similar to that of gangrene in some cases. They are readily identified by the white spot on the rear of their abdomen.

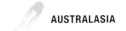
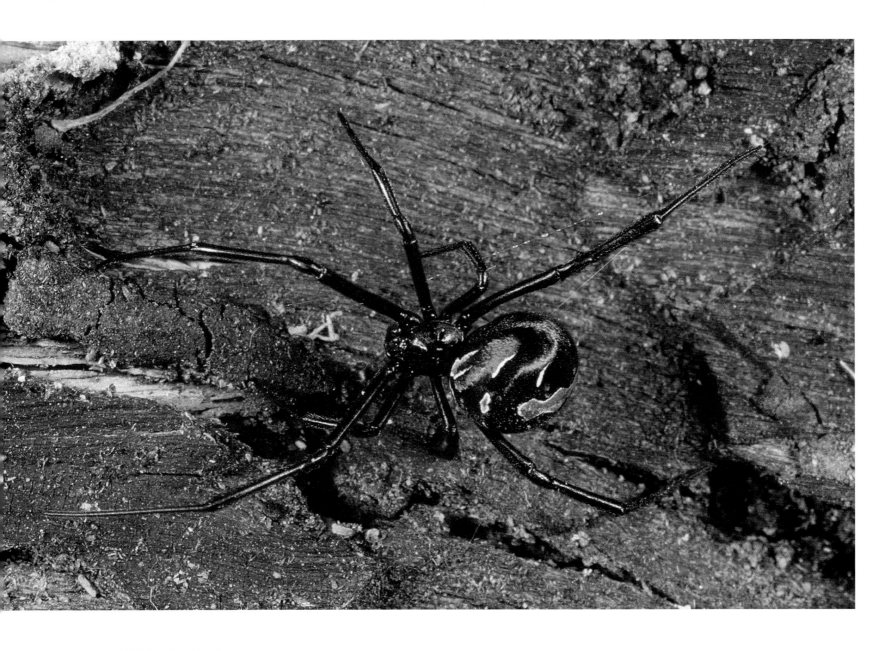

REDBACK SPIDER (*Latrodectus hasselti*)

WHERE FOUND: Throughout Australia and Asia.

If there is a story of someone retreating to the outdoors 'dunny' (Australian slang for toilet) and getting bitten on the bottom whilst at their ablutions, it is probably going to be the Redback that is implicated. Redbacks are members of the *Latrodectus* genus, which includes the Black Widow (*Latrodectus mactans*) and Brown Widow (*L. indistinctus*) of North America. Easily identified by a red, orange or brownish stripe on the abdomen, Redbacks are responsible for by far the most spider bites in Australia. These occur particularly during the summer months, and over 250 people each year receive antivenin. Maybe ten times this number actually get bitten, but have effects that are mild or perhaps not even recognized, and therefore do not receive any antivenin.

People usually get bitten at home, having inadvertently sat or placed their hand upon a spider whilst in the garden or outbuildings, although Redbacks will also get into clothing and footwear. The female Redback alone is the source of the problem – the male is tiny, only about 3mm in diameter, and his fangs aren't strong enough to penetrate human skin – but females are not generally considered aggressive and will bite only in defence.

Redback relationships with humans may be strained, but they are scarcely better with their own kind. For a start, if the female is not receptive to a male's sexual advances, she'll just eat him straightaway. If, however, his overtures are successful, he then has to maintain her attention during mating by standing on his head and presenting his abdomen towards her mouthparts. While he inserts his palp into her and transfers his sperm, she squirts digestive juices onto his abdomen and starts to eat him; understandably, very few males survive this procedure. The whole bizarre process may well have evolved to provide the female with a good source of protein in order that her ensuing offspring stand a better chance of survival.

ABOVE *The Redback is a regular icon 'Down Under', with bars, boots and brews bearing its name. Locals often advise strangers to never use the outdoor 'dunny' (lavatory) without a good check around first!*

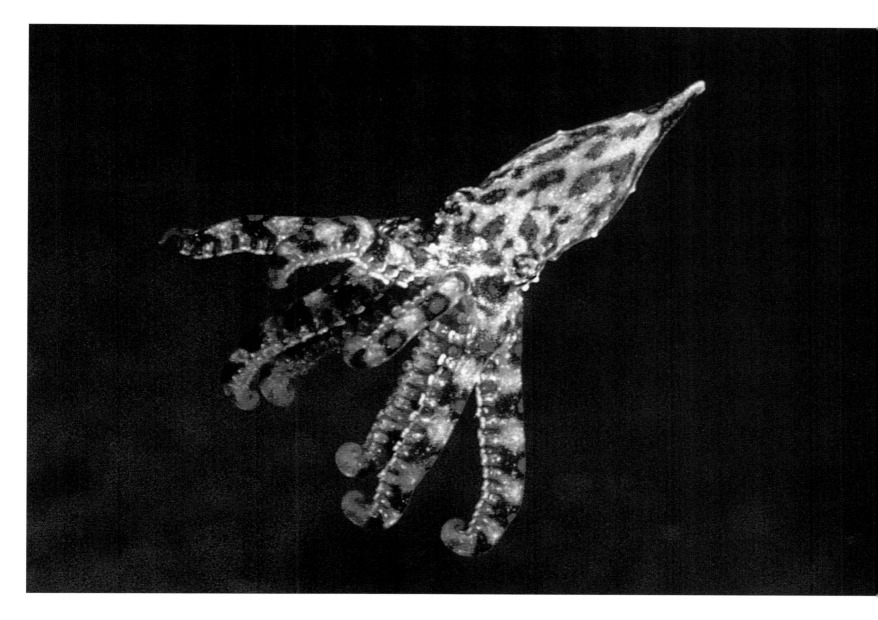

BLUE-RINGED OCTOPUS (*Hapalochlaena lunulata,* *H. maculosa*)

WHERE FOUND: Western Pacific waters.

Despite (probably true) tales of giant squid and octopus with vast arms, vicious suckers and brutal beaks, the only cephalopod that really poses any danger to people is a tiny little octopus named after the blue-rings that light up on its normally plain yellowish-brown skin when it is irritated or in danger. There are two species, both found in the waters off Australia and Tasmania. They make their homes in shallow coral and rock pools, close to the shore, and therefore occasionally come into contact with people.

The Blue-ringed Octopus has two glands secreting two different toxins, which pass into its saliva and are then chewed into its prey (mostly crabs); one vital component is tetrodotoxin, the same toxin that pufferfish have as a poison in their tissues. The octopus's parrot-like beak can easily penetrate a wetsuit, and their nasty saliva is a valuable defence mechanism, as people who pick them up – or accidentally tread on them – have found out to their cost.

Generally speaking, the bite is not especially painful in itself, but the toxin can have dramatic effects within about 15 minutes. Some reputable sources suggest one tiny, golf-ball-sized octopus may have enough venom to kill 26 people!

The delayed effect of the venom can be deceptive. A famous case involved an Australian swimmer who posed for a photo, apparently quite happily, with a Blue-ringed Octopus on his shoulder. He later collapsed and died, underlining the point that urgent medical attention should always be sought if close contact with this species has taken place, even if there do not appear to be any apparent ill effects.

There is no antidote to tetrodotoxin, although the effects can be treated – including with artificial ventilation should respiration shut down. If the patient can be kept alive through artificial ventilation, the venom has a chance to dissipate. As well as biting, the octopus can also squirt out venom, but as this is then dissipated in water it loses its potency.

ABOVE *Possibly the most beautiful of all the animals in this book, and one to which no photo can ever do justice, the Blue-ringed Octopus pulsates with electric blue colours unparalleled in the natural world.*

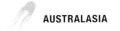

HOODED PITOHUI (*Pitohui dichrous*)

WHERE FOUND: PAPUA NEW GUINEA.

In the summer of 1989, researchers working with birds of paradise in New Guinea noticed a remarkable phenomenon when they were out ringing birds. The mist nets they used to catch birds were not only bringing in different species of the remarkable paradise family, but also more common varieties, such as the Hooded Pitohui, a brightly coloured red and black endemic songbird about the size of a Blackbird.

Several researchers who were scratched whilst holding these birds and subsequently licked the wound, or stuck their fingers in their mouths, reported a numbing, tingling sensation in the mouth – often symptomatic of the presence of a toxin. The birds also gave off an unpleasant pungent smell, and were known as 'rubbish birds' by the locals, who would eat them only after removing the feathers and skin and scrubbing the meat with burnt charcoal (organic chemists use charcoal to absorb poisons).

OPPOSITE *Poisonous birds seem an unlikely scenario, but new research offers the tantalizing possibility that the Hooded Pitohui* (shown here) *may not be the only species so equipped.*

BELOW *Further studies are required, but it seems likely that birds of paradise (this is a Lesser Bird of Paradise,* Paradisea minor) *also possess toxins in their skins, derived from their insect prey.*

Jack Dumbacher, then a research associate at the National Zoo's Front Royal conservation and research facility in Virginia, USA, returned to New Guinea specifically to study the birds and found some striking results. First of all, he crudely garnered a few drops of a substance directly from a feather and injected it into a mouse. The mouse keeled over almost instantly. In the field, some of the birds were so potent that just getting close to them would set Dumbacher off sneezing and make his eyes water, whereas others were almost toxin free. They were obviously sequestering their poisons from something in the environment, probably an insect which had in turn been feeding on a toxic plant. When tests were run on the chemicals present in the bird's feathers and skin, batracho-toxins were found – a parallel with poison dart frogs (see page 72). The birds were not only poisonous, but possessed the most powerful natural toxins known to man!

Today, Dumbacher and his colleagues are continuing their studies on these remarkable birds. Aside from the three species of pitohui, they have encountered other Papuan birds, such as the Blue-capped Ifrita (*Ifrita kowaldi*), that also seem to carry distasteful chemicals in their skin. It is often the brightest coloured birds that are the most potent. Tantalisingly, birds of paradise themselves are generally scorned as a food source by New Guinea natives on the grounds that they taste bitter and pucker the lips and mouth if eaten. It may be that the coloration of these birds also serves an aposematic function, warning predators that they pack a poisonous punch. It has also been suggested by Dumbacher that the accumulation of batrachotoxin may have antibacterial and insecticidal qualities, thereby helping to keep the birds free from bugs and infections.

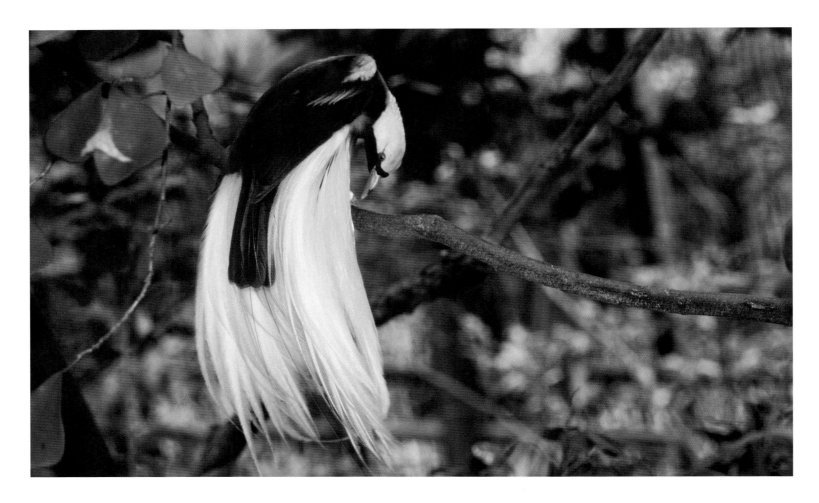

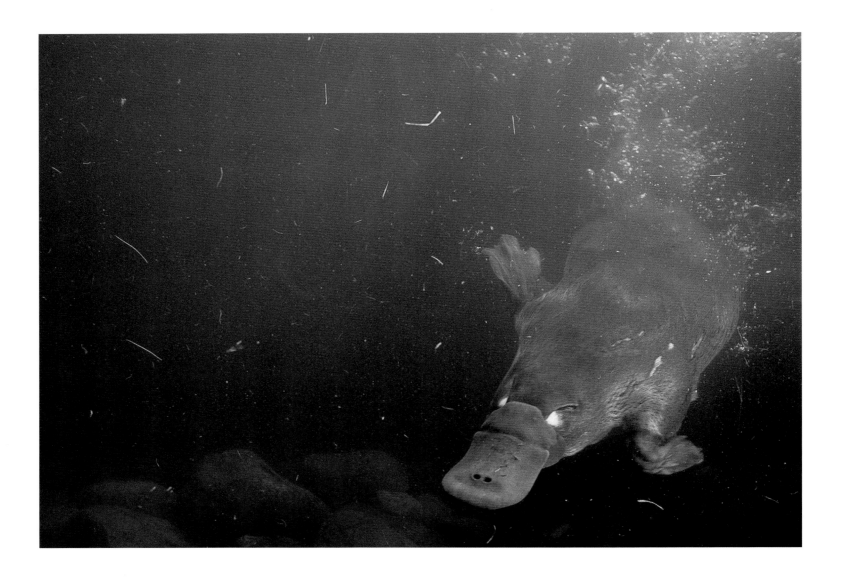

PLATYPUS (*ORNITHORHYNCHUS ANATINUS*)

WHERE FOUND: EASTERN AUSTRALIA AND TASMANIA.

Arguably one the world's most ludicrous beasts, one of only three egg-laying mammals and apparently just a crude composite made by stapling a duck's bill onto a beaver, how on earth could the Platypus also be venomous? Yet the male of the species does indeed possess venom and, unlike the other venomous mammals, it has the ability to seriously injure and even kill a healthy adult human. The venom has similarities with those of the tropical lancehead snakes and the Green Mamba, and is said to be even more painful than being shot. An Australian who had served in the Vietnam war and who later plucked a Platypus out of his fishing net and got latched by it, said the pain of the bullet was insignificant by comparison. He never regained the use of his limb.

Only male Platypuses have the venom-injecting apparatus, which comprises movable spurs on each rear leg. Each spur is attached to a venom gland and lies flush against the leg, but has a sort of joint which allows it to be erected when required. The production of venom peaks in mature males during the breeding season, in late winter and spring, so it seems likely that it is used mostly when they are competing for mates or breeding territories. Certainly, more than one

male has been killed in captivity by a rival's venom. The only other mammal with a comparable mechanism is the Echidna (*Tachyglossus aculeatus*), but although the male Echidna has a similar spur on the ankle of its hind leg, it lacks the functional venom gland of the Platypus.

It seems that – as in the case of the Solenodon (see p.52) – the presence of venom in mammals is relic physiology, mostly apparent in animals that seem to be a kind of evolutionary throwback to a time when venom might have been more appropriate. Now, perhaps, those same animals have evolved more effective locomotion and other sensory adaptations to improve evasion of predators and hunting performance (for example, the Platypus's electrical impulse-sensitive bill), and the need for venom is therefore obsolete.

ABOVE *The Platypus can find its invertebrate prey in the muddiest of creeks, relying not on sight but on the electro-receptors in its bill.*

OPPOSITE *Certainly one of the world's weirdest creatures, the Platypus is also one of the few venomous mammals. The male's spur can inject a highly powerful toxin capable of causing death to a human.*

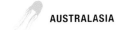

AUSTRALIAN VENOMOUS SNAKES

WHERE FOUND: Throughout Australia and also on nearby islands, including New Guinea.

Australia's venomous snakes have earned the country a notoriety it certainly doesn't deserve. Certainly if you look at the LD50 statistics for the toxicity of Australian serpents (see p.155), they are far and away the most potent, but with between 1,000–3,000 snakebites recorded each year, an average of just two fatalities is expected.

Australia's most frightening snakes all belong to the Elapidae (cobras and their relatives), comprising 75 species and spreading out over neighbouring islands, including New Guinea. The majority of these snakes are adapted to feeding on frogs and lizards, as historically small mammals were nothing like as prevalent here as on other continents. After the European colonization of Australia in the late 1700s, rats, mice and larger mammals such as rabbits soon proliferated, some to plague proportions, yet snake-feeding strategies seem to have been slow in keeping up with the changing times.

The most powerful venom, drop for drop, is produced by the Inland Taipan (*Oxyuranus microlepidotus*); a single bite from this beautiful snake is enough to kill 250,000 mice and, by extrapolation, 100 people! However, no one has ever been killed by one. This is mainly because they are shy snakes that tend to avoid human contact. However, people do occasionally get bitten and yet survive. This seems to be explained by the fact that the Inland Taipan has highly specialized venom, designed to work primarily on rodents. Both it and its coastal cousin (*Oxyuranus scutellatus*) are very similar to the African mambas in their prodigious size, length, extreme toxicity and small mammal diet. They also practise the bite-and-release technique of hunting, allowing their mortally envenomated prey to stumble away and die, before they follow its scent trail and feed at their leisure. This explains the extraordinary power of taipan venom.

BELOW *Drop for drop, the venom of the the Inland Taipan is the most powerful of any snake. However, this is potentially one of the least dangerous species, with no recorded human fatalities from its bite.*

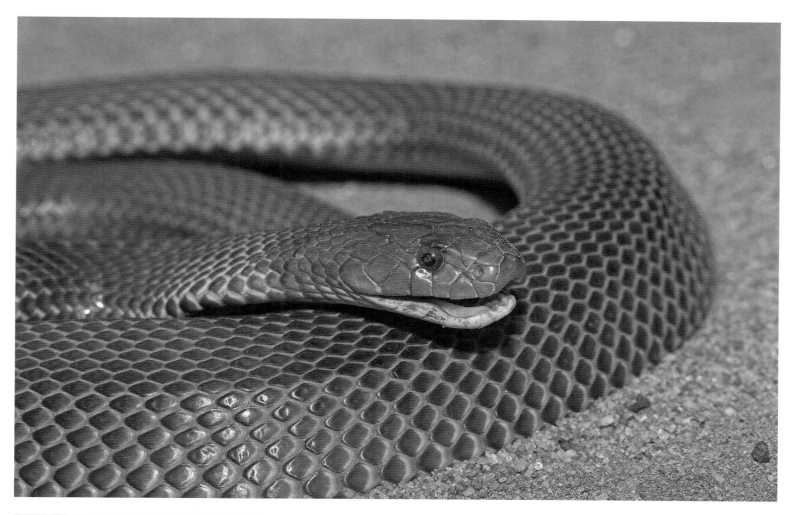

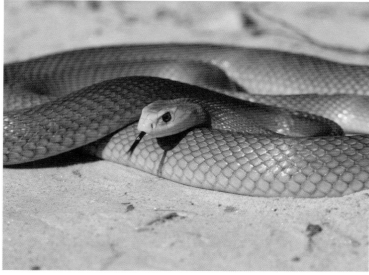

ABOVE TOP *The King Brown (also known as the Mulga, after the mulga grassland habitat in which it often occurs) is the most widespread venomous snake in Australia. It can be highly aggressive in defence, spreading its neck in a form of hood not unlike that of a cobra.*

ABOVE *Despite its name, the Coastal Taipan is frequently found in the sugar cane fields of Queensland, where it hunts rats and other rodents.*

OVERLEAF *Until the advent of antivenins, tiger snakes were responsible for many snakebite incidents in Australia. This specimen is an Eastern Tiger Snake,* Notechis scutatus.

Prior to the development of taipan antivenin in 1956, there were only two recorded survivors of taipan bites. Herpetologist Kevin Budden was not one of those lucky ones. He caught the first ever taipan used for scientific research in a dump near Cairns and then proceeded to hitchhike back into town with the snake (and presumably a very understanding or stupid driver). Unfortunately, it bit him just as he tried to bag it, and he died shortly afterwards. However, his efforts were not in vain, as six years later an antivenin was created from the venom of that one captured snake, and nowadays the taipan bite – though always serious – is rarely fatal.

The snake that Australians fear most is without doubt the King Brown or Mulga (*Pseudechis australis*). A look at the LD50 list (see p.155) reveals that the toxicity effect of this intimidating snake on mice per unit volume comes in at just a little more powerful than that of purified wasp venom!

Another elapid worth mentioning is the Common Tiger Snake (*Notechis scutatus*). These stunning serpents are named for the vibrant yellow and black stripes found in the classic specimen, although jet black is also a very common coloration. When threatened, the Tiger will spread the beginnings of a hood and lift a decent portion of its body off the ground. One of the most interesting facets of Tiger Snake biology is found on the islands between the mainland and Tasmania. Generally speaking, Tigers live in swampy areas and feed primarily on frogs. These islands, however, are dry and frogless, and were cut off from the mainland about 6,000–10,000 years ago by rising sea levels.

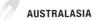

However, for about six weeks of the year birds such as Muttonbirds and Storm Petrels breed on the island, providing a surfeit of regular prey. All the snakes need to do is wait in the birds' burrows all year long for this feast to arrive! Their black coloration comes in handy, as it helps them warm up and become active more quickly, and also aids their digestion. The Tiger Snakes on Chappell Island are the largest of all Tigers, reaching up to 2.1 metres against an average elsewhere of between 1 and 1.8 metres.

I have to admit that the first time I caught a Death Adder (*Acanthophis* spp.), I was in a state of total ignorance. It's called an adder, and has that characteristic stocky body and arrow-shaped head, long curved fangs, cryptic coloration and ambush style of hunting. Everything about it says 'viper', yet it's not. The Death Adder is as much an elapid as the Indian Cobra or the Tiger Snake, though it seems to bear no resemblance to its stately relatives. It sometimes sidewinds on sand or mud, will flatten its body out widthways in response to threat, lures prey by wiggling its contrastingly coloured tail, and feeds on lizards, birds and mammals. It has been known to cause bites that are fatal to humans, with venom which is (theoretically at least) four times more powerful than that of the King Cobra.

One interesting area of study is the unfolding relationship between Australian snakes and the humans with whom they share their home. The first people came to Australia via South-east Asia somewhere between 30–50,000 years ago and it has been inhabited ever since. In the rest of the 'Old World', however, humans have been around for hundreds of thousands of years. Is it possible that the elapid snakes of Africa and Asia have evolved their hoods, elevated stance and ability to spit venom specifically to combat people? What about the species of snake that play dead? *Hemachatus haemachatus*, the Rinkhals (see p.100), is one of the cobras that can spit venom, but hassle them too much, and they're liable to just lie sideways on the ground with their mouths open, playing dead. This wouldn't have much effect on a nosy hyena looking for an opportunistic feed, but might well convince a passing human that it's not worth smashing the thing over the head with a rock. Certainly the elapids of Australia, such as the Tiger Snake and taipans, are showing the beginnings of cobra-esque behaviour, standing upright and fanning out the back of the neck into a kind of proto-hood. Could this eventually develop into full-on cobra behaviour as they learn to live with humans?

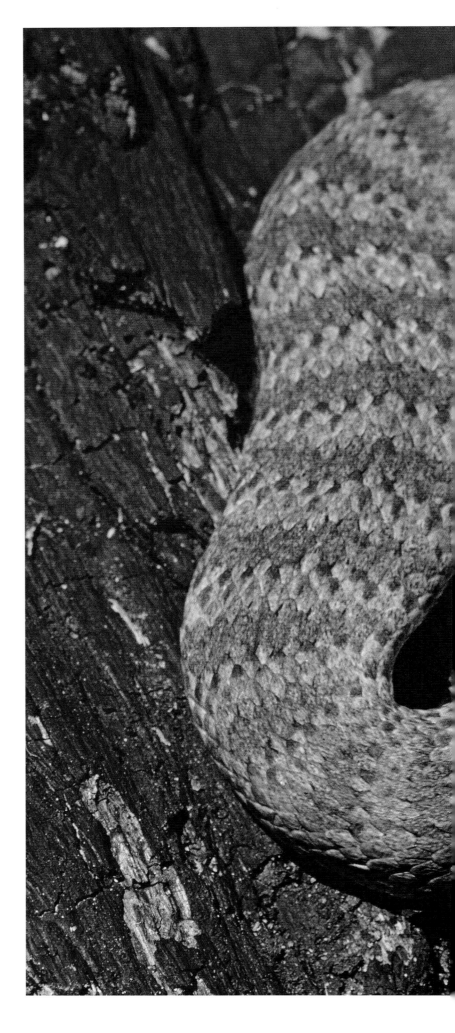

RIGHT *The least cobra-like of all the elapids, the Death Adder looks much more like a viper, hence its common name.*

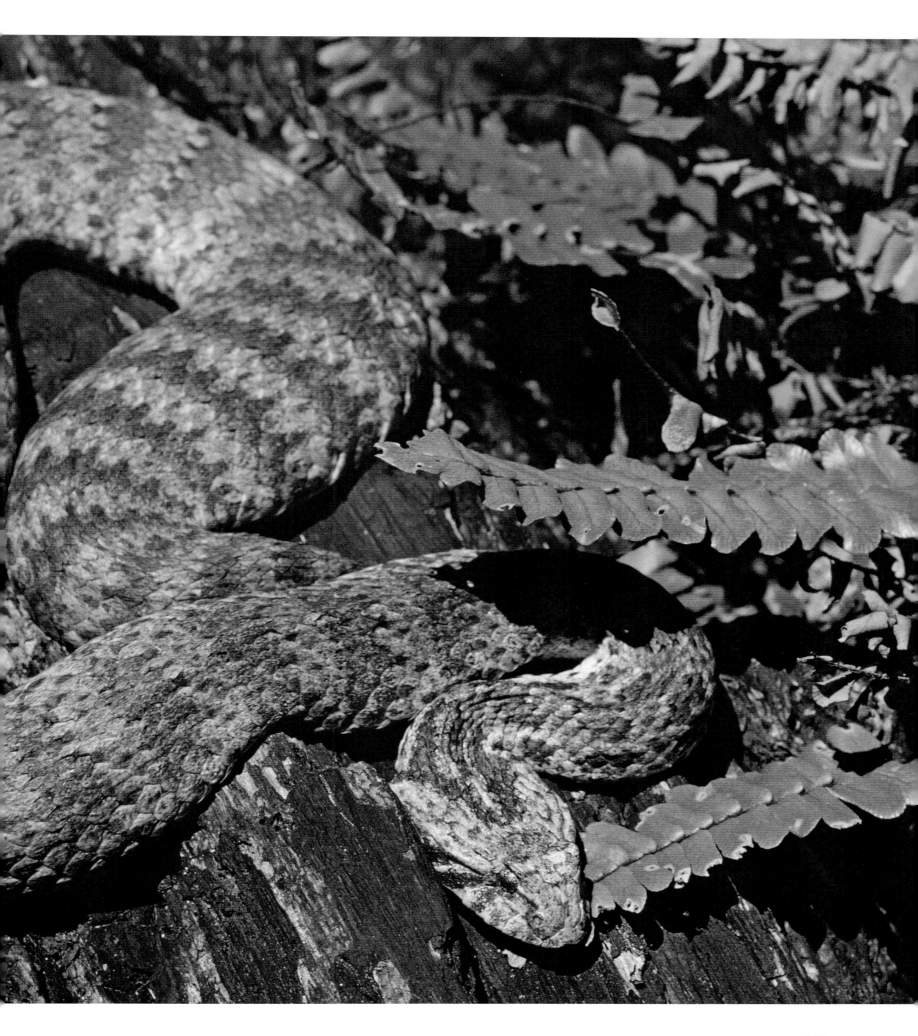

CANE TOAD (*BUFO MARINUS*)

WHERE FOUND: NATIVE TO CENTRAL AMERICA, BUT
INTRODUCED TO AUSTRALIA AND SPREADING ACROSS THE
COUNTRY FROM QUEENSLAND.

Australians do not have a good record when it comes to feral
creatures, i.e. those that have been brought to Australia from other
parts of the world and have subsequently run riot and become
nothing less than pests. Rabbits, mice and rats have all proliferated
beyond the wildest expectations, and even foxes were brought
halfway round the world so they could be hunted on horseback.

However, the history of these species pales into insignificance
alongside the legendary tale of the Cane Toad. Anyone who has

travelled the long roads of Queensland, seeing nothing but sugar
cane fields and smelling the sweet stench of the refineries, will know
that the Australians take their sugar seriously. So much so, that when
two species of beetle began to blight the sugar cane in the 1930s,
the decision was taken to import an amphibian predator from Central
America to try and control the beetles.

Only 102 toads were introduced, and no one could have foreseen
the impact they would have – Australia has no native species of toad,
and just wasn't ready for this monster. Worse than this, however, the
introduction scheme was spectacularly ill-conceived. The toads are
large, and not the world's greatest climbers or jumpers; conversely,
the beetles spent most of their time high up the sugar cane and,
when their larvae were emerging from the ground, the toads were not
active, so the two rarely came into contact. Introducing Cane Toads

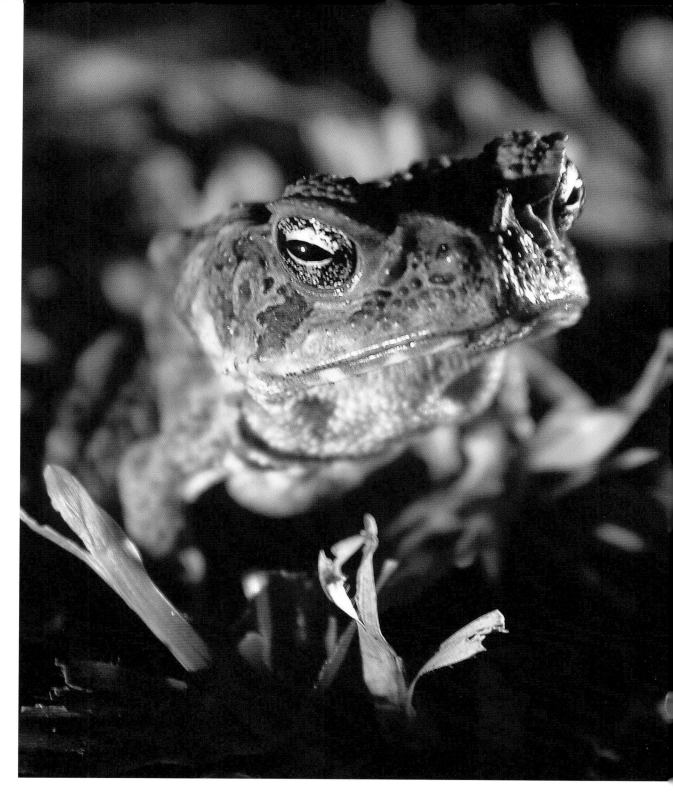

therefore had no effect whatsoever on the beetles, yet meanwhile both toads and beetles proliferated in glorious abandon. The toads can lay as many as 60,000 eggs per spawning, and these hatch earlier than native frogs, thereby outcompeting native tadpoles for food. If this were not enough, the Cane Toads also eat native frogs and their offspring. The Cane Toad is poisonous at every stage of its lifecycle – fish that eat its tadpoles die, animals that eat the adults die or get very sick. Even 'mouthing' a toad, or drinking water a toad has been sitting in, can make a pet or child sick.

Cane Toads are responsible for the reduction of many species of Australian wildlife, yet there are signs of hope. In Queensland, certain bird and rodent species have learned how to eat Cane Toads by pulling away the soft belly skin and eating the internal organs, leaving the skin and the deadly parotoid glands behind. So all may not be lost.

OPPOSITE AND ABOVE *The cautionary tale of the Cane Toad in Australia should be one that teaches mankind not to mess with the intricacies of nature. Sadly, we tend not to learn from history or from our own mistakes.*

CHAPTER SEVEN

ASIA

In the jungles of Asia, one of the most feared creatures is known as the 'five-pace snake', for the simple reason that if it bites you, you will allegedly manage to run only five paces before you collapse. *Agkistrodon acutus*, as it is more properly known, is the Sharp-nosed Pitviper, and undoubtedly one of the most dangerous serpents. Even so, five paces may be a little exaggerated! Yet Asia is home to a host of dangerous beasts, from the longest venomous and non-venomous snakes (King Cobra and Reticulated Python, respectively) to the most dangerous in terms of human casualties (Russell's Viper and Saw-scaled Viper). It also hosts the world's largest lizard, the awesome Komodo Dragon, whose venom we are only just beginning to understand.

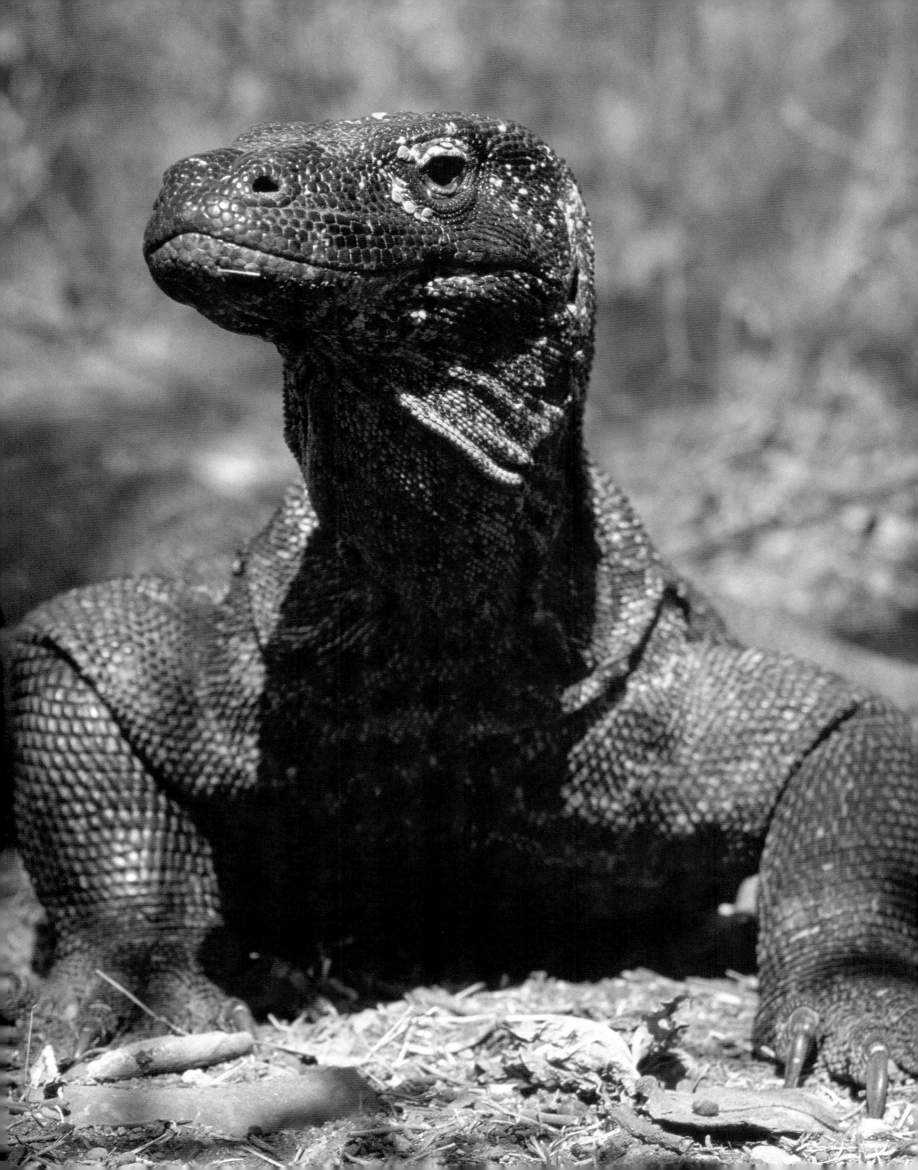

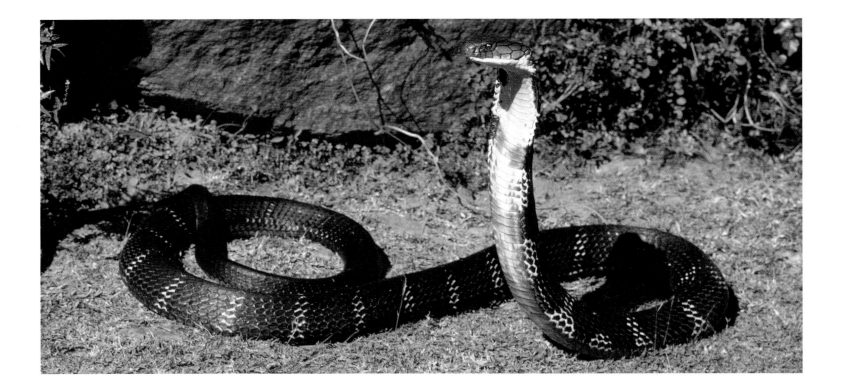

KING COBRA (*Ophiophagus hannah*)

WHERE FOUND: India and South-east Asia as far as Bali and the Philippines.

The first time I encountered a King Cobra was as a tender eighteen-year-old in the jungles of Sumatra. It stood upright on a fallen log and towered above me, swaying from side to side as if trying to hypnotize me. As I stood there fascinated, my knees trembling, it seemed that my terror was making me hear things and that the snake was actually growling at me like an angry Rottweiler. A few years later I learned of the unique membranes at the back of their throat; the King was indeed vibrating its reptilian hiss through these membranes to produce a snarl that any big dog or cat would have been proud of.

The King Cobra is probably the scariest snake in the world to be in close proximity to. Having had to catch one by the tail whilst halfway up a tree, I can personally vouch for the fact that you certainly need to know what you're doing to handle one of these extraordinary beasts. It is one of the most intimidating creatures imaginable. This is no ordinary cobra; the longest recorded specimen comes in at a formidable 5.7 metres, making it by far the longest venomous snake. It also seems to be unusually intelligent; whilst most cobras will fix on pretty much anything you wave in front of them, and will happily strike at a camera lens leaving the photographer safe, King Cobras will follow the camera up to the arm that holds it, follow the arm up to the body and then strike at that.

Unlike many of the other elapids, King Cobras will keep a hold of their snake prey (*ophiophagus* means 'snake-eating') until it succumbs to their stringent venom; with an average venom yield of 421mg (ten times more than a taipan; possibly one hundred times more than an Eastern Brown!), their bite is always serious, and has the potential to be lethal in humans in just a few minutes. Luckily

though, despite its fearsome reputation, the King Cobra will flee if given the chance, and put on a dramatic and sustained threat display before actually attacking.

When first threatened, the King Cobra will rear up, spread its hood by elevating its long cervical ribs, and assume the erect posture so characteristic of the elapids. The hood is, relative to body size, a little narrower than the hoods of other *Naja* species cobras, but as they can hold about a third of their body off the ground, a fully-grown specimen could potentially stand up and look a six-foot man in the eyes! However, the King Cobra is not really a significant threat to humans; they live in dense forest far away from human settlements, and their impressive threat displays are designed to help ensure the cobra never has to actually attack.

In the wild, King Cobras will feed only on other snakes. People who have taken the bold step of trying to keep a King Cobra in captivity have experimented with dipping rats in liquidised snake to try and persuade their captive specimens to eat, usually with minimal success. Anyone who studies the King for any amount of time gains a healthy respect for them. During mating the male performs an extraordinarily erotic pas-de-deux with his partner, twisting himself about her in arousing foreplay before he actually mates with her. The female is, thereafter, one of the best mothers of all reptiles, gathering together a nest of dry leaves and rotting vegetation, generally in bamboo thickets, in which to incubate her eggs. She will guard the nest aggressively, and is never to be taken lightly in this – or any other – situation.

PREVIOUS PAGE *The Komodo Dragon, one of the most fearsome predators in this book.*

ABOVE *Truly the most exciting of all snakes, the King Cobra.*

OPPOSITE *The black-and-white banding of the King Cobra fades as the snake matures. Most of the five metre-plus specimens are more dull olive green.*

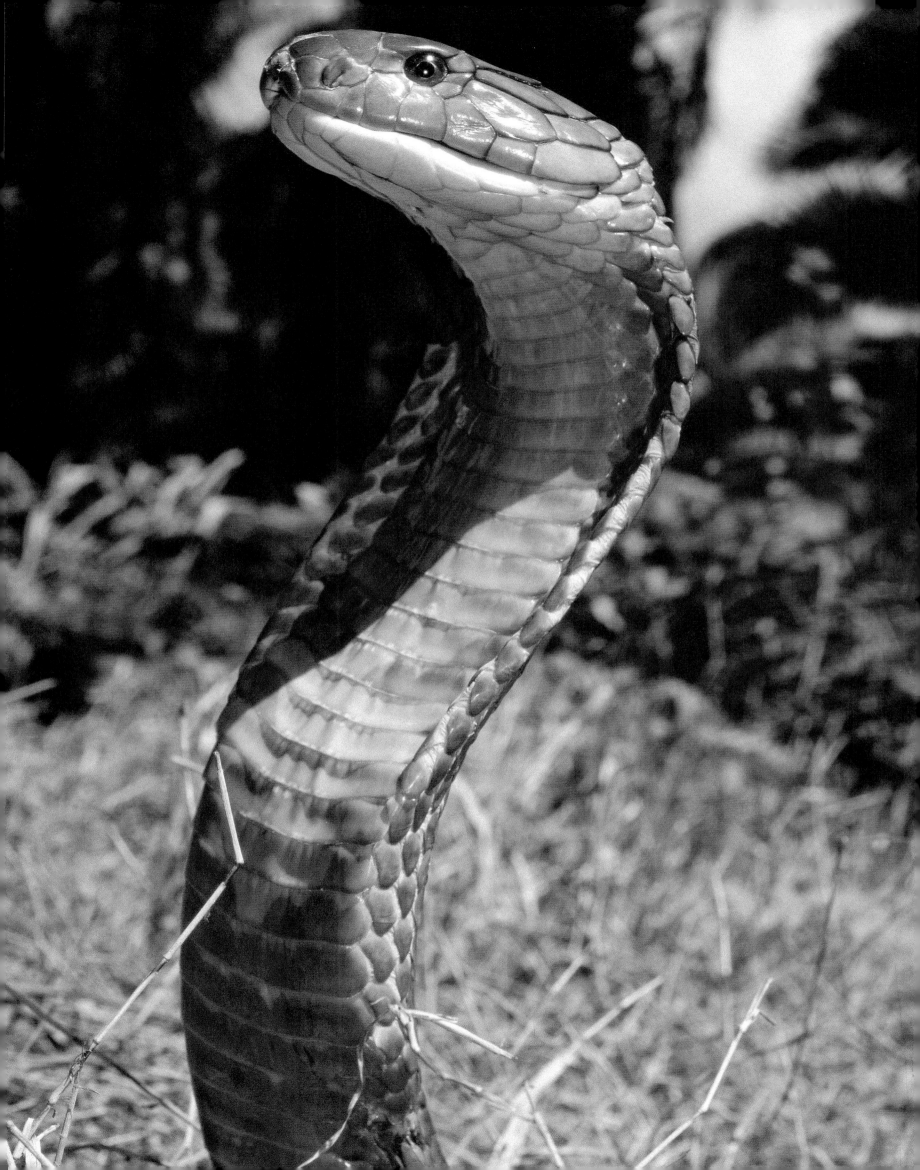

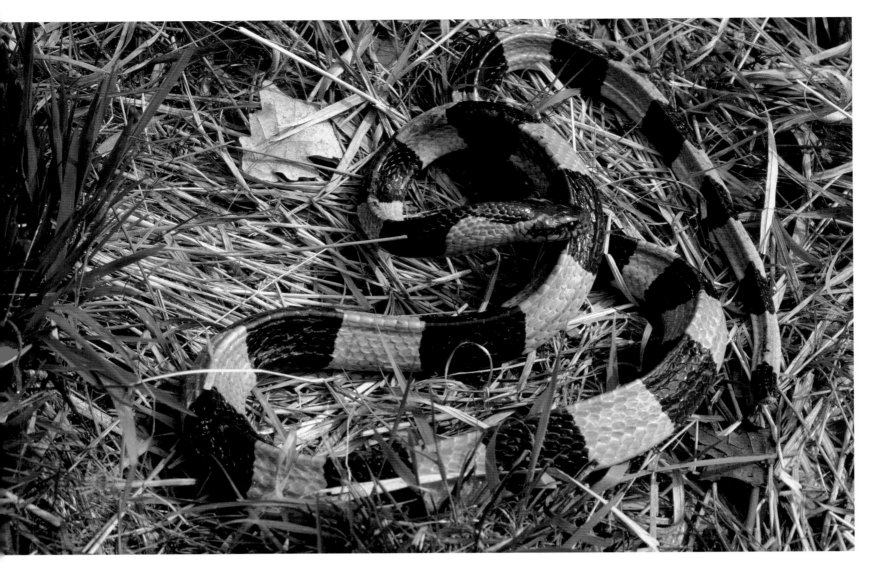

OTHER COBRAS (NAJA SPP.)

WHERE FOUND: ACROSS SOUTHERN ASIA.

Ever since reading the story of *Rikki-Tikki-Tavi* in Rudyard Kipling's *The Jungle Book* as an animal-obsessed child, I have been fascinated by the wily Asian cobras and the insidious krait. It wasn't until much later that I learned of the variety of species and habits of these snakes, but even today they can still surprise.

Both the Spectacled and Monocled Cobras (*Naja naja* and *N. kaouthia* respectively) are a delightful whimsy of evolution. The perfect eyeglasses on the rear of the hood are supposedly to create the impression of a head with eyes on both sides, so that a predator has no idea from which side to approach in order to catch the snake unawares. Then there's the single eyeglass of the Monocled Cobra – what's its purpose? It looks more like a bullseye than a fake face. Traditional Indian folklore describes how the markings were given to the cobra by the God Brahm, after the snake shaded him from the powerful sun with his hood.

Many of the cobra species are fairly common throughout Asia and crop up often in urban locations, following the rats and mice that in turn have followed the people. At least six species of Asian cobras

seem to be capable of spitting their venom towards the eyes of an adversary, though none of them is as adept at this as their cousins in southern Africa.

Of the cobra relatives, the kraits are feared for their unfortunate habit of seeking the warmth of sleeping humans, who (in the stories, at least) roll onto the interloper in their bed. As krait bites are lethal but pretty well painless, the apocryphal victims don't wake up…ever. Meanwhile, the Asian coral snakes are not quite as colourful as their Central American cousins, but still demonstrate some vibrant reds, bright blues and striping. The banded coral snakes will flatten their bodies and reveal their bright white, black and red undersides to anything considered a threat. They also have their mimics: totally harmless snakes that derive undeniable benefits from resembling a snake that sensible predators would want to avoid.

ABOVE The Banded Krait (Bungarus fasciatus) *is highly venomous and responsible for many cases of snakebite in South-east Asia.*

OPPOSITE *Legend relates how, after the God Brahm sheltered from a storm beneath the umbrella of a serpent's hood, he touched the cobra and left these marks as a blessing. More prosaically, they probably confuse predators, which may mistake the back of the hood for the face, complete with fake eyes.*

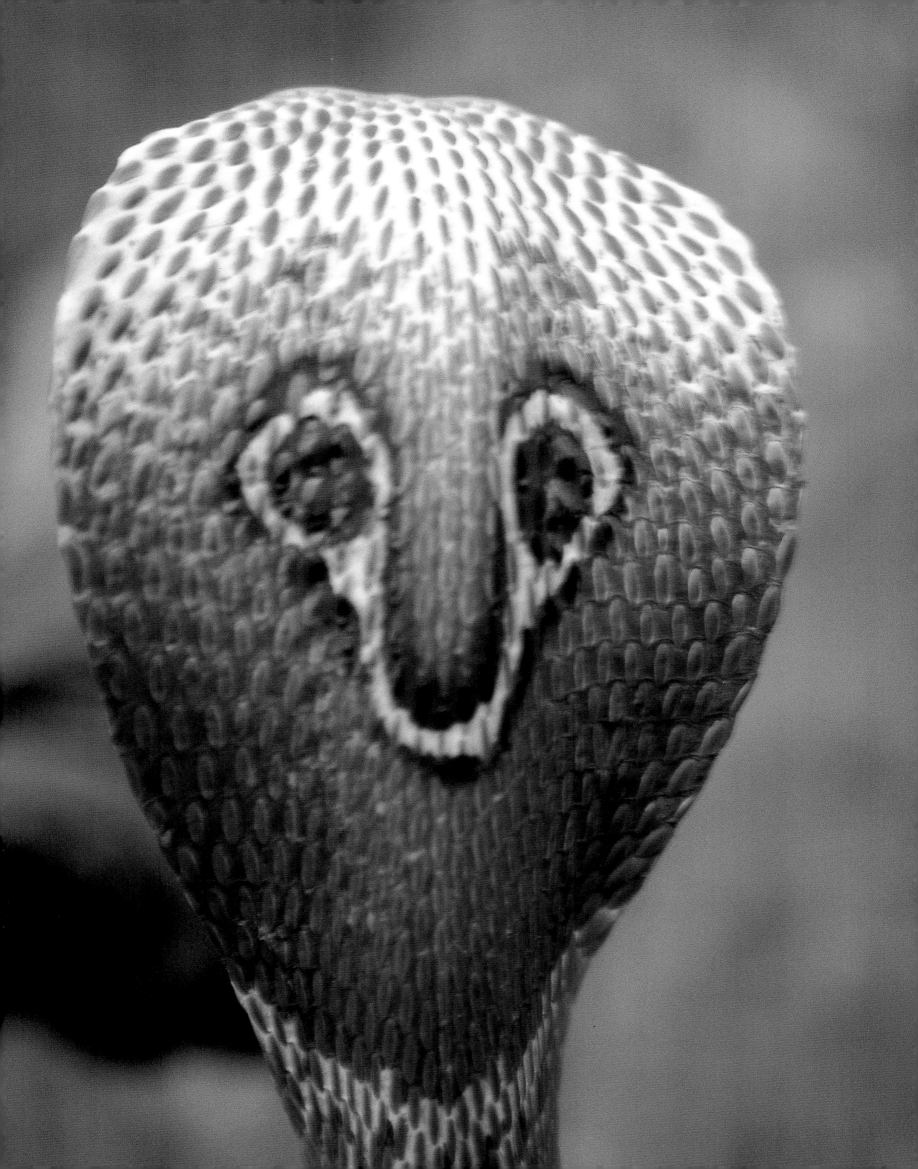

RUSSELL'S VIPER (DABOIA RUSSELII)
AND SAW-SCALED VIPER (ECHIS CARINATUS)

WHERE FOUND: MUCH OF ASIA, INCLUDING INDIA, SOUTHERN CHINA AND TAIWAN, SOUTH-EAST ASIA.

The relatively humble Russell's Viper arguably takes the title of the most deadly snake in the world. With its smaller and less conspicuous relative, the Saw-scaled Viper, it is certainly responsible for more snakebite deaths than all other species put together.

The Saw-scaled Viper is named for the serrated edges to the scales; when irritated, the snake can rub these together to create a rasping sound designed to deter attackers. In much of rural Asia, snakebite is almost always inadvertent, though there are a few bites suffered by snake catchers and snake charmers. For the most part, though, those who are bitten are working the fields and step on or pick up the snake in handfuls of rice paddy or other vegetation. When this happens, the risk of envenomation seems to be very much down to how irritable the species is, and if it's a Russell's or Saw-scaled Viper, the answer – usually – is very.

One of the more unpleasant side effects of a bite by a Russell's Viper is that recovery is rarely complete. Renal failure is commonplace, with total lack of blood coagulation leading to blood flowing into any available body space. Peculiarly, a reduction in male sex hormones has also been recorded on many occasions. Survivors may totally lose their libidos and their secondary sexual hair (facial hair, for example), and even suffer a reduction in the size of their sexual organs – literally emasculated by the snake!

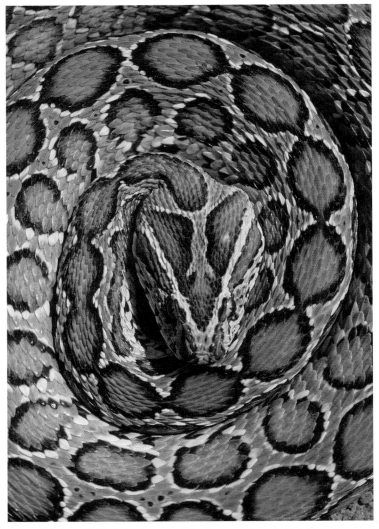

BELOW *Russell's Viper, probably the most lethal snake in the world, due to a combination of unfortunate developments that bring them into regular contact with people. This is an immature specimen, but still highly dangerous.*

ABOVE *This beautiful but deadly snake takes its name from Patrick Russell, an 18th-century British physician and naturalist to the East India Company. He conducted the first detailed study of Indian serpents.*

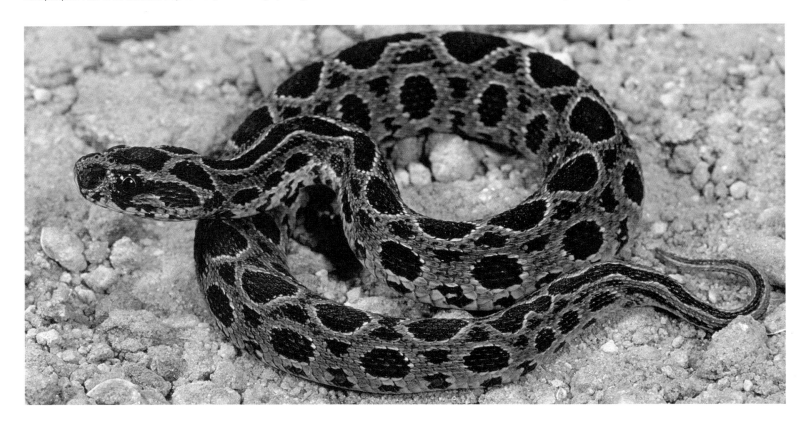

DEATHSTALKER SCORPION

(*Leirus quinquestriatus*)

WHERE FOUND: Desert habitats throughout the Middle East, extending into north-east Africa.

The somewhat morbidly named Deathstalker (its Latin name means 'five-striped smooth tail') is one of the very few scorpions that poses a serious threat to people. A rather jittery, aggressive beast, it will readily face down a potential threat with quite deadly weaponry, its venom being the most toxic of all the scorpions for which results exist. A study from Israel revealed that only localized reactions occur in 97 per cent of the victims, but the venom can be potentially lethal in children because the severity of the symptoms is weight-dependent. Several fatalities are reported every year.

The Deathstalker is generally an attractive, bright yellow colour, with an unusually thin tail for such a seriously venomous scorpion. Usually, a rule of thumb for working out whether or not a scorpion is dangerous is to look at the tail – fat equals nasty, thin means feeble. This rule is exactly reversed with the pincers – if they're fat, they're the scorpion's primary means of defence and attack and the sting is

probably pretty weedy. My own pet Emperor Scorpions (*Pandinus imperatus*) have claws like giant lobsters and can give you a bit of a pinch, but I pretty much had to press their stinger into my skin before I got stung, and the result was no more powerful than a bee sting.

Deathstalker venom contains a rather nasty blend of neurotoxins, one component of which is called chlorotoxin. This is a powerful peptide, which serendipitously has been shown to have potential for treating gliomas – brain tumours – in humans. It has been proved to go straight to the centre of the problem in mice, and human trials are currently underway. Other factors in the venom may also help to regulate insulin, and therefore treat diabetes. Meanwhile, there are antivenins for Deathstalker venom, made by German and French pharmaceutical companies.

BELOW *A sting from a Deathstaker Scorpion is not just painful; it also carries the the risk of anaphylaxis, a potentially life-threatening allergic reaction to the venom.*

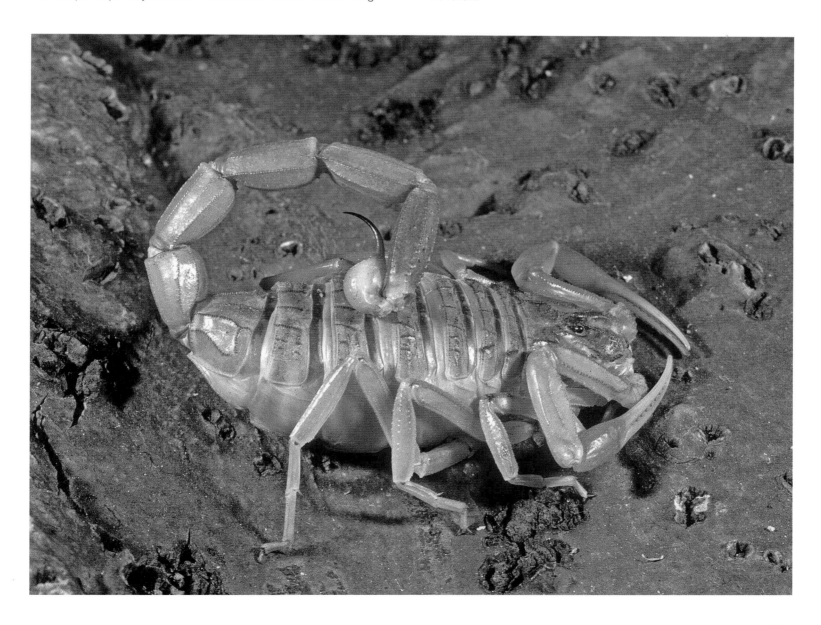

CROWN-OF-THORNS STARFISH

(*ACANTHASTER PLANCI*)

WHERE FOUND: Coral reefs in tropical waters.

This enemy of the coral reef has been known to occur in plague proportions and to eat areas of reef the size of cities, leaving a bleached white, dead coral skeleton behind. Such congregations may number as many as several million individuals, and consume virtually every living coral in their path. What happens when they have destroyed a reef is unknown; they certainly dissipate very quickly, but whether they move en masse to another reef, or die off, is uncertain.

This is a big starfish, as much as 40cm in diameter, and hefty and well built. Sharp spines cover its entire dorsal surface. It prefers to live in more sheltered areas, such as lagoons, and in deeper water along reef fronts, avoiding the exposure of shallow water on the tops of reefs. Each starfish has venom-producing glandular cells at the base of each spine, releasing a bluish liquid. The spines often break off into the wound of anyone handling them, which causes swelling and possibly cell death in the immediate area. Nausea and vomiting can occur, possibly due to the extreme pain, and if the spines remain in the flesh, they can cause pain for weeks afterwards. As many well-meaning divers trying to remove Crown-of-Thorns from reefs have found out, these are also remarkably hard organisms to destroy, being capable of regenerating lost limbs and even surviving extended periods out of the water.

OPPOSITE *One of the true denizens of the deep, the Crown-of-Thorns Starfish is the dark destroyer of the coral reef.*

BELOW *Starfish feed by regurgitating their stomachs and digesting prey outside of their bodies. Unfortunately, the Crown-of-Thorns may do this over hundreds of miles of reef, killing vast areas of coral.*

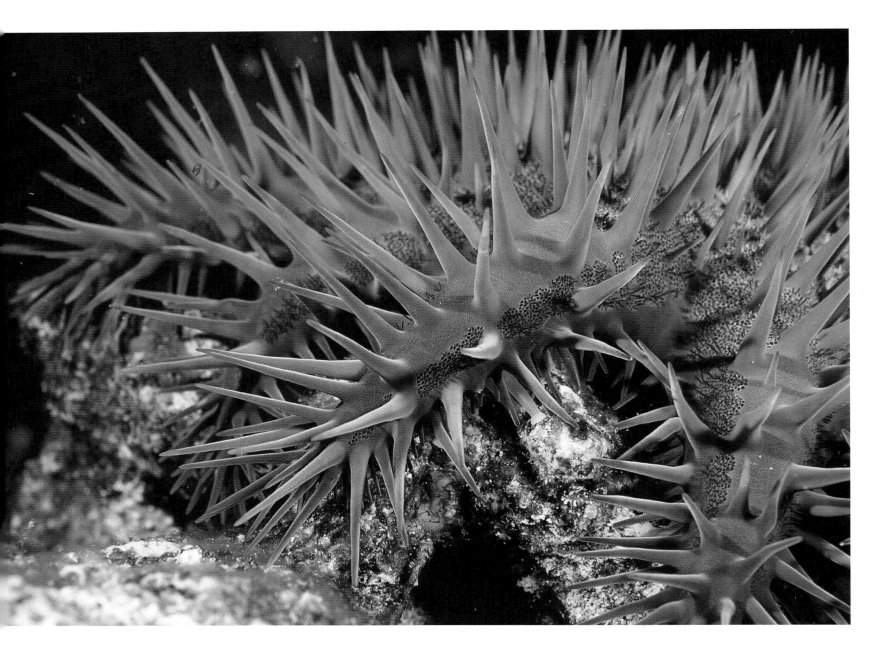

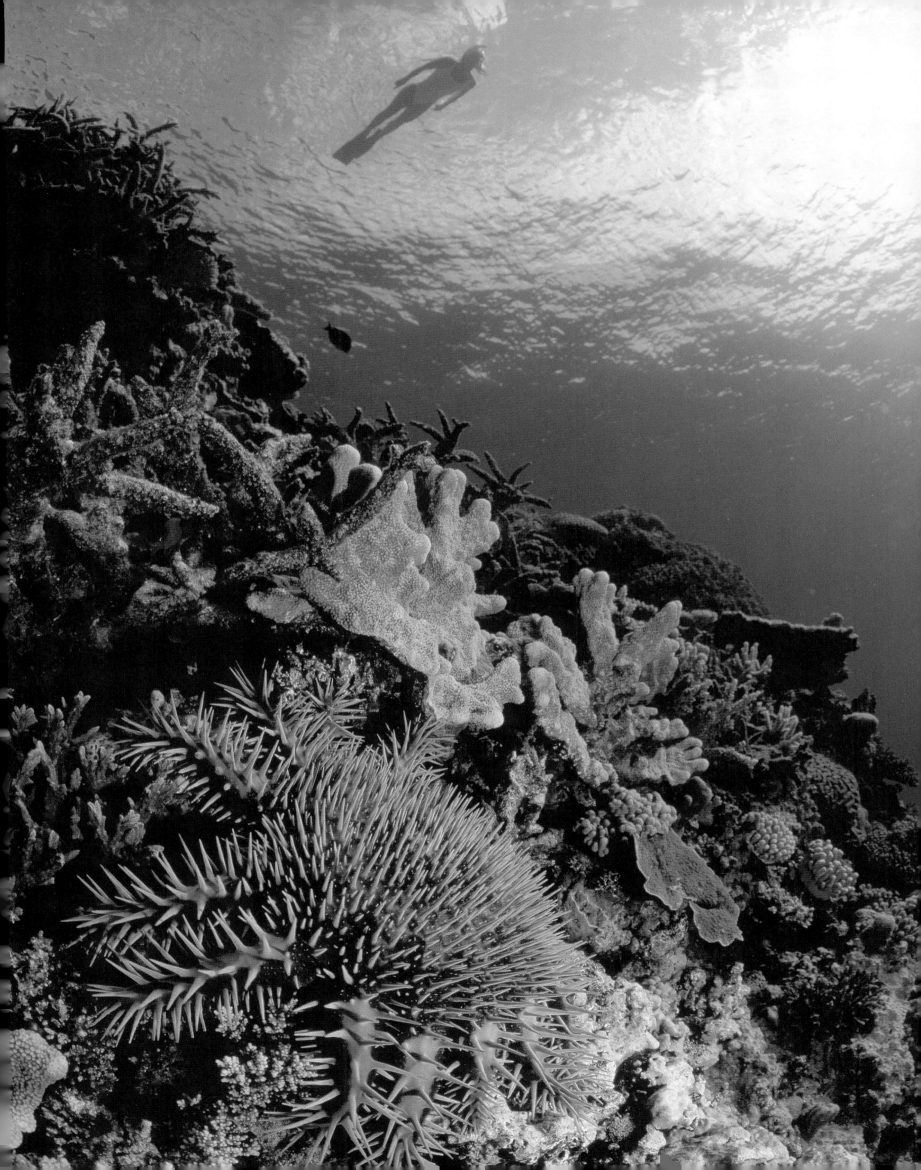

RED TIDES AND CIGUATOXINS

WHERE FOUND: Warm waters worldwide.

Turning the seas red for weeks or months at a time, Red Tides result from blooms of planktonic algae, particularly unicellular dinoflagellates, which produce lethal toxins such as gonyautoxins. Red Tides are a natural phenomenon, but it appears that they can be exacerbated by human activities causing the run-off into the sea of nitrates and phosphates.

During Red Tides, filter-feeding creatures are particularly susceptible, as they concentrate the toxins in their tissues. Shellfish such as mussels can amass enough of these toxins to kill a human, without suffering any negative effects themselves. Other dinoflagellates may live in the water column, on the surface of larger algae. These produce toxins such as ciguatoxin, which accumulate in the food chain, from herbivorous fish through to larger carnivores. the effect of consuming such fish, known as ciguatera poisoning, is thus most common as a result of eating large carnivorous fish such as Giant Wrasse and reef fish like parrotfish. With symptoms such as neck aches, chills or sweats, a metallic taste in the mouth, or tingly

numbness, this type of poisoining affects an estimated 50,000 people globally every year, mostly in Indo-Pacific and Caribbean waters, but is rarely fatal. Turtle flesh – particularly that of the Hawksbill Turtle – is also very suspect in such circumstances; another very good reason why these beautiful creatures should not end up on the dinner table.

ABOVE *Red Tides may be a natural phenomenon but evidence suggests that they are exacerbated by human negligence and pollution.*

OPPOSITE *The attractive exterior of a cone shell (in this case a* Conus spp. *from the Solomon Islands) belies a dangerous animal within, complete with harpoon.*

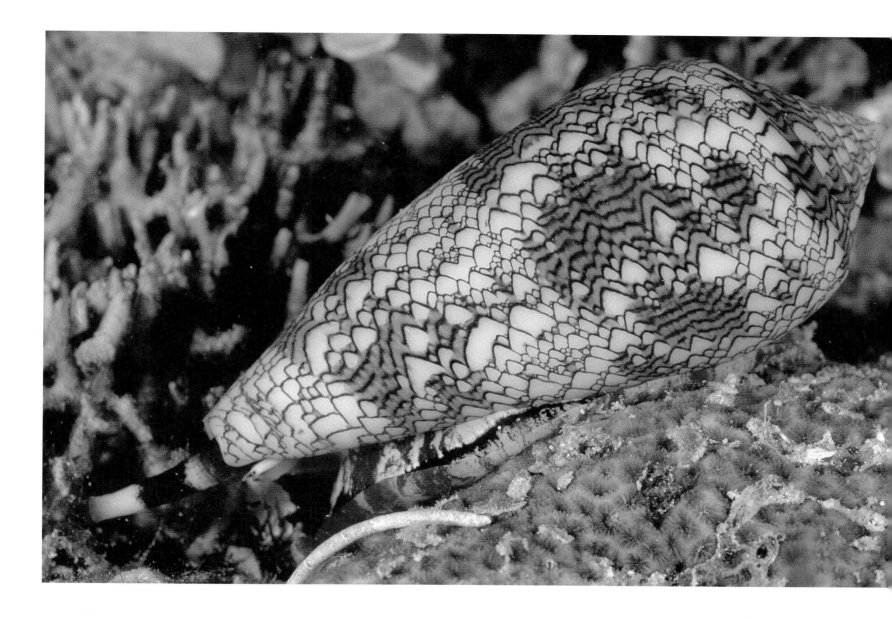

CONE SHELLS (*Conus geographus, C. textile*)

WHERE FOUND: Indo-Pacific waters, with some also in the Atlantic and western Pacific.

Cone shells are actually predatory gastropod snails – gastropod meaning 'stomach-footed'. Mostly nocturnal, they live in waters from 600 metres to the shallow waters of the intertidal zone, and are voracious carnivores, the most dangerous ones feeding on fish. A snail that harpoons swimming fish? It really is as spectacular as it sounds, and watching a cone shell skewer a fish is certainly one of the great sights of the natural world. The shell moves very slowly over the sea floor in search of prey, approaching discreetly before suddenly shooting out its 'spear' at lightning pace, skewering the hapless prey.

The spear is a refinement of that part of a gastropod's mouthparts known as the radula. This is usually formed as a sort of file for scraping off food items, but in the cone shells it has evolved and enlarged into a kind of harpoon attached to a venom bulb. The cone shell fires this harpoon from the narrow end of the shell into its prey. Once the prey is immobilized, the cone shell will evacuate almost the entirety of its soft body from the safety of its shell, and digest the

meal externally. During this somewhat macabre procedure, the snail is obviously at its most exposed and in danger of predation itself.

Though there are occasional human fatalities caused by simply stepping on cone shells, the majority of injuries occur when people are collecting the shells, which are extremely attractive. So if you see a shell like this it is vital not to touch it, however sure you are that it's empty. The cone shell's neurotoxic venom acts on the nerves, resulting in neurological weakness, lack of co-ordination, and adverse effects on vision, speech and hearing. Nearly 30 human fatalities have been reported, all due to paralysis of the respiratory muscles.

To date, the venoms of 50 of the 500 species of cone shells have been investigated. Several factors of the conotoxins that comprise the cone shells' venom have been shown to have potential as analgesics, and other elements may eventually be used to combat Parkinson's disease and epilepsy.

The Augur Shell is another predatory snail that feeds on marine worms in a similar fashion to the cone shell. Its shell is far longer and thinner, and corkscrewed. It has not been implicated in human accidents, but is considered dangerous enough to be treated with care.

PUFFERFISH (TETRAODONTIDAE SPP.)

WHERE FOUND: WARM, SHALLOW, TROPICAL TO SUB-TROPICAL WATERS AROUND JAPAN, CHINA, THE PHILIPPINES, TAIWAN, THE WEST INDIES AND MEXICO.

Known variously as pufferfish, blowfish or swellfish, the bony fish of the Tetraodontiformes (meaning 'four toothed') are known to contain lethal tetrodotoxins throughout their tissues, but particularly in their livers. With as many as 20,000 different types of fish in the seas around us, one might imagine therefore that humans steer a wide path around these particular species. Yet in Japan, the eating of pufferfish – known there as fugu – is a national habit, and it is even eaten raw as sushi and sashimi.

Fugu chefs have to train for three years under a fugu master, must be licensed by the Japanese government, and have to retake their licence every year. It's no wonder that such care is taken over its preparation, as death can result from an amount of the toxin small enough to fit on the point of a pin, and there's no known antidote. It is a great honour to be served fugu in Japan, and seen as a way of confronting one's own mortality – sometimes known as the 'brush of death'. If it's prepared correctly (i.e. all the most toxic organs are completely removed), the diner should experience a faint sensation of intoxication, with a light tingling on the lips. If it's not prepared correctly, lung failure and asphyxiation can ensue! There are over 200 cases of fugu poisoning reported annually, and as many as half of those result in death.

Nor is it just humans that are vulnerable to the pufferfish. Fishermen have long known that if you keep one in close contact with other species of fish, the others will all die. This is the result of the pufferfish's skin secretions, which, whilst massively diluted in the sea, can build up in a tank and kill everything.

Pufferfish eat great numbers of marine plankton called Dinoflagellates, in which the alkaloid tetrodotoxin is found. This is bioaccumulated by the pufferfish in their skin and organs, yet they possess a mutation that prevents the toxicity from poisoning them. Interestingly, elements of this toxin are now being used in medicine, as an aid for recovering heroin addicts.

BELOW *Pufferfish spines may look like a formidable weapon, but in fact they possess no venom-injecting capacity. The lethal poisons are actually contained within the creature's internal organs.*

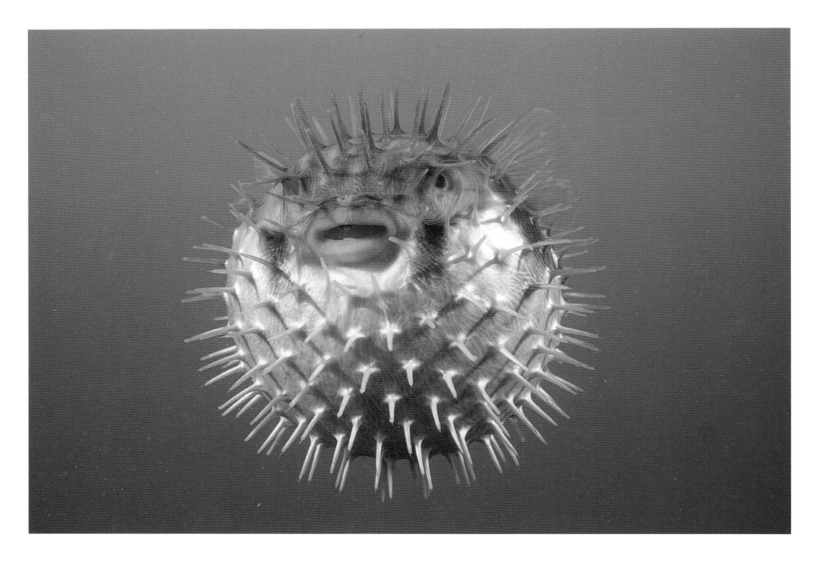

YELLOW-BELLIED OR PELAGIC SEASNAKE

(*Pelamis platurus*)

WHERE FOUND: ACROSS THE INDIAN OCEAN AND PACIFIC, FROM THE EAST COAST OF AFRICA TO THE WEST COAST OF THE AMERICAS.

This species is unusual amongst the seasnakes in that it is pelagic, spending its life out in the open sea, and feeds at the surface rather than at the sea bottom. All seasnakes are venomous (this species and *Enhydrina schistosa*, the Beaked Seasnake, are considered the most dangerous) and major features of seasnake envenomation are muscle pain, tenderness and sometimes spasm. The bite itself is not particularly painful and may go unnoticed initially, distinguishing it from envenomation by stinging fishes or jellyfish, for example. It's not until the myotoxins kick in and you start experiencing severe muscle aches (30 minutes to three hours later) that you realize there's a problem. There is a positive side, though – defensive seasnake bites are regularly dry (i.e. without venom), and some studies have suggested that as many as 80 per cent may result in little or no venom being injected. In fact, recorded seasnake bites are very rare indeed; however, when research was carried out in specific developing countries where seasnakes occur, it became clear that bites were actually quite common, but they were just not being reported.

With their flattened tails and valved nostrils, seasnakes are well adapted to a saltwater life. They are, of course, excellent swimmers and divers, and live on a diet of fish and eels. They strike their prey with great speed and paralyze it with powerful muscle toxins, before eating it whole (like all snakes they cannot chew chunks out of their prey). They have special glands under the tongue to dissipate salt, nostril valves to close up their nostrils on their dives – which can be up to three hours long – and they've been reported in mass aggregations, forming slicks of snakes several miles in length, turning the surface of the sea into a writhing, seething morass of serpents.

Seasnakes shed their skins much more frequently than land snakes, as often as every two weeks, in order to get rid of parasites such as barnacles. They may also tie themselves into knots in order to scrub off parasites, and will even allow cleaner wrasses or shrimps to do the job. The young are born alive at sea, except for those of the Banded Sea Krait (*Laticauda colubrina*) and three other closely related species, which come ashore to lay their eggs.

BELOW *The Yellow-bellied Seasnake spends its entire life at sea, and so is rarely encountered by humans other than fishermen. The most frequent sightings involve specimens washed up on the shore, as here.*

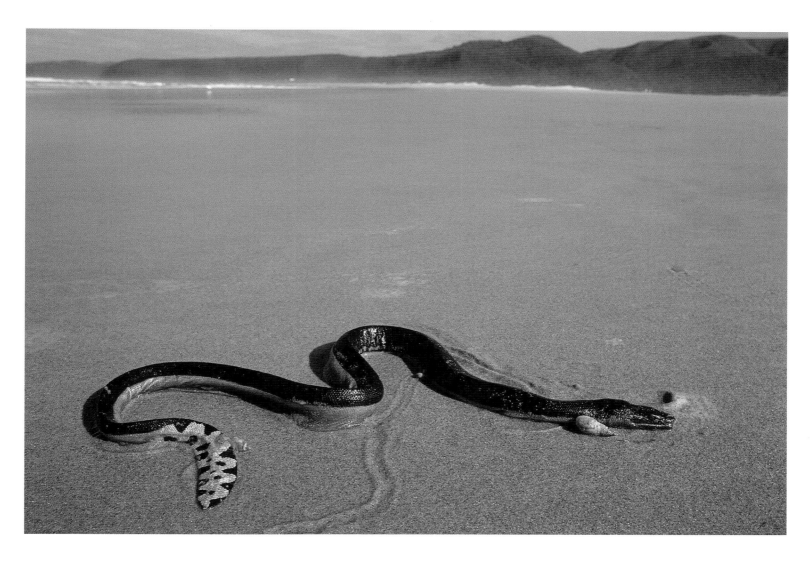

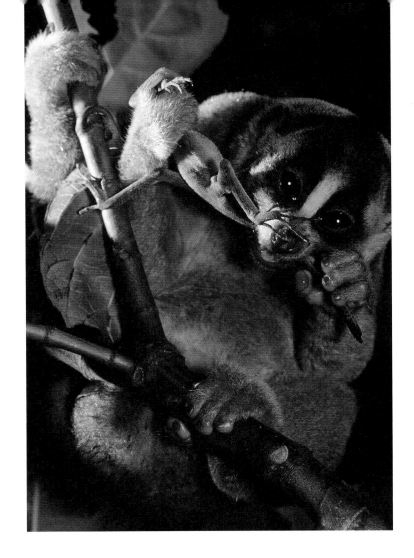

SLOW LORIS *(Nycticebus coucang)*

WHERE FOUND: India and Bangladesh through South-east Asia.

With gigantic eyes, a habit of marking territories with urine and making loud whistles or a buzzing, hissing vocalization when threatened, together with a slow, methodical, stalking movement, the Slow Loris is a peculiar but endearing denizen of the jungle night.

The word 'loris' comes from an old Dutch word meaning clown or simpleton. The lorises belong to the primate group known informally as prosimians, and so are related to humans, albeit very distantly. They feed primarily on large invertebrates, but will also happily take a lizard or large amphibian if they get the chance. They have excellent night vision, their huge eyes gathering large amounts of light, which is enhanced by the tapetum – a special layer of cells in the retina, which reflects light back through the light-sensitive cells.

What is most unusual about the Slow Loris, however, are the sebaceous glands in the crooks of its elbows. When it is preparing to bite, it first licks these glands, coating its teeth in a poison they secrete. This gives the bite a nasty kick, which can make the bite site itch, swell and ache for days afterwards. A mother Slow Loris will also lick her babies with this poison if she is about to leave them alone for any amount of time – presumably this serves to deter predators.

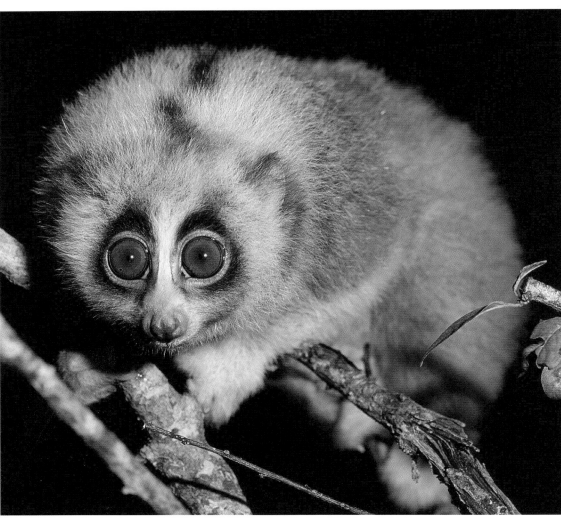

ABOVE AND OPPOSITE *Slow Lorises have a varied and sometimes surprising diet. If the opportunity arises, they will even tackle birds.*

LEFT *Never be fooled by the doe-eyed appearance of this creature. During a vet check on an injured specimen I received an almost affectionate nibble on my arm, which turned into an angry, red, itchy wheal.*

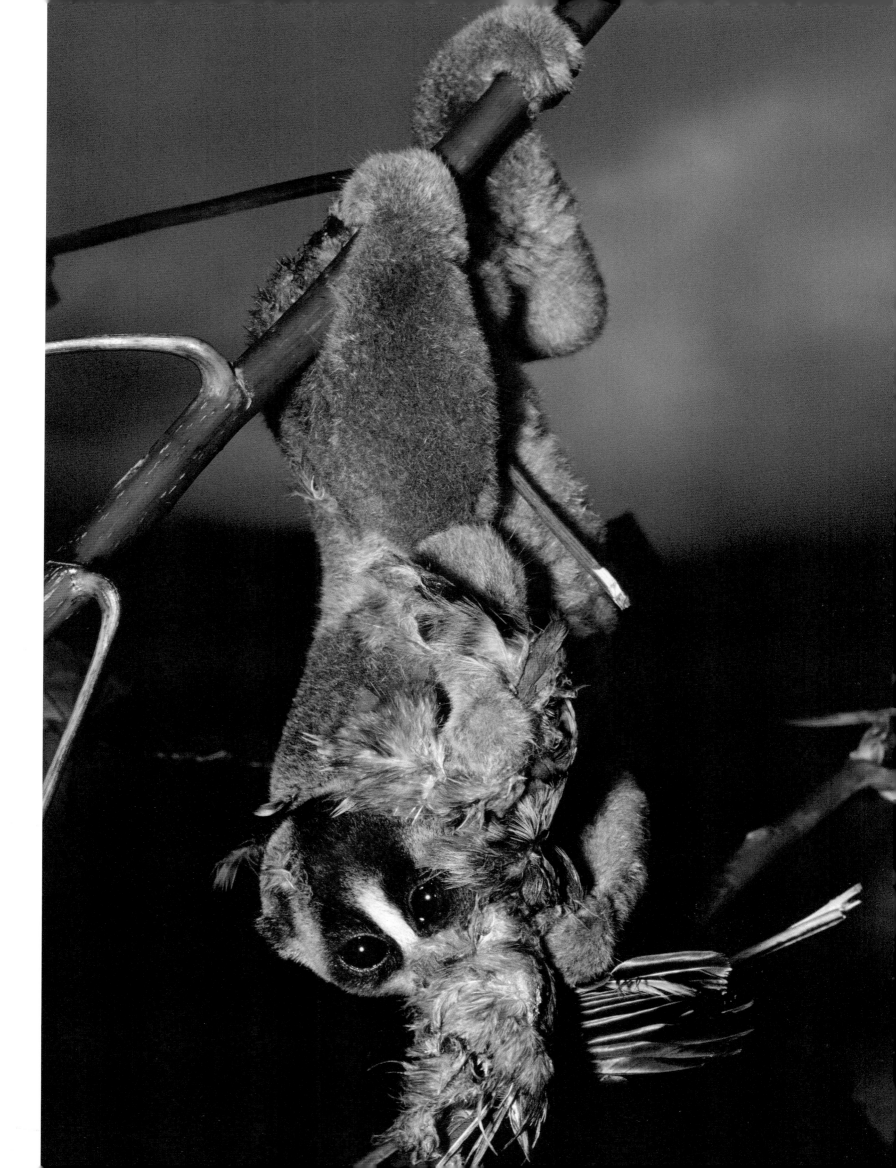

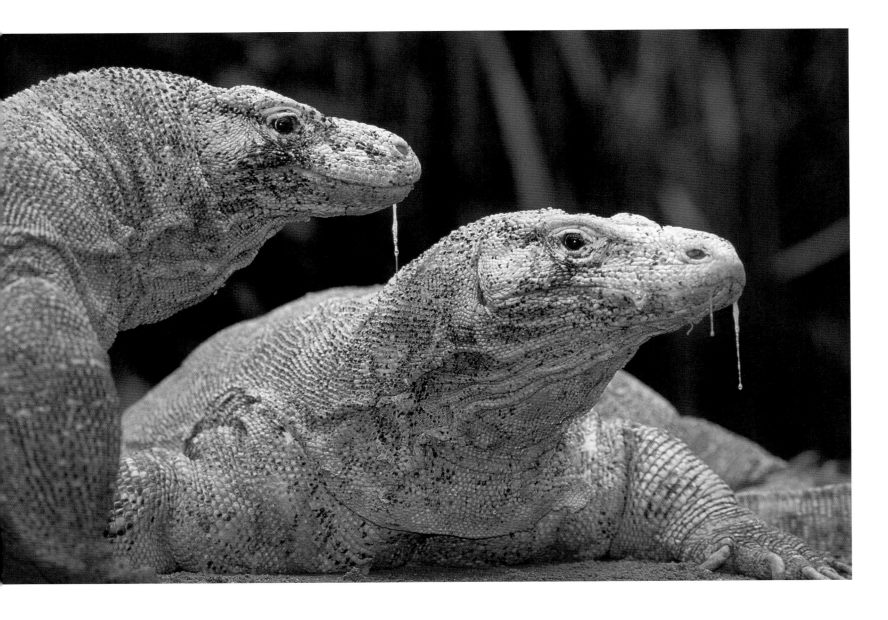

KOMODO DRAGON (*Varanus komodoensis*)

WHERE FOUND: Komodo and surrounding islands in Indonesia.

'The dragon lay motionless in a pool of brackish water, eyeing us with a fearless disdain born of a history spent at the business end of the food chain. Its only motion was the occasional flicking of a serpentine tongue, tasting the strange intruders on the air. A tourist, frustrated by the unphotogenic display being offered him, waved away the guide's protestations and walked to within metres of the apparently dozing beast, camera poised. The dragon was unperturbed, until the interloper got that little bit too close. The blur of motion as the monster snapped his bulk from the pool and soared towards the hapless tourist was that of a striking cobra, covering about two metres before we had even registered its movement. The tourist, to his credit, moved at the speed of light, off through the bushes and into the distance. The dragon paused briefly to munch distractedly on the discarded camera, spitting out the mangled heap of plastic. He then slipped back into his waterhole, the hierarchy rightfully restored.'

[account written after a visit I made to Komodo in 1991]

The Komodo Dragon is the largest extant lizard in the world. By an unexplained fluke of evolution, it lives only on the island of Komodo, the tiny neighbouring islands of Padar, Motong and Rinca, with a few animals also in western Flores. When on the island of Komodo, there is a sense that you have been caught in a timewarp. This is due not only to the presence of the famous dragons, but also to the wild craggy landscapes, dried-up riverbeds, ravines and scrubby savannah, which combine to create an almost prehistoric atmosphere.

Unlike many rare species around the globe, the dragon, or Ora as it is known locally, is actually steadily increasing in numbers. It has no direct predators and man has never persecuted it in earnest. There has never been any real reason to hunt the dragons – their skin is latticed with thin dermal bones and could never be made into serviceable leather. As for meat, there's little point in tackling one of these beasts on an island that abounds with deer and pigs. The Ora does suffer indirectly from the overhunting of these animals, as they are its main source of prey, but Komodo is one of the few national parks in Asia that is currently relatively free from poaching. Whilst the dragons are also vulnerable to scavengers and smaller predators eating their young and eggs, the species is not currently endangered. It has existed in almost identical form for around 130 million years, but

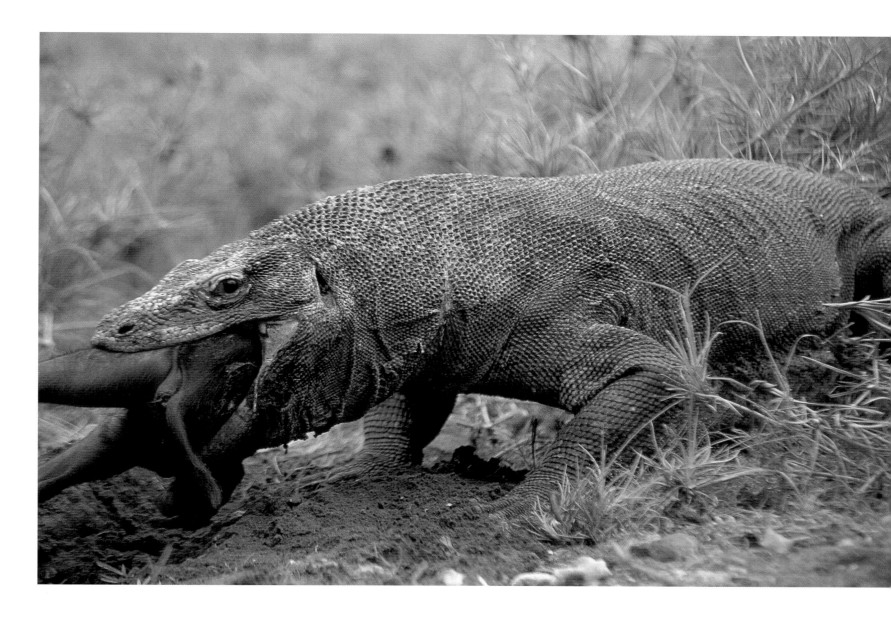

far from being an obsolescent dinosaur, it is a fearsome modern predator and, occasionally, a man-eater.

The dragon is actually a varanid or monitor lizard, so-called because in popular folklore they 'monitor' crocodiles, warning of their presence. The largest recorded Komodo Dragon was well in excess of three metres long and weighed a mammoth 150 kilos. They are truly omnivorous, gladly devouring anything within reach and baulking neither at cannibalism nor at attacking creatures many times their own size. There are even documented reports of dragons pulling down and consuming fully-grown Water Buffalo.

Komodo Dragons usually hunt by waiting hidden beside well-worn game paths; they strike down their prey either with a slash of their immensely powerful tail or by slicing the tendons in the prey's legs with scalpel-sharp fangs. However, with large prey the dragon attacks, makes a bite, and then waits for the victim to deteriorate and collapse. Originally this was attributed to the huge infections that result from a dragon bite – their mouths are full of powerfully toxic bacteria – but a team of researchers led by Brian Fry is now proposing that Komodo Dragons are actually venomous and that around 200 million years ago they shared a common ancestor with venomous snakes. This may explain why the dragon's prey suffers the

effect of a bite within minutes, with swelling, extensive bleeding and shooting pains. This is obviously far too fast to be the result of bacteria alone.

Attacks on people by Komodo Dragons are very rare. Perhaps the most high-profile incident was an attack in 2001 by a specimen in Los Angeles Zoo on Phil Bronstein, the husband of actress Sharon Stone. He nearly lost a foot, and spent days on intravenous anti-biotics. Several children living in the small fishing village on Komodo have been less lucky, however, as was a visiting Swiss tourist in 1974. He was completely consumed, and all that was ever found was his camera.

OPPOSITE *The saliva dripping from the maws of these two Komodos is not only laden with nasty bacteria, but also contains a true venom.*

ABOVE *Although the dragon can rip and chew more than its distant reptilian relatives, it does tend to swallow its food whole.*

OVERLEAF *On the scrubby plains of the island of Komodo, a pig (truly a fearsome adversary) has met its end in the jaws of a dragon.*

145

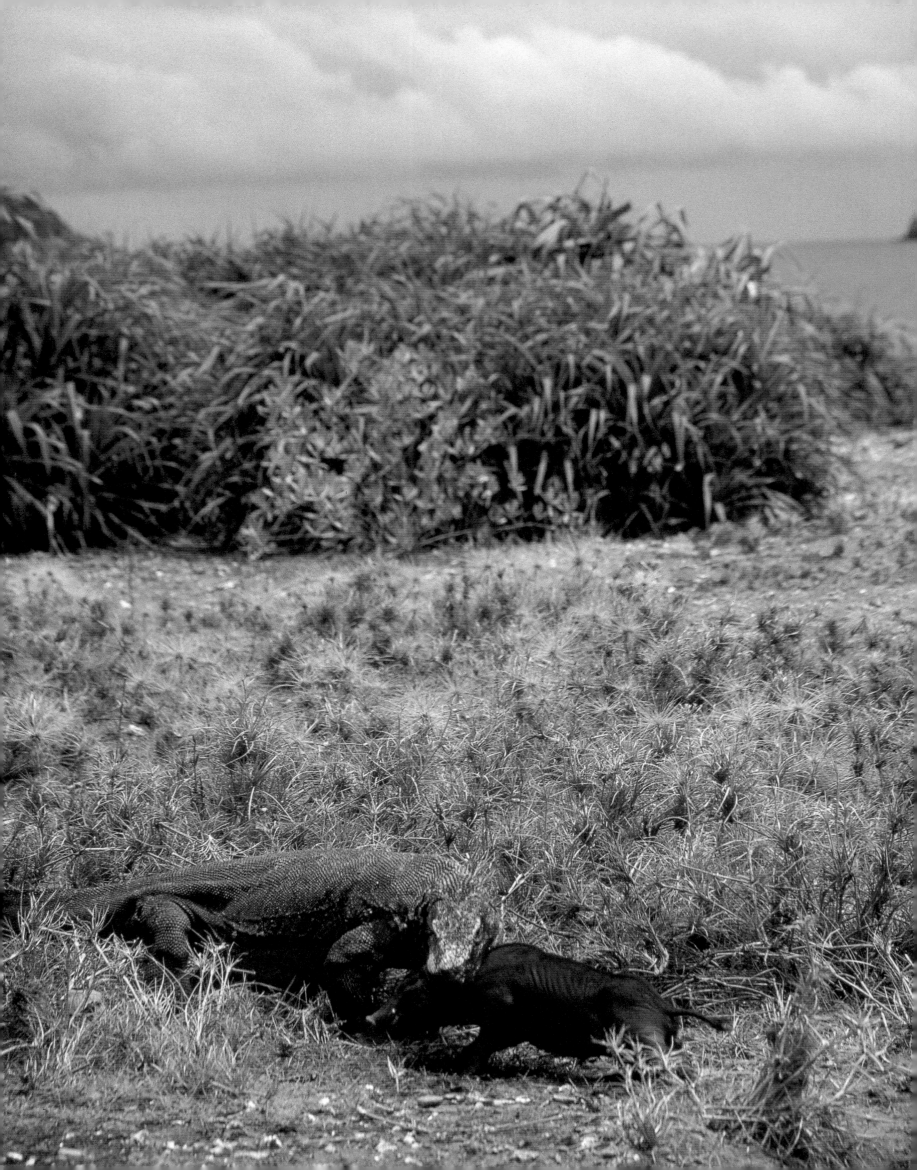

ASIAN GIANT HORNET (*Vespa mandarinia*)

WHERE FOUND: EASTERN ASIA

The largest of all the social wasps, this voracious predator – known colloquially as the Yak-killer Hornet – is up to 5cm long and has a wingspan of up to 7.5cm. Its stinger is a centimetre long and pumps out a venom that contains very high proportions of acetylcholine. This leads to a supremely painful sting and one capable of disintegrating human tissue! To make matters worse, the stinger itself is not barbed, and so can be used repeatedly. Without proper treatment, just a single sting can kill a human – about 40 people a year die from allergic reactions to it.

However, it's the hornet's powerful crushing mandibles that are generally used to incapacitate prey, the stinger mostly being used for defence. The hornet's prey consists of other invertebrates, and it is particularly partial to European Honeybees, brought to Eastern Asia for their honey yield, which is superior to the native species. One hornet can kill 40 honeybees in a minute, and a swarm can wipe out an entire hive of tens of thousands. Once a scout hornet has located a honeybee hive, it marks it with pheromones, which its compatriots then use to locate the bees. The invading hornets chew their victims into paste and feed them to their larvae. The larvae respond by producing a clear liquid, which is a super high-energy food that allows the hornets to fly as much as 60 miles a day at speeds of up to 25 miles an hour.

However, not all bees are helpless against hornets. The Japanese Honeybee, *Apis cerana japonica*, has evolved a remarkable response to attacking hornets. Hundreds of honeybees will cluster by the entrance to the nest whilst keeping the entrance enticingly open, thereby tempting the hornets inside. Once the hornets enter, several hundred more bees will gather around them, vigorously vibrating their flight muscles. This energy expenditure raises the temperature inside the honeybee mass to 47°C, which is bearable for the bees, but proves too much for the trapped hornets, which die.

BELOW *The Asian Giant Hornet has all the equipment required for the role of a predator, not least the biggest sting of any wasp.*

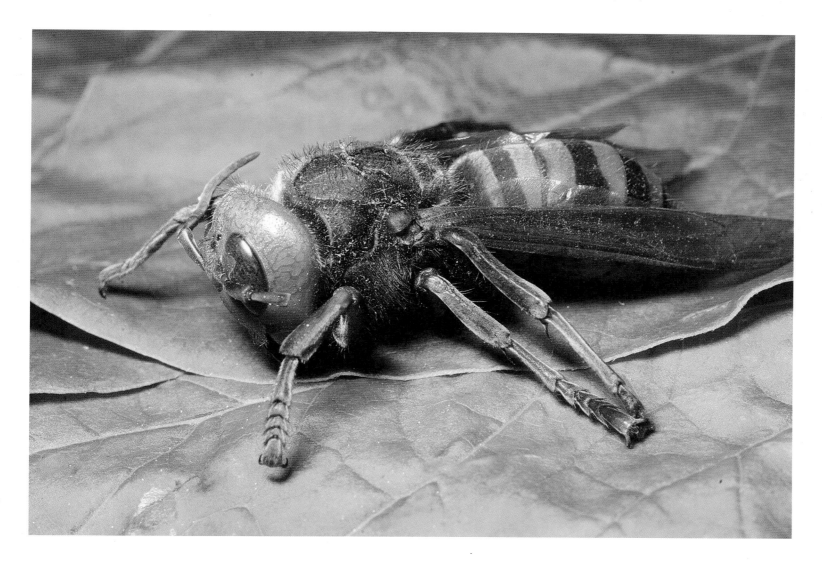

THE FUTURE FOR VENOMOUS WILDLIFE

Over the course of prehistory, there have been at least five great mass extinctions of wildlife on Earth. Each was due to a cataclysmic event such as a meteor strike, volcanic eruption or dramatic climate change, wiping out anything up to 96 per cent of the species then extant on the planet. Anyone who spends any time working with wild animals can be in no doubt that we are now on the verge of a sixth mass extinction, and that this time it is we who are to blame.

THE PRESSURE BUILDS

The human population has doubled since my parents were children, and 1,000 years ago there were probably only 300 million people on earth. Today there are over SIX BILLION, all needing to be fed and provided for from the same finite resources, and each one consuming more, and being more wasteful, than their ancestors. As a result, the world's wildlife is under massive pressure, increasingly driven into ever smaller corners of the planet. The level of environmental destruction is frightening; some habitats have been destroyed completely, replaced by urbanisation or monoculture. Very few landscapes survive in anything approaching pristine shape. Meanwhile, the exploitation of certain types of wild animals is running at unsustainable levels, threatening both the future of the species involved and the ecosystem of which they form a part. So whilst the human era may have been good news for rats, cockroaches and pigeons, the vast majority of the planet's wildlife is in serious danger from human expansionism.

The impact of non-native species

It is tempting to think that the world's venomous creatures are tough enough to look after themselves, but this couldn't be further from the truth. For example, many of the venomous mammals discussed in this book are under danger from non-native species that have been introduced into their environments by humans. Indeed, in the 1970s the Solenodon was suspected to be extinct as a result of introduced mongooses and rats killing them and their young. Releases into the wild have at least ensured the animal's rather tenuous survival – for now at least. Meanwhile, both the Water Shrew and the Platypus are suffering from human disturbance and the 'development' of river banks; added to which, Platypus eggs are eaten by Red Foxes and rats, which since their introduction by man have caused untold damage to the native fauna of Australia.

Probably even more dangerous to mammals everywhere is the attachment people have to domestic cats. Cats are exceptional predators, so much so that in the wild their home range spans about 4.5 km sq.: that's how much wild land is needed to provide enough food for just one cat. Imagine how many domestic cats are kept nowadays as pets in that kind of space, and how much less wild food there is available to them in our urban environments. Even though they're fed by their owners, that doesn't stop each cat from killing hundreds of songbirds, amphibians, reptiles, small mammals and invertebrates every year. Scientists in Wisconsin, for example, estimate that 7.8 million songbirds die annually in the paws of cats in that state alone, and in the UK the once-common Slow-worm (*Anguis fragilis*) has been virtually wiped out in many areas by cats. If you are a cat owner, then I urge you to put a bell round its neck, keep it indoors at night, and keep bird-feeding tables well in the open away from hedges and bushes from which cats can stalk their prey.

The risk of extinction

Around the world, reptiles are under a number of threats, both modern and ancient. Snakes – whether venomous or not – have always been persecuted, due to their image as dangerous beasts and to the perception in some cultures that they have a mythological connection to dark spirits and evil. Their function in keeping down pest animals is poorly understood and cannot be accurately analyzed, but to remove snakes from the environment would almost certainly cause widespread calamity as disease-ridden crop-consuming rodents proliferate. Mankind's persecution of snakes has been so successful that many species are already believed extinct; the last ever recorded specimen of the Autlan Rattlesnake (*Crotalus lannomi*) was killed on a Mexican road in an area where 'rattlesnake roundups' still wipe out hundreds of thousands of snakes every year in barbaric so-called festivals.

Probably most at risk of genuine extinction as a class, however, are the amphibians. They are incredibly susceptible to habitat destruction, water and air pollution and the greater ramifications of climate change. Amphibians have permeable skins which allow a great deal of gas and fluid exchange with their external environment, and this makes them extremely susceptible to fertilizers, herbicides, pesticides, sewage, metals and other pollutants in the water, as well as airborne pollutants. Also, as they lead a sort of double life, with half their life cycle taking place in the water and half on land, they are twice as likely to suffer from any degradation of their environment. Scientists have recorded an alarming global decline in amphibian numbers, since the apparent extinction of the Costa Rican Golden Toad (*Bufo periglenes*) in 1989 drew attention to the situation. In some parts of the world the excessive collection of frogs for food has led to alarming increases in certain insect populations, which have in turn devastated agricultural crops; in Africa this has been linked to the renewed spread of malaria. To put matters into perspective, 1,000 tiny cricket frogs in a small American pond were found to consume around 4.8 million invertebrates per annum.

Perhaps most worrying, however, is a chytrid fungus that is sweeping the world and killing off billions of amphibians. It has caused 100 per cent mortality in some populations, and all of the amphibians included in this book are in serious danger of extinction. Scarce and localized species, such as the dart frog *Phyllobattes terribilis*, which takes proud place at the top of our toxic table, are particularly vulnerable. *Terribilis* lives in small numbers in a very small part of the Amazon rainforest and could be wiped out by a single logging concession or the arrival of disease.

The desecration of the oceans

The marine species listed in this book are mostly to be found on tropical coral reefs, one of the most abused environments on the planet. Over 90 per cent of the world's coral reefs have been adversely affected by human activity. The dynamiting of reefs as a method of collecting fish, and the even more disturbing use of cyanide to kill fish, both totally destroy coral structures that are thousands of years old. Furthermore, coral 'bleaching', caused by toxic run-offs from land and unusually high water temperatures, is also responsible for the death of massive areas of reef. Sewage and silt running off the land – when, for example, mangroves are cleared to make way for hotels – covers up corals and obstructs their life-giving relationship with sunlight. As the reefs die, their inhabitants are deprived of their homes and starved of food.

The human plunder of the world's oceans is also taking its toll. Beautiful cone shells and related species are removed in their

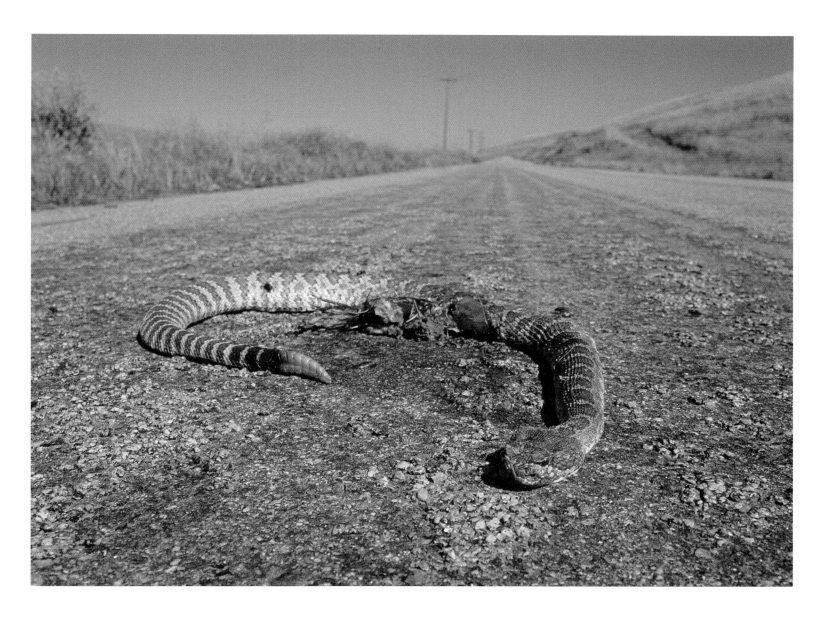

thousands to be sold in markets as adornments for mantelpieces around the world. If this continues at its current rate, the strip mining of our seas for food risks leaving huge tracts of ocean virtually devoid of life. It's a concept so unimaginable that few actually believe it will happen, but Europe's present 'cod crisis' is just the tip of the iceberg. It may seem that the venomous marine species mentioned in this book may not be at risk – surely if a fishermen netting for mackerel comes up with a Lionfish or Pufferfish as bycatch he will just throw them back? Well yes, but these fish have swim bladders which over-inflate when hauled to the surface, thereby crushing the fish's internal organs. Even if the bycatch fish are thrown immediately back overboard, they will not survive.

A last opportunity?

As has already been discussed, natural toxins have taken millions of years to evolve and comprise some of the most extraordinarily complex compounds on the planet. The most effective hypertension reliever known to man comes from lancehead venom, and chemicals from amphibians, molluscs and bee venom, amongst others, are already providing the pain relievers of the future. Other venoms are playing a critical role in finding relief for diabetes, arthritis and many

other human ailments. Who knows where the cure for cancer or HIV/AIDS may reside – possibly in the saliva of the Komodo Dragon, or in the toxic skin secretions of an obscure toad? If we don't do our absolute utmost to preserve the fabulous jewels of our natural world, we may find ourselves overrun with pests and disease, but without the pharmacological treasure troves that could help us solve the very problems we've created.

PREVIOUS PAGE *The destruction of rainforests in Indonesia continues, cleared for timber and to make way for farmland and palm oil plantations. It's believed that Indonesia alone loses 6.2 million acres of forest every year, suggesting it could all be gone within 20 years. The forests are home to many forms of wildlife, including a large number of venomous species that could be of huge benefit to mankind.*

ABOVE *This rattlesnake has met its end on an American highway. Sadly, many road-users will deliberately swerve to run over snakes.*

OVERLEAF *Scorpions pinned to make macabre souvenirs in Tunisia. Many venomous creatures are considered fair game for this sort of treatment.*

APPENDICES

APPENDIX ONE EFFECTS OF DIFFERENT TYPES OF VENOM

TYPE OF VENOM	HOW IT WORKS	EXAMPLE SPECIES
Neurotoxic (Alpha and Beta Neurotoxins)	The main effect is to block nerve impulses to the muscles, causing cramps and rigidity. It also affects the production of the neurotransmitters, acetylcholine and norephinephrine. This leads to a neuromuscular blockage, causing respiratory failure and death. Onset of symptoms is from a couple of minutes to as much as ten hours after the bite.	*Elapidae* – Cobras and their relatives. Marine stingers such as Box Jellyfish, Weeverfish, Scorpionfish, Stonefish, Cone Shell, Blueringed Octopus. Funnel-web Spider venom – known as atraxotoxin – acts directly upon the nervous system. Black Widow venom also causes a condition known as latrodectism. The scorpion venoms, like those of other arachnids, are high in neurotoxins. Curare, the active component of dart frog poisons (Dendrotoxins).
Haematoxic/Haemolytic	Haemorragine toxins affect the circulatory tissues; they alter and dissolve the blood vessel walls, leading to severe and uncontainable internal bleeding. Symptoms usually seen within 20 minutes.	*Viperiids* (vipers) *Crotalids* (eg. rattlesnakes)
Cytotoxic/Necrotic	Causes blistering, ulcers and tissue death – necrosis. Particularly common in spider venoms, and results from the spider's feeding behaviour – it cannot chew up prey, so injects toxins to predigest food outside the body.	The recluse spiders are the most toxic of the spiders with necrotic venom. Brown spiders, house spiders, wandering spiders (including White-tailed Spider), wolf spiders and sac spiders (*Cheiracanthum* spp.). Some of the most horrific necrosis can be seen after snake bites. Infections can also result in substantial tissue damage.
Cardiotoxic	Disturbs the plasma membranes of some cells, causes tachycardia, hypotension and fluctuations in heart rate and rhythm and blood pressure, leading to cardiac arrest.	*Buthidae* fat-tailed scorpions, and most other severe scorpion stings. Viper venoms. Box Jellyfish.
Myotoxic	Leads to muscular degeneration. Onset of symptoms within 2 hours.	Seasnake venoms contain a high amount of myotoxins, as do the venoms of other elapids such as taipans.

APPENDIX TWO LD50 COMPARATIVE TABLE

SPECIES NAME	LOCATION	SUBCUTANEOUS LD50 (mg/kg) mice
Phyllobates terribilis, Poison Dart Frog	S. America	0.0008
Oxyuranus microlepidotus, Inland Taipan	Australia	0.025
Pseudonaja textiles, Eastern Brown Snake	Australia	0.0365
Aipysurus duboisii, Dubois Seasnake	Tropics	0.044
Pelamis platurus, Yellow-bellied Seasnake	Tropics	0.067
Oxyuranus scutellatus, Coastal Taipan	Australia	0.106
Bungarus multicinctus, Banded Krait	Asia	0.108
Notechis a. niger, Tiger Snake	Australia	0.131
Echis carinatus, Saw-scaled Viper	Asia	0.151
Atrax robustus, Sydney Funnel-web Spider	Australia	0.16
Leiurus quinquestriatus, Deathstalker Scorpion	N. Africa, S.W. Asia	0.16–0.50
Crotalus scutulatus, Mojave Rattlesnake	N. America	0.23
Naja naja, Spectacled Cobra	Asia	0.29
Phoneutria nigriventer, Brazilian Wandering Spider	Brazil	0.3
Androctonus australis, Fat-tailed Scorpion	N. Africa	0.32
Dendroaspis polylepsis, Black Mamba	Africa	0.32
Ophiophagus hannah, King Cobra	Asia	0.35
Synanceia spp, Stonefish	Tropics	0.4
Heloderma suspectum, Gila Monster	N. America	0.4–2.7
Daboia russelli russelli, Russell's Viper	Asia	0.75
Buthus occitanus tunetanus, Fat-tailed Scorpion	N. Africa	0.90
Latrodectus mactans tredecimgluttatus, Black Widow Spider	Europe, N. America	0.90
Centruroides exilicauda, Bark Scorpion	N. America	1.12–1.46
Scolopendra viridicornis, Giant Centipede	S. America	1.5
Tetradontiformes, Pufferfish	Tropics	1–2 (ingested)
Crotalus adamanterus, Eastern Diamondback Rattlesnake	N. America	1.89
Pseudechis australis, King Brown Snake or Mulga	Australia	1.9
Vespids, Wasp sting (purified toxin applied intravenously)	Widespread	2.5
Pterois spp., Lionfish	Tropics	4.4
Apids, Common Bee sting (applied intravenously)	Widespread	6.0
Vipera berus, Common Adder	Europe	6.45
Bothrops jararaca, Lancehead or Fer-de-lance	C. America	7
Bitis gabonica, Gaboon Viper	Africa	12.5

(This list is not to be considered an exhaustive 'top thirty', as there are many other analogous species that would register in this table.)

FURTHER READING

Greene, H.W. (1997) *Snakes: The Evolution of Mystery in Nature*. University of California Press.

Not just the best book on snakes ever written, but one of the finest natural history works of any kind. Beautifully written, by one of the world's most pre-eminent herpetologists, full of mythology, great science, and the author's infectious fascination with and delight in the world of serpents! One of the only encyclopaedia-type works I've ever sat down and read cover to cover like a story book.

Dr McGavin, G. (2006) *Endangered, Wildlife on the Brink of Extinction*. Cassell Press.

Potentially a thoroughly depressing read transformed into riveting reading by Dr McGavin's genuine enthusiasm for his subject, positive outlook and suggestions for the future. This book should be required reading, and because it is written by one of the world's foremost entomologists, the bug section is particularly good stuff!

David Grimaldi, D. and Engel, M.S. (2005) *Evolution of the Insects*. Cambridge University Press.

A masterpiece that – though hefty both in size and content, is well worth trawling through. There's a hundred lifetimes' worth of study in here, but also enough thrilling surprises and fun information to keep it interesting. Less of a coffee table book than an actual replacement coffee table.

Eisner, T., Eisner, M. and Siegler, M. (2005) *Secret Weapons, Defences of Insects, Spiders, Scorpions and Other Many Legged Creatures*. Harvard University Press.

Focusing on invertebrates with natural weaponry, with a tendency to focus on North American fauna. Some fabulous accounts, but very repetitive.

Edited by Meier, J. and White, J. (1995) *Clinical Toxicology of Animal Venoms and Poisons*. CRC Press.

My bible when writing this book, with endless and exhaustive statistics and scientific explanations, but perhaps only a tome for those with a serious interest in the subject – it's kind of expensive and rather esoteric!

www.venomdoc.com – website of venom specialist Dr Brian Grieg Fry.

Dr Brian Fry is one of those responsible for the ground-breaking research on Komodo Dragon venoms. He's a respected world expert on venom, and his fantastic website is easy to get around, well illustrated, and packed with fun stories as well as hardcore science.

John Coburn, J. (1991) *The Atlas of Snakes of the World*. TFH Publications.

The most comprehensive photographic key to world snakes currently on the market, though expensive and feeling a little dated now.

Edited by Tu, A.T. (1998) *Marine Toxins and Venoms*. Colorado State University Press.

Another scholarly and dry work, but the definitive study of the toxins used by marine fauna.

Reichling, S.B. (2003) *Tarantulas of Belize*. Krieger Publishing.

Paul A Meglitsch, P.A. (1972) *Invertebrate Zoology*. Oxford University Press.

Marais, J. (2004) *A Complete Guide to the Snakes of Southern Africa*. Struik Press.

Chris Mattison, C. (1999) *The Encyclopedia of Snakes*. Blandford Books.

Edited by O Toole, C. (2002) *The New Encyclopedia of Insects*. Andromeda Oxford Limited.

INDEX

ACKNOWLEDGEMENTS

Photographs on p10, p11, p13, p17, p18, p29, p57, p82, p98, p100, p102 and p127 © Mark Vinall

Photograph on p25 © Mark MacEwen